Transforming Lives
$40 at a Time

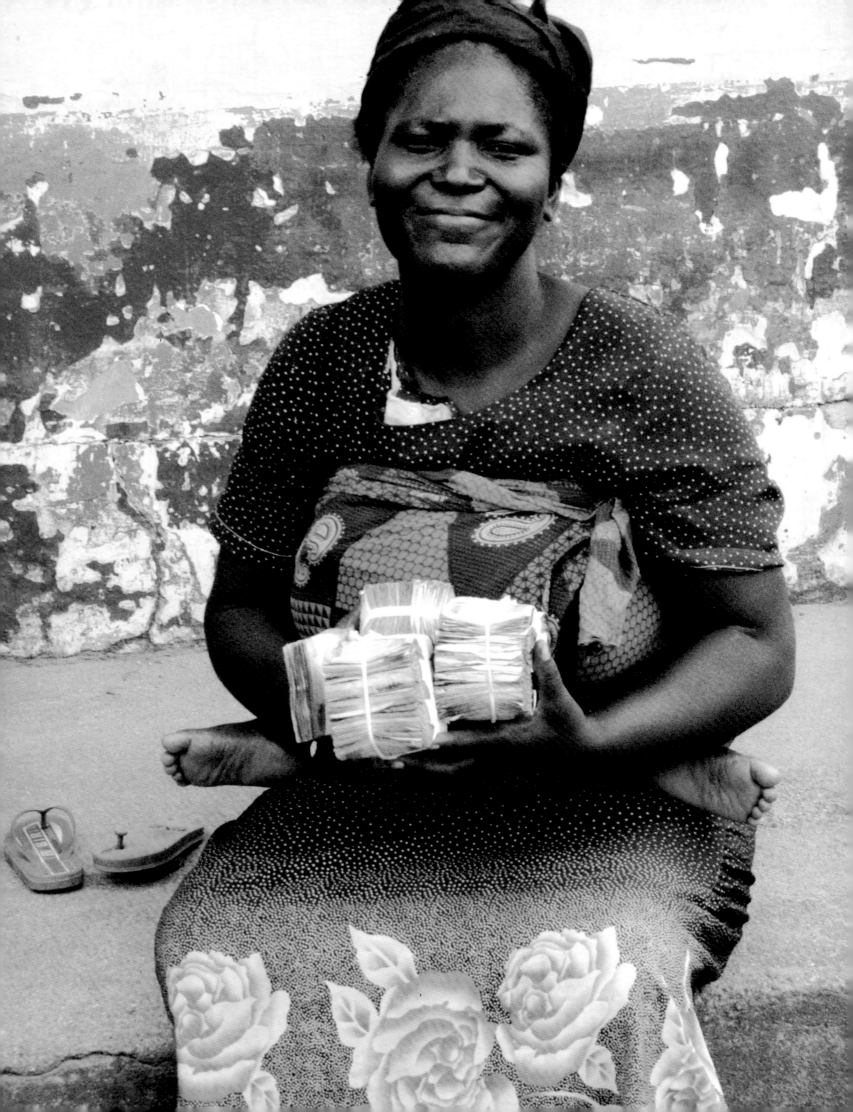

Transforming Lives $40 at a Time

Women + Microfinance: Upending the Status Quo

Photographs and Stories by
Dana Elizabeth Whitaker

Opening Eyes
7 Tanglewood Road
Berkeley, CA 94705

www.openingeyes.net

Printed in the United States of America

Photographs and text by Dana E. Whitaker

Cover and text design: Jonathan Gullery / RJ Communications

Sources:
 Maps: CIA World Factbook, www.cia.gov/cia/publications/ factbook/index.html, Sept. 2006.

 Country Statistics: UNICEF, www.unicef.org/infobycountry/ index.html Sept. 2006

Muhammad Yunus quote, jacket back: 'A Hand Up Doesn't Always Require a Handout.' *Wall Street Journal*, Oct. 14-15, 2006. pg. A6.

ISBN: 0-615-13533-1

*With joy and gratitude I dedicate this book
to two inspirations in my life: my husband Mark,
who encouraged me to follow my passion even in the
face of my fear, and our son Jack, who at age six,
asked me as I was departing on yet another trip,
"You're really trying to help people, aren't you mommy?"*

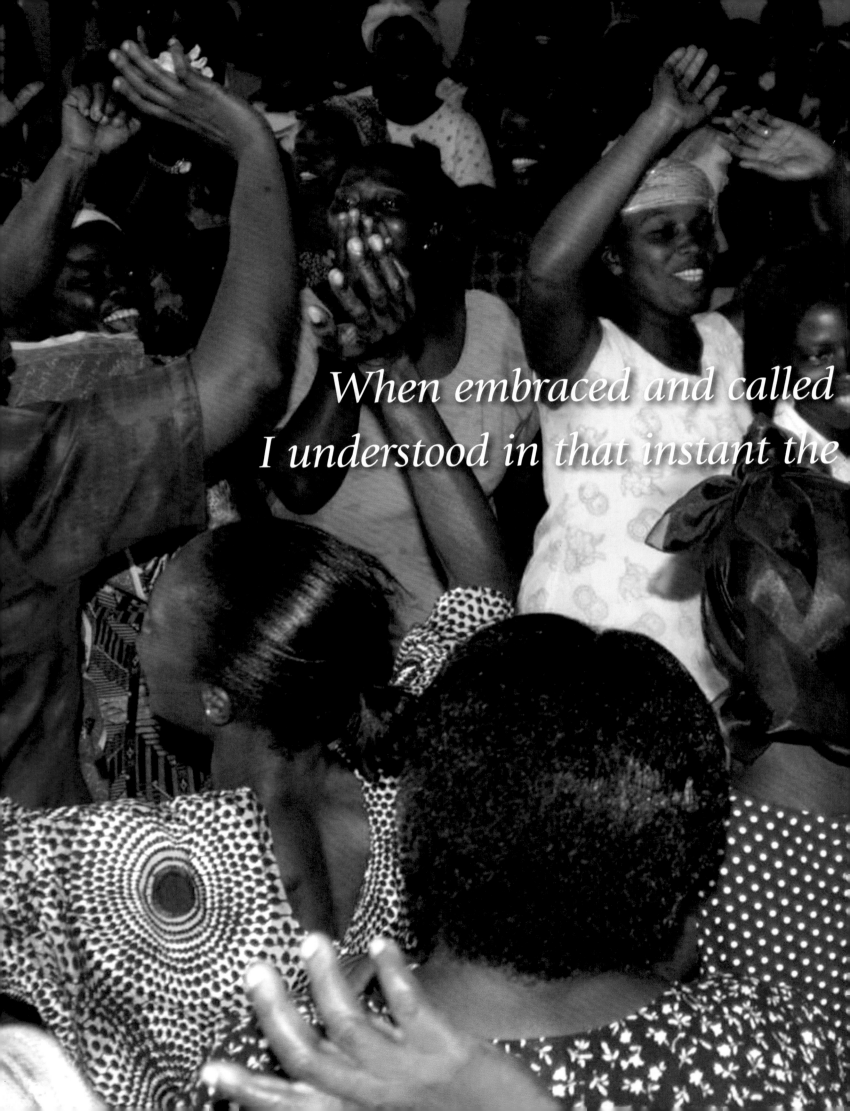

When embraced and called
I understood in that instant the

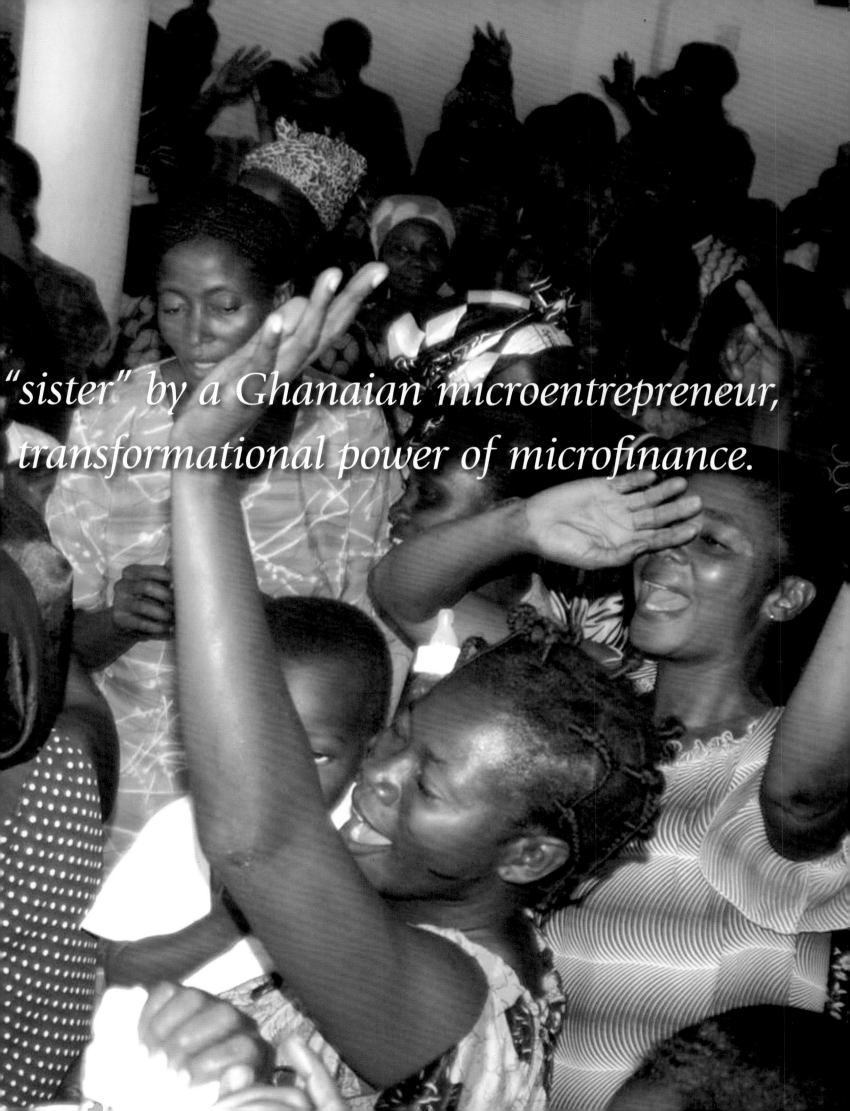

"sister" by a Ghanaian microentrepreneur,
transformational power of microfinance.

Contents

United States

Central America

South America

Africa

*Within all stories, numbers in parentheses denote US dollars

Foreword

THERE ARE STORIES that need to be told — stories that put a human face on poverty, that acknowledge the rich dignity of the human spirit, and that remind us that it is possible to make a difference in the world. This book, Dana Whitaker's Transforming Lives $40 at a Time, contains stories that need to be told.

There should be a warning label on this book, however, for stories like these are dangerous. They challenge. They confront. They inspire. To read these stories is to enter a world that will grab hold of your soul and ask, "Now that you know about us — have seen our lives and heard our dreams — what will you do?" And you will never be able to turn your back on this world again. For to turn your back is to turn away from people you now know – proud women like the Chinese rug-maker, Mrs. Du Ying, or the Chilean shopkeeper, Juana Rojas Araya. It is easier, some might say even safer, not to know these women, not to hear their stories. Open this book and you will open your heart. Open this book and you will be called to action.

Several years ago I started a new hobby. I undertake no obvious physical dangers in assembling this collection, yet it thrills me all the same. I collect stories from the men and women who work alongside me in the microfinance sector. I ask my colleagues how they came to microfinance and, equally important, why they persevere in spite of notoriously low pay, difficult working conditions, overwhelming travel schedules, or a host of other complaints.

While grumblings may vary from person to person, each of the stories I've collected so far shares a common thread, weaving us together into a community that some call a movement, others call an industry, and still others call a sector. Whatever label one chooses, those of us working in microfinance were drawn to microfinance and are now bound to microfinance by the people we serve. And we all have our favorite stories of clients who reached out, touched us, and transformed our idea of work into what often becomes a life's calling.

For me, it is a woman in Tanzania. She and I have never spoken directly to each other as we share no common language. Yet her words, as translated by her Swahili translator, are etched in my heart.

"Thank her for my soft knees," she urged the Swahili translator who was helping me.

"Her what?" I asked.

The translator exchanged a few more words with the woman, then turned to me and tried again." She's thanking you for her soft knees. Because of the microfinance loans you've given her business, she no longer needs to kneel before her husband to beg for money for their children's school fees."

I don't remember anything else about this woman. I don't remember her name. I don't remember how many children she has. I do remember, however, two important things. I know that, with the assistance of a very small loan, her status in her family has improved, and her children are in school. That is all I need to know. That is enough to keep me working in microfinance for a long, long time. And if I should start to waiver in my commitment to this profession, I need only open this book, *Transforming Lives*, and I will find yet another reason to continue.

For that is yet one more magical thing about microfinance — the harder we work to transform the lives of our clients, the more likely our own lives also will be transformed. How better to invest $40?

Deborah Burand
President of Women Advancing Microfinance (WAM) International
Executive Vice President, Programs, Grameen Foundation

Preface

TAKE A MOMENT to imagine. Imagine your house. Take a mental walk through each room admiring all you have accumulated – the soft fabric covering a cozy sofa, a beautiful piece of art adorning a well-painted, sturdy wall, a memory-provoking curio ornamenting a book-filled shelf. Open closets overflowing with linens, hanger upon hanger of warm jackets and coats, stacks of games, extra toys, and boxes bursting with holiday decorations. Now return to each room and unplug everything electric. Heated blankets, alarm clocks, your hairdryer. The stove, oven, refrigerator, microwave, dishwasher, washer and dryer. All lamps, telephones, televisions, and computers. Now imagine emptying your house of all these items.

Roll up every rug, pull up all the carpeting and remove every windowpane throughout your house. Now imagine ridding your home of these things too. Disable the heater, air conditioner and plumbing, and turn off the water main into your house. Then move one bed, a few blankets, one dresser, one small table and a single chair, a few bowls, pots and utensils, and a bag of beans and rice into one small room of your house. Allow each family member to choose one pair of shoes, one change of clothes and one special keepsake – a book, a photograph, a piece of jewelry or a toy. Put these items in that room as well. Now imagine your manicured lawn and gardens, the rest of your house and all its contents disappearing.

Literally billions of people around the world do not need to imagine this bleak scenario; they live it every day, or worse. Around the globe, an astounding 1.2 billion or one in five people, struggle to stay alive on less than $1 every day. Three billion people, or half of us living on the planet, barely subsist on $2 a day.[i] An unconscionable 23,000 children under five die every single day of largely preventable diseases such as pneumonia, malaria, measles, diarrhea, and malnutrition.[ii] One billion people entered the 21st century unable to sign their names, much less read a book, and two-thirds of them are women.[iii] One hundred million children of primary school age cannot attend school because their families lack funds for school fees, uniforms, books, or sometimes, even shoes.[iv] Afraid of, intimidated by, or unable to access or afford clinic-based healthcare, at least one woman dies every minute from complications during or just after childbirth, leaving one million motherless children behind.[v] Armed conflicts, the virulent HIV/AIDS epidemic and nature's wrath – earthquakes, tsunamis, drought

– compound the heart-wrenching devastation of an unimaginable number of livelihoods and lives.

The task of eradicating global poverty and its disastrous effects may seem hopeless. But it is financially poor, yet profoundly resourceful women in villages and urban centers, mothers and grandmothers, married and divorced, educated and illiterate, healthy and disabled, who are proving that poverty can be overcome. They know this because they are leading the way.

Women by the millions are taking advantage of *microfinance*, a broad portfolio of financial services and products targeted especially for the poor. What exactly is microfinance? In order to dispel any false assumptions, perhaps it is best to begin with what microfinance is *not*. Microfinance is not welfare. Nor is it a handout doled out to the poor. Microfinance *is* an ever-evolving selection of financial offerings including credit, savings, remittance services, and most recently, health, life and business insurance available to those who have no access to traditional financial services. Microfinance institutions (MFIs) exist because while the poor want and need these services, they have been excluded from the formal banking sector for a number of reasons: they lack convenient access, they may be intimidated, illiterate, or they have no collateral to obtain a loan. In addition, traditional commercial banks hold that the transaction costs to service microloans or microdeposits exceed the break-even point, rendering them unprofitable, thus unattractive, business risks.

Microfinance, on the other hand, allows for even the poorest of the poor to enter the formal financial arena. That is because MFIs seek out clients where they live and work, illiteracy is not considered a barrier (a thumbprint may often serve as a legitimate signature), conventional collateral is not required, and financial products are affordable (fees charged are higher than what a commercial bank charges for its large, conventional, collateralized loans, ranging from 15 to 35 percent, but far below rates demanded by local moneylenders whose charges range between 120 and 300 percent[vi]). Furthermore, for many MFIs that are able to offer their services efficiently on a large enough scale for the MFI to become self-sustaining, they do so profitably.

Besides financial services, many MFIs offer courses either as a direct service, or through an adjunct organization or agency. Business development courses include training in how to write a business plan, obtain a business license and insurance, develop a marketing strategy, and budget money effectively. While helpful for any nascent microentrepreneur, these courses are particularly useful in developed countries such as the United States, where business start-ups are subject to stringent and often complex rules and regulations. Women (and as a result, particularly their daughters)

are reaping significant benefits from non-financial courses in literacy development, proper healthcare, and nutrition, family planning and HIV/ AIDS prevention as well. The United Nations Development Program's *Human Development Report 2005* states: "Improved access to health and education for women, allied with expanded opportunities for employment and access to microcredit, has expanded choice and empowered women [in Bangladesh]. While disparities still exist, women have become increasingly powerful catalysts for development, demanding greater control over fertility and birth spacing, education for their daughters, and access to services."[vii]

Microfinance providers operate in a number of different forms. Non-governmental organization (NGO) microfinance institutions often depend on grant funding from donors, subsidized loans, or self-generated revenue. Commercialized microfinance institutions have more options available to them for funding and hence outreach. These funding options may include public deposits, debt, convertible debt, quasi-debt and equity. These commercial MFIs are most often regulated and must meet certain requirements before being authorized to accept deposits or access other funding sources. Commercialized MFIs generally apply commercial or market-based principles to microfinance with an eye towards MFI self-sustainability. While some NGO MFIs are able to access commercial debt, in most countries they cannot accept deposits from the public unless they are regulated. This places a limitation on many NGO MFIs as they are not able to take advantage of the low cost of capital available with mediating deposits, nor are they able to offer this valuable savings service to their clients. While possible, without the additional income flow, becoming a self-sustaining organization is more difficult for NGO MFIs. This book focuses on the multiple benefits that microentrepreneurs gain from microloans, however, it is important to point out that not all clients seek loans. Business training may be a woman's primary goal. And savings, particularly by those in developing countries, plays a key role in reducing poverty and mitigating risks of unforeseen expenses among the poor.

Microcredit, or the provision of small business loans, allows borrowers to open and operate businesses of their own. This opportunity is especially crucial to the poor because of the global dearth of permanent, salaried jobs. Contrary to the conventional belief that the poor are "unbankable" or an untenable business risk, by 2006, 113,261,390 people, 81,949,036 of whom were amongst the poorest of the poor when they took out their first loan, have proven this opinion wrong.[viii] Microentrepreneurs are using their loans to buy supplies to produce homemade goods such as reed mats, saris or pastries. Some are purchasing prepared items such as prepackaged snacks, school supplies and sundries for resale door to door, from makeshift stalls in a market, or as their businesses profit, from shops of their own. Others

are investing in livestock such as chickens, pigs, or a water buffalo, which yields profits both from its milk and its work in the fields. Borrowers are also purchasing farming materials such as tomato and cucumber seeds, or rich dirt, plastic wrap and spores to grow mushrooms. And they are profiting. As their businesses grow, microentrepreneurs hire others whose lives in turn, prosper. As significant, these microentrepreneurs have maintained an enviable repayment rate of 95 to 98 percent on their loans.[ix] Indeed, using their profits and savings, these women are pulling themselves, their families and entire communities free of poverty's dehumanizing grip.

Since the poor generally have no collateral to qualify for a traditional bank loan, MFIs have created a group lending approach that allows groups of women to act as each other's guarantor. If a group member is unable to meet her financial obligation, the others cover her payment. Any member who does fall into arrears is expected to reimburse her group as soon as she is able. In essence, the system is based on trust, trust that each member will do everything possible to uphold her commitment to use her loan for business purposes, and to budget wisely in order to repay a portion of her principal plus interest on a weekly, bi-weekly or monthly basis, depending on the procedures set up by each MFI. Individuals who operate successful business ventures and have a proven repayment history, often have the opportunity to become independent borrowers with access to larger, individual loans.

Why are women the primary loan recipients? The 768 MFIs listed on the Microfinance Information Exchange (MIX Market) report that on average, 80 percent of their clients are women. Studies have shown that while men tend to spend their profits on themselves, women, who are families' primary caregivers, use their hard-earned profits to more adequately feed, educate, house, clothe and obtain medical care for their children. These provisions, provided by and large by women, are critical to breaking free of the vicious cycle of poverty. Additionally, women devote their loans and profits to expanding their businesses and establishing secure savings accounts for emergencies, and future wants and needs. From a business perspective, studies have also shown that women are a more reliable credit risk; they repay their loans at consistently better rates than men.

Microfinance began in the 70's on two sides of the globe, by Professor Muhammad Yunus, 2006 Nobel Peace laureate and founder of the Grameen Bank, in Jobra, Bangladesh, and ACCION International in Recife, Brazil. By 2005, ACCION had spread its expertise developing sustainable anti-poverty programs to its to partners and affiliates in 22 countries in Latin America, Asia, sub-Saharan Africa and the United States, and had made $9.4 billion in microloans to 3.97 million borrowers.[x] In Professor Yunus' case, a mere $27 loan split between forty-two women, each in perpetual debt to a local moneylender who charged an exorbitant rate of interest, allowed

these budding microentrepreneurs to work their way out of poverty. This seemingly small act set in motion what has become the Grameen Bank that, as of May 2006, had lent US$5.52 billion to 6.33 million borrowers in 67,670 villages throughout Bangladesh.[xi]

While microfinance is not *the* panacea to addressing all of poverty's ills, it has and is proving to be *a* key solution. Today, there are over 100 million active clients taking advantage of microfinance services around the world. Over 10,000 MFIs are working to eradicate poverty. The United Nations named 2005 the International Year of Microcredit. In support of the UN's Millennium Development Goals, the Microcredit Summit Campaign (a network of over 4000 microfinance practitioners) has pledged to ensure that 100 million of the world's poorest families rise above the $1 a day threshold by 2015, thus lifting 500 million family members out of extreme poverty. Regional and global networks such as the Katalysis Network serving MFIs in Central America, and the Microfinance Network, a global association of leading microfinance institutions, bring together practitioners to develop best practices and share expertise about how to reach the greatest number of clients with financial services, attain organizational sustainability, and measure genuine impact. A growing number of private entities now provide individuals and businesses with the opportunity to make equity investments in MFIs that give investors a financial as well as a social return. Business schools around the world have added programs focused on corporate social responsibility, including microfinance. Advocates, such as RESULTS, with branches around the world, are working diligently to influence government agencies to enhance their support of microfinance programs. Donors and volunteers spanning the globe are committing their resources to help the poor help themselves.

When I first learned about microfinance I was absolutely amazed. Was it possible that with the same $40 I might spend on one evening's meal, a woman like Ghanaian Stella Sabang, one of the first microentrepreneurs I met, could start a business whose growing profits would feed her family indefinitely? Fund her children's schooling? Put a solid roof over their heads? A dream, I thought. But if it were true, I wanted everyone to know about it and maybe even be inspired to help. When I realized that there was no book in the market highlighting those most directly involved in microfinance – microentrepreneurs – I decided that I would be the one to witness and report on this global phenomenon.

Traveling, photographing and interviewing people were not new to me. I had traveled to many parts of the developing world: war-torn Nicaragua and El Salvador; around the world as an advisor and professor's assistant with Semester at Sea, a shipboard educational program for college students with stops in South Africa, which at the time was embroiled in apartheid,

and Sri Lanka, a country in the throws of civil war; and a few years later to Cuba to understand and experience firsthand, Castro-style communism.

As a teacher for 17 years, I helped students hone their writing skills and understand the complexity of the world. But did my role as an educator, teaching English and World Cultures, qualify me to venture into the world of professional photojournalism? The question for me was, "Do I have the capacity to capture in words and pictures, the essence of these women's aspirations, struggles and successes?" After a year of contemplation, I decided I had to give my idea a try. I didn't want to regret not having taken advantage of the opportunity to meet women around the world who, with the help of microfinance, are upending the economic and social status quo. And I didn't want to wake up some day wishing I had had the nerve to attempt something as momentous as trying to portray their lives in pictures and text. Embarking on this journey challenged and inspired me in countless ways, both personal and professional. My only regret was the need to select amongst the millions of women who are taking risks much greater than mine to transform their lives.

In August 2003, with wholehearted encouragement from my husband Mark, and our son Jack, then five, I headed to Ghana with my Nikon D100 digital camera, a notebook filled with questions and an open heart and mind. Over the next three years, two of which I took a sabbatical from teaching, I visited MFIs and their clients in Guatemala, Bolivia, Chile, Argentina, Bangladesh, India, the Republic of Georgia, Jordan, Vietnam and China. Since microfinance is also practiced in the developed world as a means of combating poverty, I interviewed clients in France and the United States as well.

While I had initially intended to include only women in my book, given that they comprise approximately 80 percent of the microentrepreneurs in the world, I changed my mind when I met some men whose microbusinesses are also impacting their families' lives in significant ways. It is these heroic women and likeminded men that *Transforming Lives $40 at a Time* is all about. The stories and photos will bring you face-to-face and heart-to-heart with individuals from every continent who are using microfinance to provide otherwise unimaginable and unattainable opportunities and security for their families. And that is not all. Through their hard work and success, their societies are gaining something more than sustainable economies; research has shown that access to financial services is changing the status of women. They have more self-confidence, more decision-making power and greater influence in their communities. As Adwoa, a Ghanaian woman and now the primary financial provider for her family announced to me, "Now I want for nothing. I have pride!"

Even with all the work that is being done, CGAP (The Consultative

Group to Assist the Poor) estimates that institutions are currently "serving less than one-sixth of the potential microfinance market," and that "some three billion people of working age lack access to financial services."[xii] My hope is that a single photograph or story from this book might inspire a commitment to get involved in some way, so that our combined resources and resourcefulness can put an end to poverty around the world.

Just imagine.

Dana E. Whitaker

Notes

i EarthTrends Environmental Information. World Resources Institute. earthtrends.wri.org/updates/node/6

ii IMCI, A Joint WHO/UNICEF Initiative, www.who.int/child-adolescent-health/ New_Publications/IMCI/imci.htm

iii UNICEF. "The State of the World's Children 1999: Education." www.unicef.org/sowc99/index.html

iv *World Development Report 2004: Making Services Work for the Poor. The Microfinance Revolution.* (Washington, DC: The International Bank for Reconstruction and Development/The World Bank, 2003) p.20.

v World Health Report, WHO www.who.int/features/qa/12/en/index.html

vi Grameen Foundation. "Frequently Asked Questions about Microfinance." www.grameenfoundation.org/what_we_do/microfinance_in_action/faqs/#1

vii Daley-Harris, Sam. The State of the Microcredit Summit Report 2005. pg. 13-14.

viii Daley-Harris, Sam. The State of the Microcredit Summit Report 2006. pg. 2.

ix Grameen Foundation.

x ACCION Home Page, www.accion.org/about key stats.asp

xi Grameen Bank Home Page www.grameeninfo.org/bank/GBGlance.htm

xii CGAP. "Microfinance by the Numbers." www.cgap.org/portal/binary/com. epicentric.contentmanagement.servlet.ContentDeliveryServlet Press / / byNumbers.pdf

Acknowledgments

I AM MOST GRATEFUL to the women, children and men around the world who opened their lives to me. Who dared to share their fears, struggles, hopes, successes and dreams. Who cried, laughed and even danced with me. Who, after baring their deepest vulnerabilities, hugged me and thanked me for coming to meet them and for telling their stories. Thank you Pentamma, Mrs. Jayamma and her husband, Asara Tsehai, Judith Pothier, Leonardo Arce and his family, Sandra Laurence, Pascale Francoise, Fabiola Suxo and members of Ahorro y Credito, Juana Rojas Araya and her daughter Teresa, clients of Pro Mujer, Du Ying, Pan Zhong Li, Yang Hengbian, Du Xiulan and her husband, Nada Abuhalawa, Khatuna and Irma, Magdalena Mesia and her family, Lata, Gogita Adamadza and his family, Jaeda Begum and her family, Florentino Quelca, his son Gustavo and their employees, Suha Nowaf and her family, Mohamad Musa Abu Attallah, Hoa Thi Mai and her family, Le Thi Tho and her family, Khadija Eshash, Bertha Lauriana Baneno, Teresa Augustin and her family, Akosia Addai and her apprentices, members of the Nyame ne Yen woho Trust Bank, and Ramatu Moro-Muhammad.

Although just one author's name appears on the book's cover, this project is the result of the devotion of literally hundreds of individuals. From inception to distribution, each stage was only realized through unsparing support beginning with my family and extending around the globe. At lunch one day, my dear friend Professor Francisco Vasquez helped me brainstorm a career move I had been contemplating but did not yet have my finger on. Writing this book is the result. I thank him for helping me realize this life-altering "Ah ha!" Excited yet unsure if I could accomplish such a venture, my husband Mark Petersen offered me just the right words of encouragement. "You are so clearly passionate about this project. If you don't do it, you'll always look back and be sorry." I thank him for those words. And he never gave a second thought to our frequent flier miles as they diminished to zero. He spent week after week during the past three years, juggling his business schedule (which invariably became more hectic the moment my plane left the ground) with his parental responsibilities. Our five year-old son Jack cried so hard at the airport prior to my first departure that I almost cancelled my trip. When I finally arrived in Ghana after eighteen hours of anguish over leaving him, I called home to find out that he had stopped crying within minutes of my departure. My absence, in fact, resulted in a bond between my husband and son that has made them closer to one another in the most beautiful way. Author, consummate connector and leadership guru John O'Neil, shared countless conversations with me about how to best move forward. He connected me to wonderful friends and

colleagues, including Andy and Janet Kimball and Niels Nielsen, who in turn provided thoughtful guidance and support.

Though I was an unknown in the microfinance and photojournalism worlds, Sam Daley-Harris, director of the Microcredit Summit Campaign, provided me with a feast of invaluable assistance. During my first visit with him, he offered to make introductions for me with his colleagues around the globe. He also gave me access to the Summit's database of microfinance practitioners for the book's "How to Get Involved" resource guide. I thank him for his open door and open heart, not only for me, but also for the impoverished of the world who he has committed his life to serve.

Never could I have met these heroines and heroes had it not been for the generosity of the microcredit practitioners who have made it their mission to help people rise above poverty with dignity. I am indebted to staff members of a number of organizations around the world, many of whom have become friends. Thank you Beth Houle, John Kamperschroer and the staff of Opportunity International, Justice Arthur, Juliet Kwayke and the staff of Sinapi Aba Trust, Angela Mason, Jason Evans, Gerlof De Korte, Teona Baghaturia and the staff of World Vision, Gerry Hildebrand, Jutta von Gontard and the staff of Katalysis Network, Bob Graham of NamasteDirect, Stuart Pons and the staff of Friendship Bridge, Victoria White of ACCION International, Horacio Ebert and the staff of BancoSol, Maria Nowak and Geoffroy Lefort of Adie, Alfonso Torrico, Raul Arce and the staff of CRECER, Chris Dunford, Claire Thomas, William and Stella Coker and the staff of Freedom From Hunger, Carmen Velasco and the staff of Pro Mujer, Isabel Infante and the staff of FINAM, Alex Counts, Deborah Burand, Barb Weber, Anna Awimbo and Ken Liffiton of Grameen Foundation, Monica Pescarmona and the staff of Grameen Mendoza, Udaia Kumar and the staff of SHARE Microfin, Ltd., Praseeda Kunam, Chris Turillo and the staff of SKS Microfinance, Muhammad Yunus of Grameen Bank, the staff of the Social Service Society, Khaled Al-Gazawi and the staff of Jordan Micro-Finance Company, Jumana Theodore and the staff of Microfund for Women, Sita Conklin and the staff of Save the Children, John Bugge of Oxfam, Nguyen Thi Hoai Thu, Nguyen Hoaithu, Ngoc Pham Bich and the staff of Tao Yeu May Fund, Sarah Tsien, Jane Yue, Sandrine Magloire Szlasa, Jake de Grazia and the staff of PlaNet Finance, staff of Hope for the Poor and the Environment, staff of the Women's Development Association, Julie Abrams, Justina Cross and Heather Haxo Phillips of Women's Initiative for Self Employment, Patti Lind from the Abilities Fund, and staff of the Association for Enterprise Opportunity. From identifying microentrepreneurs for me to interview, arranging transportation, providing translation, accompanying me on visits, answering my thousand and one questions, and providing a final edit of my stories, staff of these organizations met my every need with gracious generosity.

Not enough thanks can go to Kelly Hattel, past executive director of the Microfinance Network, and now a good friend, who so patiently helped me condense the final draft of the resource guide and reading list and connected me with key individuals in

the microfinance world. I also deeply appreciate Jennifer Nice for using her financial knowledge to explain to me the intricacies of microfinance funding. I appreciate the invaluable training David Weitz from Sarber's Camera provided me on the ins and outs of my digital camera, and the hours of assistance Hugh Lovell from Apple spent training me on how to manipulate my computer. Many thanks to author Paola Gianturco who spent time with me outlining the million steps required to move a book from thought to print. I appreciate beyond words, Jonathan Gullery, a brilliant layout artist from RJ Communications, who thoroughly understood how I wanted my book to look and feel, and then produced it.

Actually getting the right words on a page is both invigorating, and at times, a lonely pursuit. I deeply appreciate Renate Stendhal, a skillful editor who helped me craft my words so that they would mirror, as truly as possible, the lives of the women and men I had the privilege to meet and interview. I am indebted to friend and author, Debby Layton, who introduced me to Renate, and whose hilarious emails made me laugh when I might at times have done otherwise. Many thanks to Susan Fassberg both for her support of me throughout my project and for her sensibility in assisting me, along with my nephew Christopher Whitaker, with the final selection of photos for the book. Taking a break from working on her PhD., my dear friend, Penelope Ismay, generously offered to help me with a more tedious, yet essential component of the book – the context-setting country maps and statistics. I am also indebted to her for delving into the book's Preface with keen academic insight, prompting me to deepen and expand my thoughts.

There is no way that I could have created this book had it not been for the village of women who took care of my son (therefore, my husband) when I was traveling. For dropping him off and picking him up from school, feeding and housing him, and treating him as one of their own, I am extremely thankful to Debra Harper, Shelby Tupper, Melinda Haag, Nancy So-Holloway and Helen Petersen, my mother-in-law, who would fly from Portland, Oregon to take loving care of Jack, and always be ready with a meal for my husband Mark when he returned home late from work.

What would I have done without trusted friends who supported me throughout the entire three-year process? For consistently calling, emailing, offering sage advice, and at times, simply listening, I offer my deepest thanks to Laura Werlin, Nancy Chillingworth, Mem Pozzi, Katie Ross, Beth Gilbert, Pam Brandau, and my mother, Patricia O'Neil.

Finally I thank those who purchase this book. A percentage of each copy sold will be contributed to the organizations whose clients are included in the book. Each purchase will help bring one more individual closer to realizing a life that all of us desire, regardless of our circumstances – a life of security, dignity and hope.

Dana E. Whitaker

Asía

India

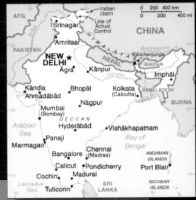

DEMOGRAPHICS AND ECONOMICS

Total Population (2004)	1,087,124,000
Gross National Income per capita (2004)	$620
Population below Poverty Line (2002) estimate*	25%
Health	
Fertility Rate (2004)	3
Maternal Mortality Ratio, (1990-2004), reported	540 (per 100,000 live births)
Annual Number of Under-5 Deaths (2004)	2,210,000
Life Expectancy at Birth (2004)	63 years
Orphans, Children (0-17) Orphaned by AIDS and other causes, (2003), estimate	35,000,000
HIV Prevalence: estimated number of people living with HIV, adults and children, 0-49 years, (2003)	2,200,000 – 7,600,000 (low – high estimate)
Immunization of 1-year-old children (2004)	
Population using improved drinking water sources (2002)	82% rural; 96% urban
Population using adequate sanitation facilities (2002)	18% rural; 58% urban
Education	
Primary School Attendance Rate (2000-2004)	73% female; 80% male
Secondary School Attendance Rate (2000-2004)	36% female; 45% male
Total Adult Literacy Rate (2000-2004)	61%

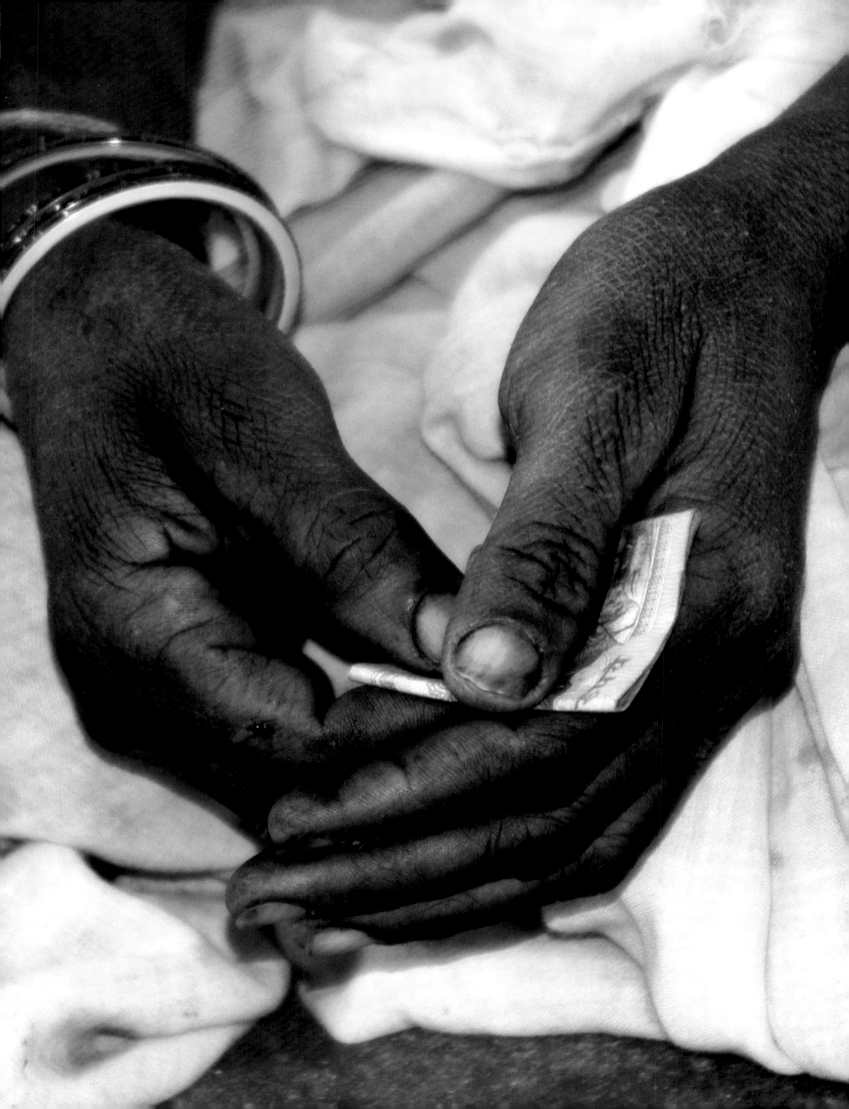

More Than a Name

THE SKS BRANCH MANAGER'S CAR becomes frosted in a dense layer of dust as he bounces along the single-lane, pock-marked dirt road leading to Singeetam, a remote village where five women are making final preparations for what they hope will be a momentous day. For the past week, they have been learning the rules of SKS Microfinance, an organization devoted to serving the poorest of the poor in Andrah Pradesh State, India.

Today, the manager will be testing them on their newly acquired knowledge. Only if each woman passes every portion of the test will they be allowed to become an SKS borrower group. If they do not pass, there are literally thousands of other impoverished women waiting for this opportunity.

These women are Dalits, the name given to those born into India's lowest caste previously known as "Untouchables." SKS has made a conscious decision to help Dalit women so that even though their position in society may not change, a microloan will give them an opportunity to open a small business, generate an income and, as all mothers long to do, sufficiently provide for their children.

The branch manager parks his car alongside the road and begins his trek to meet the women. As he wends his way through the village past white-haired widows, children drawing water into ubiquitous plastic urns from a community well, men hoisting enormous stick bundles on their turbaned heads, tired oxen receiving their end-of-the-day water baths and school children studying English from *Holy Faith* paperback books, he draws an ever-swelling crowd of curious onlookers in his wake. Finally he arrives at the farthest reaches of the village. This is where Dalits have been relegated to live.

Pentamma is waiting. Her slight frame is draped in a beige and dark-brown patterned sari over a pink, short-sleeved blouse. She has pulled her shiny black hair into a loose bun at the nape of her neck. Royal-blue bangles encircle each wrist, a blue and gold-colored bead necklace hangs around

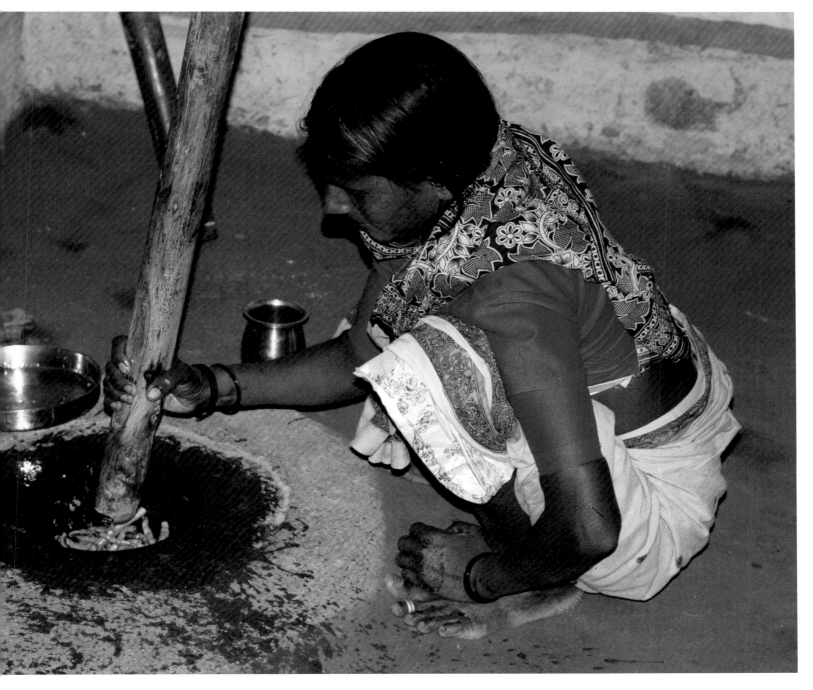

her neck, and her aquiline nose is studded with a small gold flower. On the second toe of each bare foot is a silver ring, dulled and misshapen due to constant contact with dirt in the fields, in the village, and on the floor of her house.

Never has Pentamma been visited by so many, if any, villagers, nor by such an important person as the SKS branch manager, the one who will soon decide her fate. But she greets everyone with a calm nod of resolve.

With clipboard in hand, the manager emerges from his entourage, ready to begin the first phase of the assessment. Using SKS's Housing Index, he scores the quality of her home's roof, the composition of the walls, and the number of rooms compared to the number of individuals occupying them. Then he checks for direct access to running water and electricity.

Pentamma, a Dalit (Untouchable) pounds aromatic spices in her dirt-floored, straw-roofed kitchen before cooking them in a pot over a wood-burning fire.

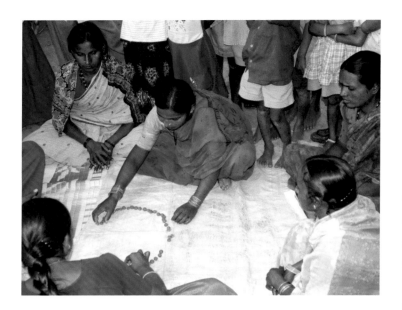

In order to become a borrower group, Pentamma (left) and four other hopeful Dalits must pass all portions of the SKS Microfinance test, including showing how a group should sit (in a circle, represented by stones).

Only if Pentamma's house scores below a 10, thus ranking her among the poorest of the poor, will she be eligible to proceed to step two in the qualifying process. Until now, the family has struggled to survive on her husband's Rs30 ($.68) plus her Rs20 ($.45) a day laboring side-by-side, when there is work. If she qualifies as a borrower, Pentamma plans to purchase a water buffalo, sell five liters of its milk everyday, and use the sixth liter to feed her two undernourished children. With gaping holes in the straw roof, walls of dried mud and thatch, two miniscule rooms for four people, and no running water or electricity, the house scores a 6, well within range of eligibility for an SKS microloan. The four other Dalit women, each of whose homes score below 10, qualify as well.

Pentamma and her group proceed to a neighbor's dirt courtyard that is hurriedly swept smooth with a dried palm-frond before being covered with a few straw mats. Pentamma clutches a large white piece of paper as she sits cross-legged beside her four other group members, their SKS trainer and the branch manager. The crowd presses in from all sides to witness the challenges the candidates are about to face. For the past five days, a trainer has been teaching the women about SKS microloan policies and procedures: the 50-week loan-cycle, 12.5% interest on their loans, and $.10 weekly savings requirements.

They have also learned about SKS's democratic system of borrower groups, a concept totally foreign to Dalit women who – according to Hindu culture – have no value. Following SKS's model of equality, they have arranged themselves in a circle, elected a group leader and will take turns speaking. The manager begins the test by asking the women to recite the SKS pledge. In unison they begin:

- *We shall attend the weekly meetings without fail.*
- *We shall pay back the loan installments without fail to our Sangam.*
- *We shall help the needy in our Sangam, whenever required.*
- *All the Sangam members will abide by the rules and responsibilities of the Sangam.*
- *We shall use the loan amounts taken from the Sangam for uplifting our family economy.*

Palpable signs of relief appear on each woman's face at the sight of the manager's smile. He then places a pile of smooth green-gray stones in the middle of the circle, instructing each woman to configure a symbolic

borrower group (a circle of five stones). Since this group will join six other groups, he then watches as together, they arrange a larger circle of 30 stones representing an SKS center.

Satisfied with that portion of the test, the manager hands out various bills and coins which he uses to assess the group's ability both to count out loan amounts that a borrower may receive (between Rs1,000 and 10,000, or $23-$230), and to calculate weekly repayments including principal, interest and savings required depending on the size of the loan. Though plodding at times, they correctly answer each of his questions. He puts the money away. Now is the time for the ultimate test.

Pentamma unfolds her piece of paper and flattens it out beside her. She will be the last in her group to take this crucial segment of the test. Finally, it is her turn. She is handed a notebook and pen. Taking a deep breath, she awkwardly weaves the unfamiliar implement between her fingers. Placing the pen's point onto the page in front of her, she very slowly begins to write. A few children stoop over her to check her progress. Somehow Pentamma is able to ignore them. She stops, checks her work against what is written on her own paper and readjusts the pen. Her marks get larger and start to drift downward, but she continues across the page until the last oversized curve has been made. Pentamma has just accomplished at age 25 what others more fortunate than her accomplish by age 4 or 5. This illiterate Dalit has just written her own name. It is the only word she can write, but it is enough.

The branch manager nods and everyone, including the onlookers, erupt with applause. A new SKS borrower group has just been born.

Twenty-five year old Pentamma struggles to achieve something others more fortunate than her accomplish by age 4 or 5 – write her name.

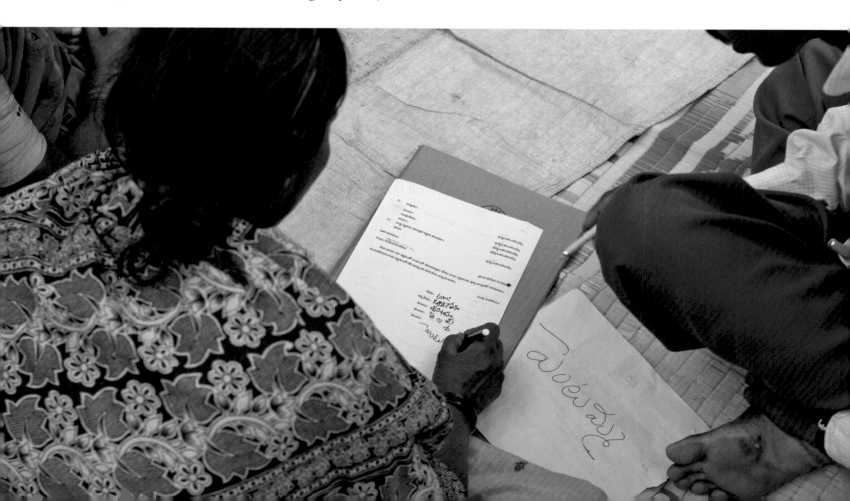

Dream Weaver

A GAUZE CANOPY OF CLOUDS hovers overhead, offering only the slightest shield against India's blazing midday sun. Mrs. Jayamma's grass-green sari over a bright purple short-sleeved blouse displays the only spot of color in the dry, sand-colored land surrounding her. Sitting cross-legged, she leans back against her dilapidated brick and mud-packed house to take advantage of the roof's overhang that furnishes her a mere sliver of added shade. She is as motionless as the day's stagnant air, except for her fingers that interlace and release at the speed of tumbleweeds scudding across the land in a fierce windstorm.

As if by magic, what begins as a loose cluster of pale yellow reeds in her hands emerges as a five-inch wide strip of woven matting that cascades into a coil in front of her. Once completed, Mrs. Jayamma will sew it together with 14 other woven strips into a six-by-six foot mat used by almost every family throughout rural India. Perhaps this mat will go to a bride and groom who will use it sit to on while they exchange wedding vows. Or it may replace an old mat worn out from use as a family bed.

While Mrs. Jayamma focuses on her weaving, her husband, Mr. Ramulu, enters their two-room house. First he passes through the pitch-dark room where the family sleeps. He then enters the back room and plugs in a bare light bulb hanging from a frayed cord. This is the family's only light source, except for the faint trickle of sunlight that seeps through a small grate-covered opening that has been haphazardly cut out of the exterior wall. A few stuffed burlap sacks and a stack of old suitcases placed against adjacent walls hold all the family's worldly belongings. Stooping over, he counts the mats lying in a pile on the dirt-packed floor that his wife has completed over the past three days.

Mrs. Jayamma sits as motionless as the day's stagnant air, except for her fingers that interlace and release at the speed of tumbleweeds scudding across the land in a fierce windstorm. SHARE Microfin loans provide her with an ongoing supply of reeds to make mats used for sitting, sleeping and marriage ceremonies.

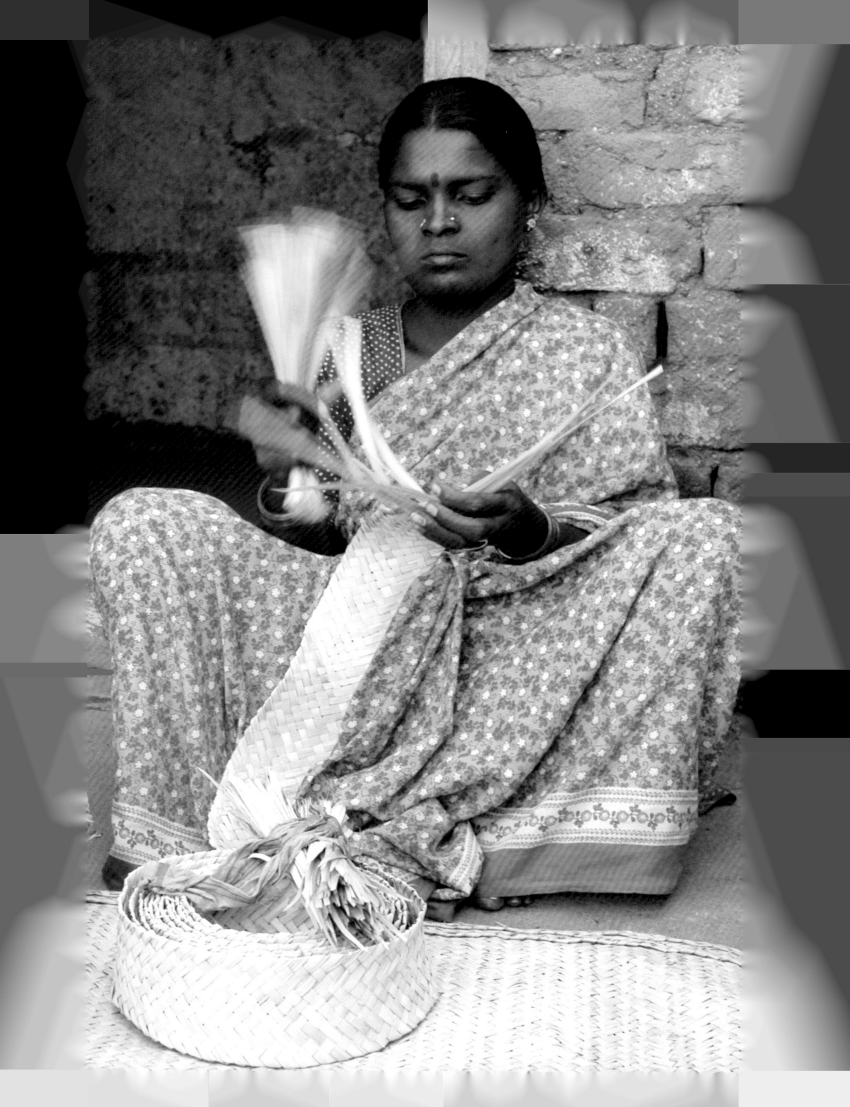

Mrs. Jayamma's husband looks over the crumbling half-wall that divides his family's tiny two-room space from their neighbor's room in a house the two family's share. With profits from his wife's mat weaving business he's built a bathroom/shower room. As soon as his wife has earned enough income, he plans to build a new house exclusively for his family.

Starting tomorrow and for the next four days, they will each hoist bundles of mats on their shoulders, board separate buses, and hope to sell the mats at village markets throughout Andhra Pradesh State, India.

Until this year when his wife became a borrower with SHARE Microfin Ltd., Mr. Ramulu worried when he couldn't find work as a day laborer. Now, even if he doesn't earn Rs70-80 ($1.55-1.75) a day, he knows his family will still be able to eat rice and vegetables twice a day, and on profitable weeks, meat on Sundays. No longer restricted to purchasing reeds only after selling a number of mats as she was in the past, Mrs. Jayamma's first loan of Rs5000 ($111) enabled her to buy reeds more cheaply and in bulk. Each mat costs Rs35 ($.77) to make. Selling the mats for Rs70 ($1.55), she reaps Rs35 profit per mat, and nets Rs5-600 ($11-13) per week, after loan, interest and requisite savings payments to SHARE.

Less worry and more money represent only part of the benefits Mrs. Jayamma's family enjoys. Even in the first months of newfound wealth, their life experienced dramatic change.

Using the first few months' profits from his wife's budding business, Mr. Ramulu purchased materials to construct an enclosed bathroom and shower. This luxurious addition, with its smooth interior walls and concrete floor is the first stage of a brand new house he plans to build – exclusively for his own family.

Currently, they share a home with their neighbors. Though each family

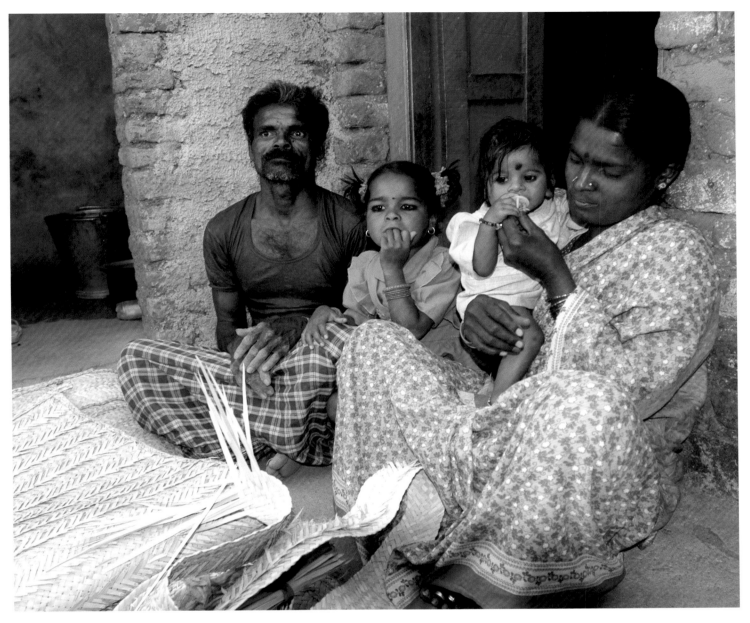

enters through a separate door, their only privacy comes from a three-quarter high wall dividing the two dilapidated living spaces. Seeing the immediate results of Mrs. Jayamma's loan-supported business, her next-door neighbor has decided to become a SHARE borrower too.

Mr. Ramulu finishes counting the week's production and goes outside to discuss plans with his wife. As soon as he sits, a barefoot girl wearing a bright orange dress with matching fresh flowers tucked into each pigtail, bounds around the corner of the house and plops down between her parents. Mrs. Jayamma puts down her work as a friend places a plump baby boy, the family's newest addition, into her arms. Bare, except for a tiny t-shirt and silver-colored bracelets around each minute ankle, he begins his contented suckling.

"Once they're old enough, our children are going to go to school," says Mrs. Jayamma.

"And they'll have a new house!" adds her husband.

Mrs. Jayamma takes a short break from her weaving to sit with her husband, their daughter, and the newest family member, a son. "Once they're old enough," she says, "they're going to go to school."

Bangladesh

DEMOGRAPHICS AND ECONOMICS

Total Population (2004)	139,215,000
Gross National Income per capita (2004)	$440
Population below Poverty Line (2004), estimate*	45%
Health	
Fertility Rate (2004)	3.2
Maternal Mortality Ratio, (1990-2004), reported	380 (per 100,000 live births)
Annual Number of Under-5 Deaths (2004)	288,000
Life Expectancy at Birth (2004)	63 years
Orphans, Children (0-17) Orphaned by AIDS and other causes, (2003), estimate	5,300,000
HIV Prevalence: estimated number of people living with HIV, adults and children, 0-49 years, (2003)	2500 – 15,000 (low –high estimate)
Immunization of 1-year-old children (2004)	85% polio; 85% measles
Population using improved drinking water sources (2002)	72% rural; 82% urban
Population using adequate sanitation facilities (2002)	39% rural; 75% urban
Education	
Primary School Attendance Rate (1996-2004)	80% females; 78% males
Secondary School Attendance Rate (1996-2004)	36% female; 35% male
Total Adult Literacy Rate (2000-2004)	41%

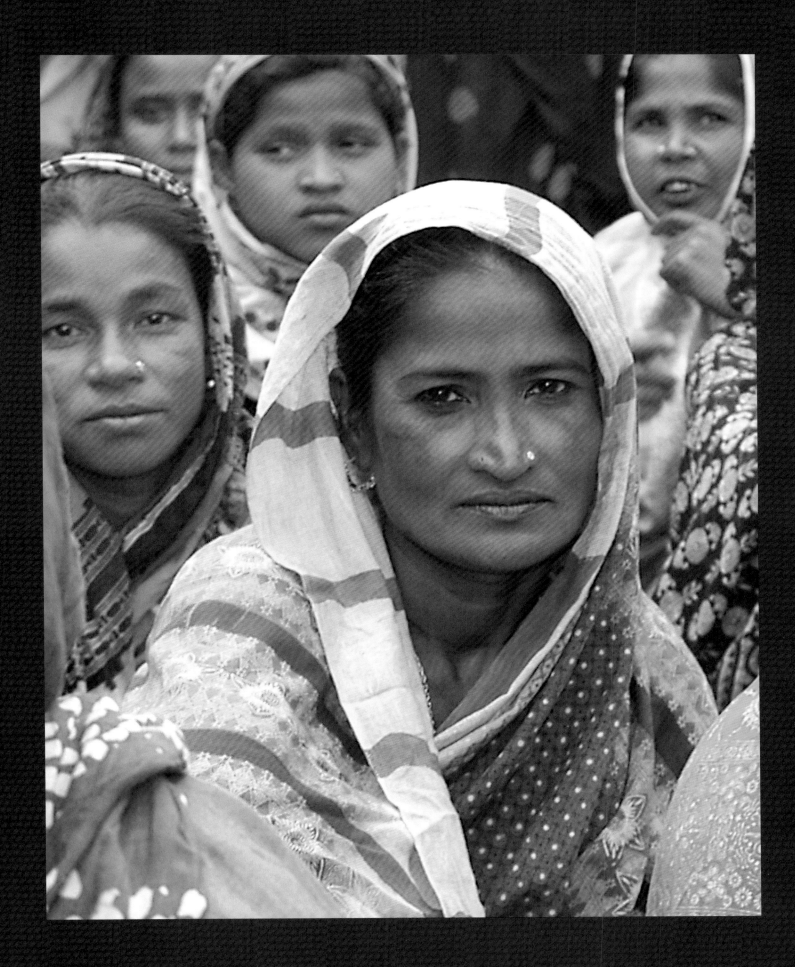

Ring of Success

A STICK AND STRAW LEAN-TO precariously propped up on a small dirt plot is what they used to call home. Like approximately half the population of 130 million Bangladeshis, Jaeda Begum and her husband, Zia Uddein, lacked any collateral to apply for a formal bank loan in order to grow their tiny grocery business and improve their lives. The only money available to them was from a local moneylender whose exorbitant interest rates insured but one outcome – lifelong debt. "Everything was impossible," Jaeda laments of her family's past.

So the couple struggled, until they learned about Grameen Bank's microfinance program serving the poorest of the poor. "If you have money and work hard, everything is possible," Jaeda declares with an air of certainty; the metamorphosis her family has experienced since her initial loan of BDT3600 ($50) in 1990 is nothing less than the miracle of a dull-gray caterpillar transforming into a brilliantly colored butterfly.

The dust-ridden main thoroughfare running through Jaeda's village on the outskirts of Dhaka is filled with a cacophony of vendors vigorously hawking their wares from makeshift stalls such as the one that Jaeda and Zia used to have. Today a steady flow of customers climbs two concrete steps leading into

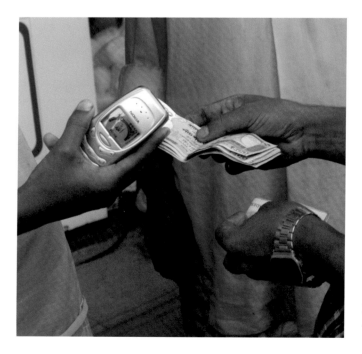

the couple's well-lit, fully stocked store. Shelf upon neatly arranged shelf of items ranging from rice and chewing gum, cooking oil to soap cover the concrete walls painted a soft, light-blue. And now that their grocery store boasts a refrigerator and freezer, villagers stop by day and night for a cold drink or sweet popsicle to counter the muggy, enervating heat.

Jaeda and Zia take turns running the store. As soon as Zia finishes feeding and milking their cows – a second profitable venture they decided to embark upon so that they could both sell the animals' milk and serve it to their three children – Zaeda will take a break.

Upon his return, Zaeda retreats down a narrow passageway flanking the left side of the store. Next to the overhang her husband built for the cows is a

very old, yet surprisingly still functional lean-to – their old house. Stooping under its roof, Jaeda takes a metal pot and fills it halfway up with water from a plastic jug. After adding a few sticks to the glowing embers inside a small rock firepot, she places the pot on to boil. Turing her back on what now serves only as the family's kitchen, Jaeda walks over to a small, self-standing structure, opens a sturdy wooden door and enters. Inside is a spacious, immaculate room with a recently swept concrete floor, cinderblock walls, and a corrugated tin roof overhead. A wooden chair and sturdy table piled high with her children's school books stand next to the large family bed, neatly made with a blue, green and white bedspread.

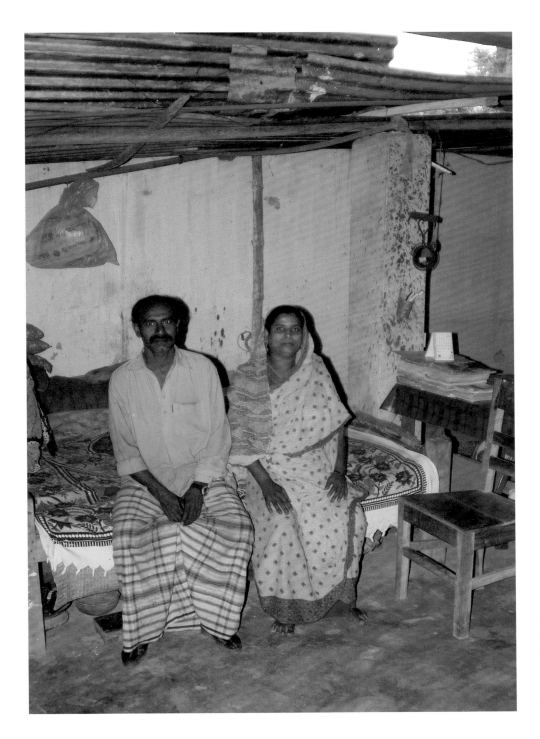

Grameen Bank borrower Jaeda and her husband, Zia's oldest son tends the family's store while they take a break in their immaculate one-room home built with income from their three successful businesses.

At the head of the bed are stacks of colorful pillows and folded comforters. Dangling from nails above the table are a blue plastic cup holding a toothbrush and toothpaste, and a red mirror with a heart-shaped handle. Clothes they own, though few, are draped over a clothesline, while their remaining possessions, secured in plastic bags, hang suspended from the ceiling alongside each wall.

As if two businesses were not enough to keep her family financially stable, when a third venture was offered to Jaeda (because of her excellent loan repayment record), her entrepreneurial drive again was sparked. In January 2004, she was invited to become a Village Phone operator (VP) with Grameen Telecom Company (GTC), a not-for-profit company, which, like the Grameen Bank, was conceived of by Professor Muhammad Yunus, a man many consider to be the founder of microfinance. With a loan of BDT12,000 ($180), Jaeda bought a handset and a telephone subscription, and after receiving complimentary training from GTC on how to operate the phone and charge for calls, she became one of 200,000 VP operators (as of May 2006) providing cell phone service to isolated villages throughout rural Bangladesh.

Her new service has reaped benefits for everyone. Villagers no longer endure hours-long bus trips to keep in touch with friends or check on sick relatives. And rather than relying solely on hearsay, Jaeda's customers are now just one call away from checking the fair market value of products they plan on selling in Dhaka and other large cities. Jaeda is turning a healthy profit too.

She returns to the street where she is met by her eldest son who has been helping his father run the store. He hands his entrepreneurial mother her cell phone and cash he has collected from a recent customer. A moment later, Jaida greets a man who wants to call a relative in another village. After

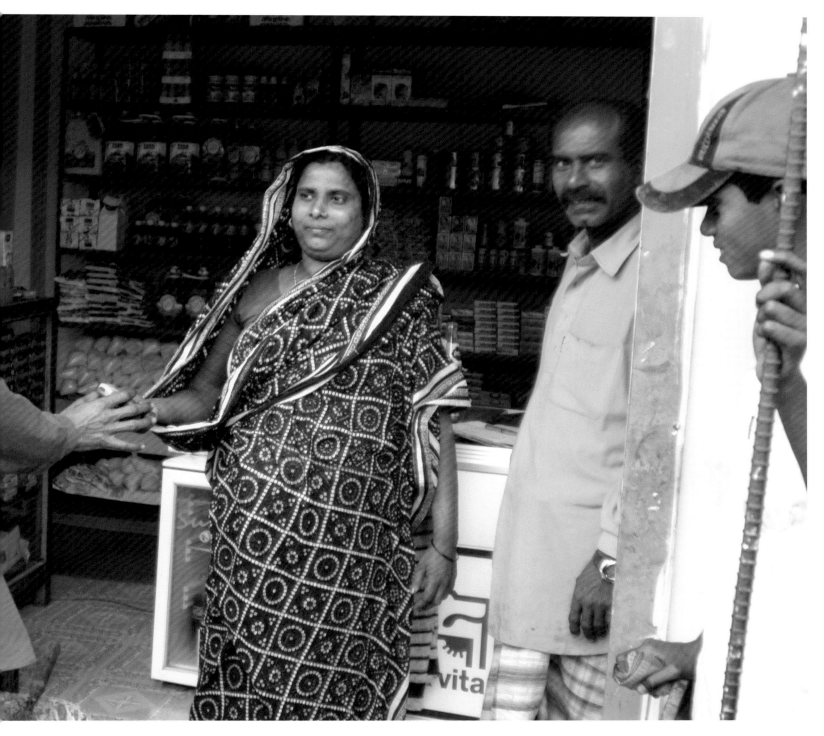

hanging up, he pays her the prescribed rate, purchases a few groceries and departs for home.

What will Jaeda do with the combined and growing profits from her store, selling milk, and now her burgeoning cell phone business? Standing next to her husband, she scans her store. Her eyes land on her son, a budding businessman in his own right. So far, he has passed grade ten, their daughter has passed grade nine, and their youngest son has completed grade eight. A satisfied smile appears on her face. "I don't really know," she says, "I'm sure my children will have plenty of ideas."

Jaeda, now a Village Phone operator, provides a convenient link to the world outside her rural village where customers pay her to call relatives and friends, or make business deals, all of which used to be hours of bus rides away.

Marigold Child

LATA CAN HARDLY WAIT. She slips on her short-sleeved, crimson-colored blouse and zips its side-zipper. After wrapping a pale-pink sari around her petite frame, she ties a brilliant red chiffon scarf around her waist, checking to make sure that the sari's embroidered hem hangs just above the floor. Meticulously, she outlines her eyes a kohl-black, and paints both her eyelids and full lips a ruby red. Twisting her dark brown hair into a bun at the top of her head, she secures it with bobby pins so that it will not move once she begins. She then presses a small vermillion dot with a diamond-like gem in its center onto her forehead. Though bindis were traditionally reserved for married Hindu women, nine year-old Lata (like other females today at every stage of life) wears one for its beauty and for its significance: female energy. She has one more set of adornments to put on, but decides to wait until just before she performs. Lata wants to look as fresh as she feels.

While she sits quietly thinking through each step, giggling girls all around her are busy touching up their makeup, layering themselves in pink and yellow satin saris and ornamenting their wrists, ankles and ears with glittering gold-colored jewelry. Down the hall, a group of boys, outfitted in bright yellow skirts and silver tinkling ankle bracelets, leap from one bare foot to the other, brandishing hooked swords in wide arcs over their heads as they practice their dance one final time before going on stage.

The audience is due to arrive as soon as they've toured the rest of the Sonar Bangla Children's Home. By now they will have visited the comfortable corrugated tin classrooms and cabins where the youngest of the boarding school's 110 students live. They will have observed the students who are focused on farming as a future vocation, tend to the school's ripening crops of onions and lettuce. And they will have watched those learning the proper techniques of raising and tending to farm animals, milk the school's cows.

Entering the girls' dressing room, a teacher announces that the guests are due to arrive as soon as the self-defense demonstration has concluded. Although every inch of her 4'6" frame is alight with anticipation, Lata calmly turns towards the mirror. From the table in front of her, she picks up a fragrant garland of golden marigolds – an auspicious flower for Hindus

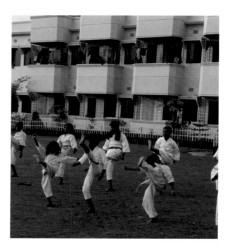

All students take self-defense classes while living at the Sonar Bangla Children's Home.

– and carefully slips it over her head and around her neck. Next she slides a marigold bracelet onto each wrist and puts a pair of dangling marigold earrings through her ears. Picking up a delicate strand of miniature marigolds, she carefully coils it around the base of her bun. With eyes at once pensive and hope-filled, Lata takes one final glance at herself in the mirror, rises and heads backstage to await her queue.

She holds her left arm above her head while her right arm extends at an angle towards the floor. As soon as the music starts, Lata is carried away. Gone in that instant are the nightmares of her life before coming to the Sonar Bangla Children's Home: her unplanned birth to a commercial sexworker, and her first years of neglect living in the dangerous, disease-ridden, dead-end alleys of Kandapara brothel, in Tangail, Bangladesh, where 1500 women share her mother's trade.

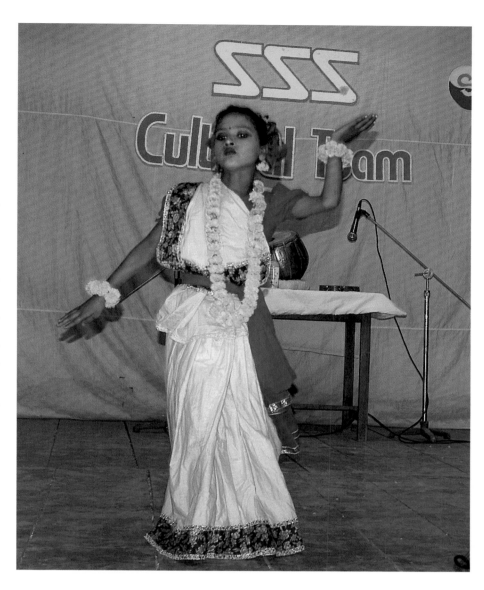

Lata, daughter of a commercial sex-worker in Tangail, Bangladesh, has found stability and security at the Society for Social Services' Sonar Bangla Children's Home, and a happy, hope-filled future for herself as a trained Bangladeshi dancer.

With graceful precision Lata looks first right, then left while her hips sway back and forth in opposing directions. She is one of the lucky ones. Her mother recognized the advantages of accepting the Society for Social Services' (SSS) offer to raise and educate her daughter and 100 other children like her in the safety and security of the Sonar Bangla Children's Home situated twenty kilometers from her first home. Surrounded by caring, supportive adults, Lata's days are now filled with studying, playing, eating healthy meals and honing her hobby for a future vocation far different from that of her mother's – as a classical Bangladeshi dancer.

Lata hopes that one day, her mother, too, will accept assistance from the SSS to change her life, find a healthy line of work and a safe, new place to call home, just like some of the other children's mothers have. Lata's swirling sari reveals two bare feet stepping lithely to the pulsating drumbeat of her country's music.

As the hour-long performance concludes, Lata and the entire SSS Culture Team of young singers, dancers and musicians walk hand-in-hand onto the stage. "We shall overcome… We are not afraid… We are not alone…" they sing in unison.

China

DEMOGRAPHICS AND ECONOMICS	
Total Population (2004)	1,307,989,000
Gross National Income per capita (2004)	$1290
Population below Poverty Line (2001), estimate*	10%
Health	
Fertility Rate (2004)	1.7
Maternal Mortality Ratio, (1990-2004), reported	51 (per 100,000 live births)
Annual Number of Under-5 Deaths (2004)	539,000
Life Expectancy at Birth (2004)	72 years
Orphans, Children (0-17) Orphaned by AIDS and other causes, (2003), estimate	20,600,000
HIV Prevalence: estimated number of people living with HIV, adults and children, 0-49 years, (2003)	840,000
Immunization of 1-year-old children (2004)	92% polio; 84% measles
Population using improved drinking water sources (2002)	68% rural; 92% urban
Population using adequate sanitation facilities (2002)	29% rural; 69% urban
Education	
Primary School Enrollment Rate (2000-2004)	99% female; 99% male
Secondary School Enrollment Rate (2000-2004)	69% female; 71% male
Total Adult Literacy Rate (2000-2004)	91%

Smooth as Silk

EVERYTHING ABOUT THE SCENE inside the house resembles a Vermeer painting. Fall's warm afternoon light streams through a window casting its golden glow onto two women whose fingers are moving rhythmically in and out of a wall of taut ivory-colored threads. Mrs. Du Ying glances over from time to time to check her daughter's progress as they add row upon row of luxurious silk threads to an emerging carpet. Though the pattern depicts medieval Europe, it mirrors the bucolic Chinese landscape outside. Men tend flocks of sheep, women wash clothes in a stream, children tumble as they play, and leaves turn from verdant green to mustard-yellow, burnt-orange and wine-red.

Ying and her young apprentice step back from the loom and retreat to their sparse, cleanly swept living room. Ying sits on her comfortable new sofa, and her daughter sits across from her on a squat, broken-backed, wooden chair, one that used to suit the tiny straw and mud hut they lived in before Ying became a client of the Funding the Poor Cooperative (FPC). Now it seems everything has changed.

"It's very significant for me to be making profits from my own business," smiles Ying, a young girl's giggle emitting from her wide-mouthed smile. "We now live in a new four-room brick house!" she begins. "I'm saving for my son's schooling, no matter how far he wants to go. And my husband is very happy since I bought him a 3-wheeled taxi, because now he has his own business too!"

Until a few years ago, all Ying had known was a relentless schedule from factory to field. During the day she worked at a low-paying job weaving silk rugs for someone else's company. After work and on weekends, she tended wheat, corn and a few vegetables on a small plot of land allotted to her family by the Chinese government. There was barely enough food or money to raise her two children.

One day in 2002, staff from FPC held a meeting in her rural community in Nanzhao County, Henan Province, China during which they offered Ying and other impoverished women an opportunity that was both tempting and frightening. She was offered a business loan of RMB1000 ($125) to invest in her own rug weaving business.

Opposite: No longer a factory worker, thanks to Funding the Poor Cooperative, Mrs. Du Ying now weaves exquisite silk rugs on her own loom. Each rug yields RMB2-3000 (($250-375), double or even triples the cost of making them. Averaging two rugs per year, her income has catapulted her family far above China's designated poverty line of 300CNY ($75) in annual earnings.

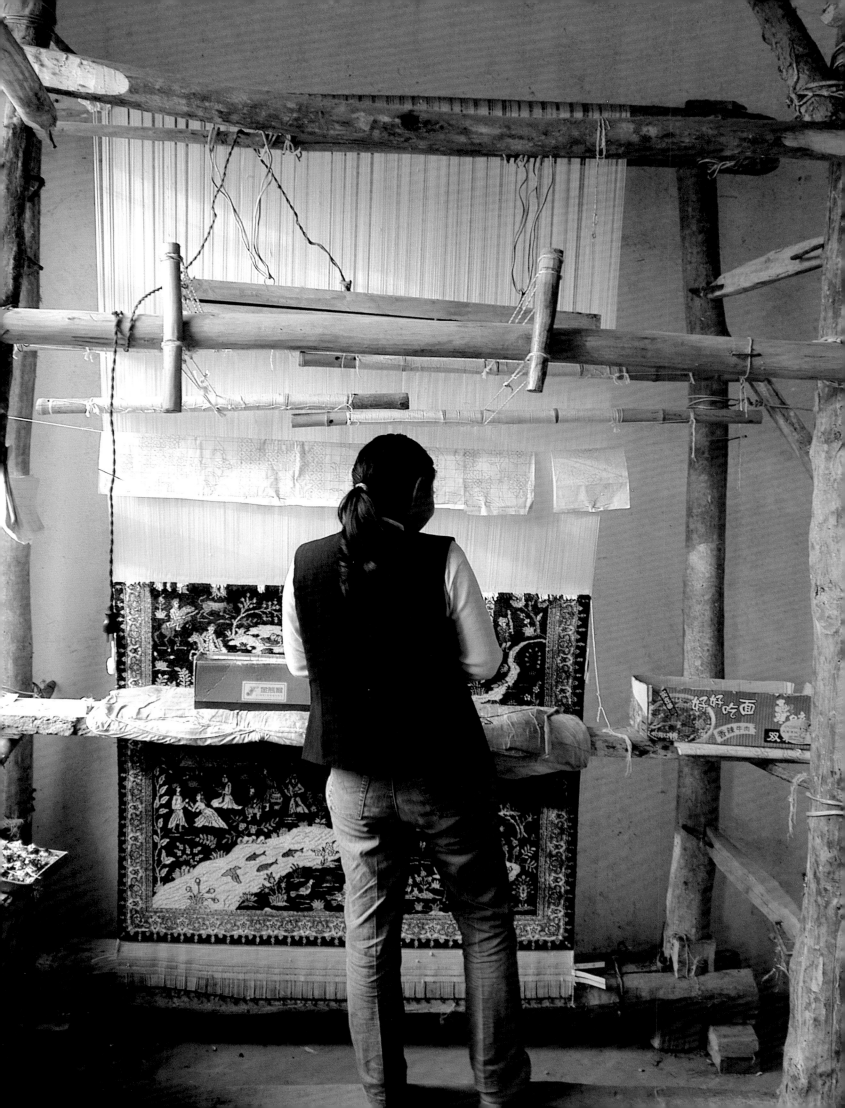

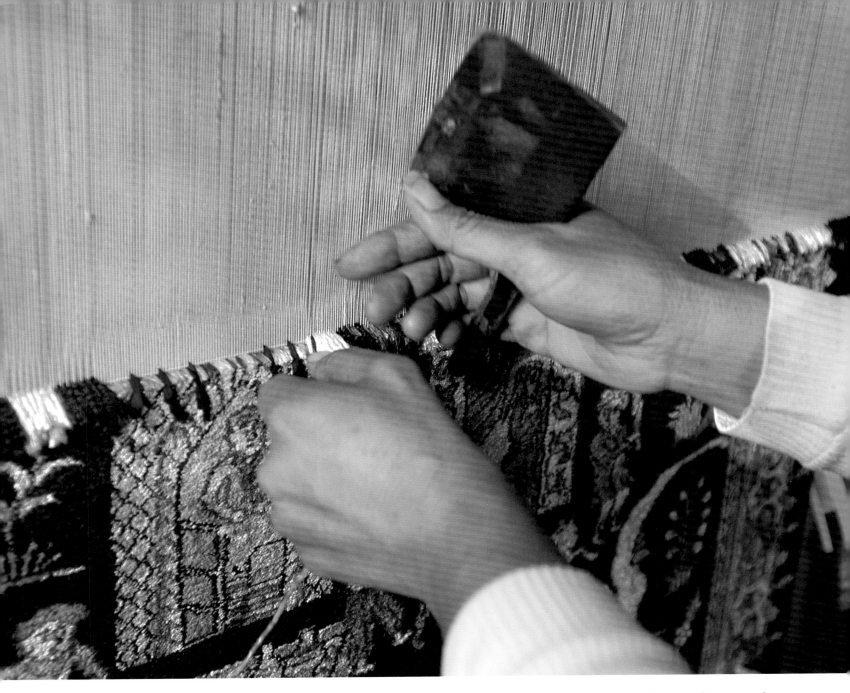

Ying works skillfully at her loom. "I like weaving and I'm good at it," Ying says matter-of-factly.

Working together, they will complete this rug in four to five months. And with China's growing rug market, especially for intricately designed pieces such as hers, Ying will sell her expertly wrought rug in the market forRMB-3000 ($250-375), double or even triple the cost of making it. That will be more than enough to repay her loan, cover daily living expenses, and purchase a comfortable chair for the living room. Averaging two rugs per year, Ying's and her husband's combined income has catapulted them far above China's designated poverty line of RMB300 ($75) in annual earnings.

"I like weaving and I'm good at it," Ying says matter-of-factly while glancing up to study the complicated paper pattern hanging from the loom in front of her. "Now I have my own business and I feel so good!" she adds, her toothy grin again appearing on her face.

An eruption of clucking suddenly arises outside the house. Ying and her daughter go to the front door and step outside onto the stoop. In the yard is a large plastic tarp, and on it are three plump, black ducks fighting each other for their share of the corn that has been spread out to dry in the sun. Even before Ying has a chance to shoo them away, they take off at a swift waddle. Ying and her daughter stand together, swathed in the afternoon's opulent hues. This is a place Vermeer would have loved to paint.

Ying's profits provided a new home, a 3-wheeled taxi for her husband, special treats for her daughter and all the schooling her son desires.

Pay Dirt

WALKING BETWEEN THE ROWS of bamboo racks that hold her 1700 plastic-wrapped dirt parcels, Mrs.Yang Hengbian stops to inspect each one for hints of growth. For the past six months she and her husband have carefully nurtured these precious packages, making sure they are positioned, protected and moistened in just the right way. It's now November, two months into the six-month period when their most exacting work takes place. Lifting up a sausage-like bundle in which she has spotted signs of life, Hengbian carefully pokes a small hole through the plastic with a blunt-ended, pencil-like stick. She knows that soon a plump, ripe mushroom will emerge.

So successful has her business and those of other women growing mushrooms been, that in the two years that they have been harvesting their crop, this impoverished rural neighborhood situated 45 minutes from the closest town has become the mushroom epicenter of Nanzhao county in Henan Province, China. Even the landscape reflects the community's success. Nearby, an enormous mushroom-shaped rock tore away from the side of a towering mountain, crashed down the jagged slope, and now protrudes prominently over a rushing river at the mountain's base.

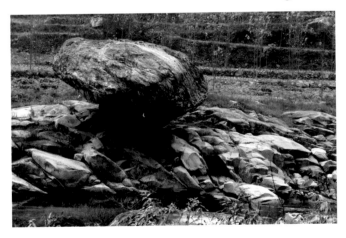

Even the surrounding landscape mirrors Mrs. Yang Hengbian's community's financial success – mushroom growing.

Prior to harvesting mushrooms, these poor women and their families eked out a living from small plots of land, growing alternating crops of wheat and corn, along with a few vegetables. In 2000, staff from Funding the Poor Cooperative (FPC), the pioneer microfinance NGO in China, presented Hengbian and her neighbors with a means to work their way out of poverty. Each woman was offered a business loan of RMB1000 ($125), a colossal amount to women whose annual family income, like others living at China's national designated poverty line, is less than half that amount.

Hovering between enthusiasm and fear, the women were finally won over when FPC promised support in every facet of their first formal business ventures. They would be taught how to prepare a business plan, run a profitable business and budget their income so that they could repay a

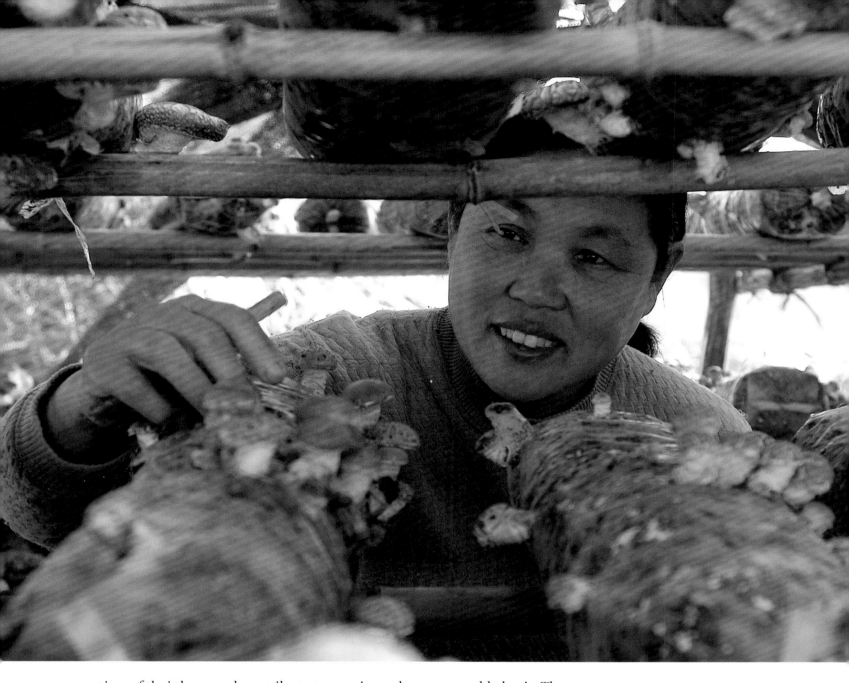

portion of their loan and contribute to a savings plan on a weekly basis. The women were also reassured by the promise of a built-in financial safety net – five-member borrower groups – should one woman be unable to repay any part of her loan including principal, interest (8%), and compulsory savings (1% of the loan) collected on a weekly basis over 12 months, her group members would cover her costs until she was able to repay them. Additionally, the Chinese government, committed to enhancing the income of its people, would provide comprehensive training in growing and harvesting mushrooms.

In the time since Hengbian, who had never sold anything but bundles of twigs for roofing, said "yes" to three FPC loans, her family's life has changed in untold ways, beginning with how little she now has to work. "Life was so hard before, " she explains. "Our small plot of land is far away from our house. And binding the twigs used to hurt my hands. Now my life is so easy. I don't even have to leave my yard to grow my mushrooms!" She

Yang Hengbian keeps a vigilant watch over her 1700 plastic-wrapped dirt parcels filled with budding mushrooms that she purchased with loans from the Funding the Poor Cooperative in Nanzhao County, Henan Province, China.

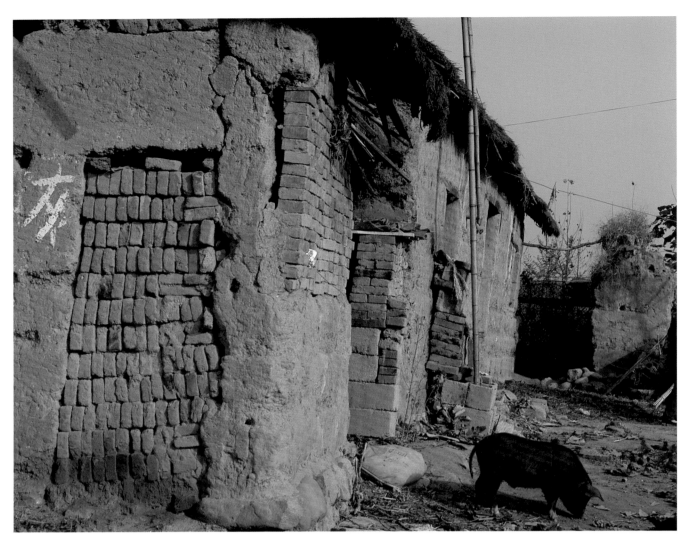

Before becoming a microentrepreneur with FPC, Hengbian's house resembled her neighbor's.

looks out to the road at the sound of a purring engine. Weaving his way around a maze of deep potholes, her smiling husband rides up on his new motorcycle. "This motorcycle is just one of the things we were able to buy with my profits," Hengbian says proudly. They now net $750 a year, ten times their previous annual income.

Together they walk up a few steps, through a wooden door set into a newly constructed brick wall and into their spacious concrete patio. Hengbian stops to wash her hands under a recently installed tap at a sink that has replaced a rusty hand pump. She has to duck under a clothesline criss-crossing the courtyard, which is draped with wet laundry recently washed in her new washing machine. Hengbian mounts the few steps leading into the living room of her four-room home. The walls, no longer mud, stone and straw, are now a durable brick. An overhead light illuminates a bank of colorfully painted scrolls and numerous photos of her two sons, one a soldier, the other a college student, whose tuition Hengbian now pays in cash.

The couple settles in, one on the comfortable couch, the other on a chair upholstered in a cheerful pink and white checked fabric. As Hengbian pours cups of tea, her husband flips on the rarely watched black and white television; they much prefer the new color T.V. in their bedroom. In the corner on a table sits the family's most recent acquisition, a telephone. "The market is so huge, there's no problem selling all the mushrooms from our entire village. Merchants even arrange to come here to buy the mushrooms directly from us." The phone rings, and she gets up to answer it. Most likely, it's another business call.

Hengbian's new house is equipped with all the modern conveniences: running water, electricity, two televisions, a washer, refrigerator, and even an indispensable telephone that she uses to keep in touch with her two sons and run her thriving mushroom business.

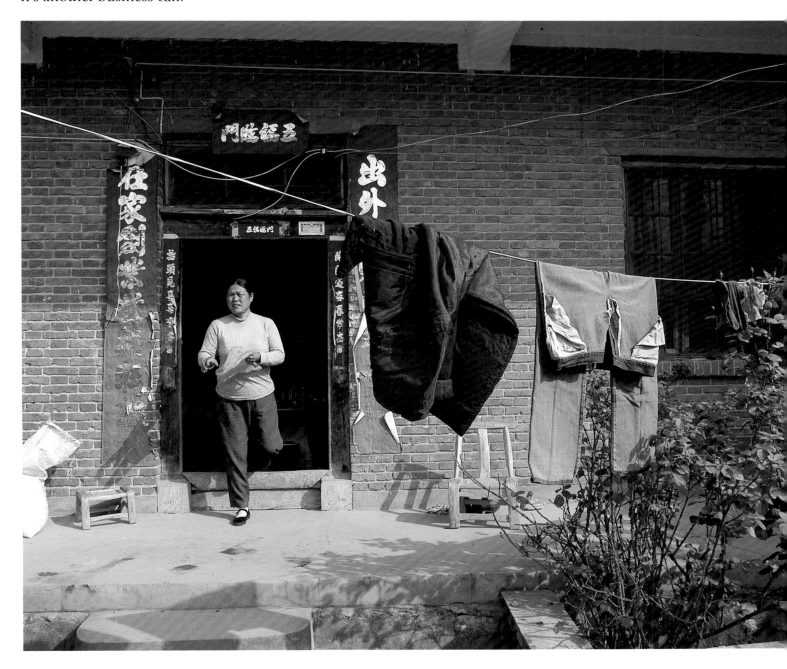

Oasis In the Desert

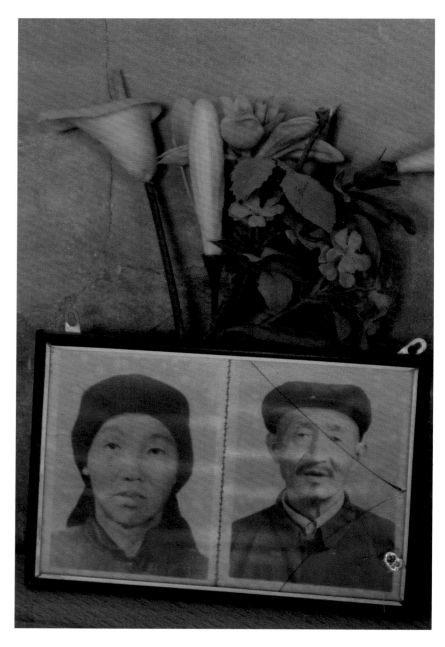

Leaning against a bunch of dust-laden plastic flowers are graying photos of Du Xuilan's parents-in-law, the previous owners of her humble dwelling and all it contains.

IN ONE CORNER of Du Xiulan's home stands a raised platform bed covered with faded sheets and threadbare comforters. A small coal stove hovers underneath the bed offering minimal warmth against winter's fast-approaching below- zero temperatures. An old 16″ black and white television sits on a dusty shelf in an even older cabinet whose doors have long since fallen off. Diffused daylight enters through a hazy glass window. At night, a bare bulb dangling from a frayed wire dimly illuminates the stark room. A child-sized chair squats beside a rustic table on top of which rests a large metal kettle for boiling water for tea, the only beverage Xiulan's family can afford. Sitting behind broken glass on a small, chipped, wooden chest, the room's only other piece of furniture, are graying photos of her husband Zhao Yan Wu's parents, the previous owners of this humble dwelling and all it contains. Taped above the photos on a cracked concrete wall is an imposing poster of Chairman Mao Zedong. These three figures are powerless to do more than watch as this family struggles to eke out a living.

Xuilan and her husband carry a daily burden in their hearts and minds. They went to a doctor hoping to treat their young son's skin disease. When they were told the price for his medicine, they returned home, distressed and empty-handed. Their unusually petite daughter never performed well in school. Now at age 17, she can't find a job. Everyday she sits idle at home. Fortunately their third daughter had some luck. She moved out after finding a job as a waitress in a village 20km away.

The couple is worried. Who will take care of them in old age? What will become of their children? The geography too, threatens the livelihood of Xuilan and millions of other rural subsistence farmers dependent on the land for growing grain and raising livestock. An encroaching desert of sand is sweeping onto this already barren area of Ningxia Province, situated in northwest China. Even the government's most aggressive tree-planting scheme may not be able to arrest the sand's relentless assault.

In 2000, a reprieve came to Xuilan. Like an oasis in a desert, the Women's Development Association (WDA) came to her community offering small business loans to groups of impoverished women. But like most disadvantaged individuals, especially Xiulan, the poorest woman in her community, she was afraid. Would she be able to operate a profitable business? Earn enough income to pay back the six-month loan of RMB1000 ($125)? She could not take the risk of plunging her family even further into poverty.

Desertification is threatening the livelihoods of poor farmers and ranchers like Du Xiulan, who, as the poorest woman in her community, is struggling to support her children in Ningxia Province, China.

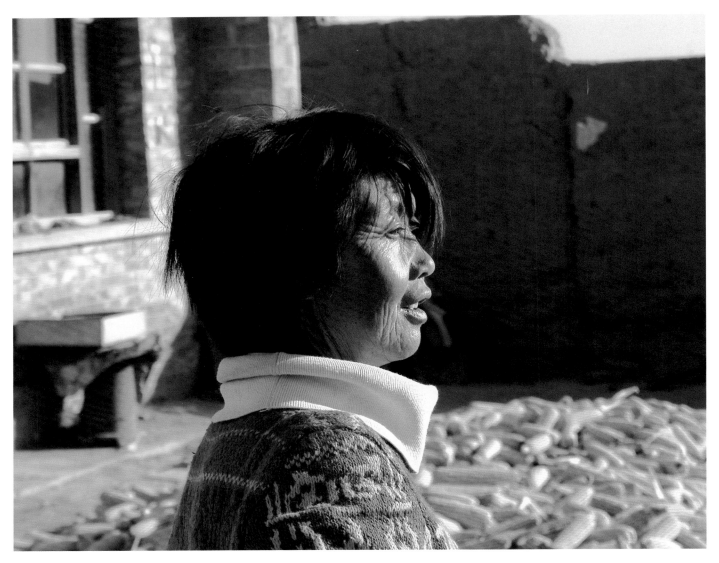

As the poorest woman in her community, raising an ailing son, and no savings, Du Xuilan needed a business loan from the Women's Development Association more than anyone.

Finally, after gentle coaxing from other women who recognized both her anguish and her need, Xiulan agreed to join a borrower group.

With her first loan, she purchased 300 chicks. Diligently feeding them corn grown on her small plot of land, the hearty birds were ready to sell after six months. Stuffing them into cages, she and her husband paid for a truck ride to the market. To Xiulan's surprise and relief, she sold her entire flock.

Upon her return, she repaid her loan, plus interest, and contributed to her first-ever savings account. Then she bought medicine for her son. With the remaining money, Xiulan and her husband set up a budget for additional medicine and more nutritious food for the family. Though the budget was very small, it provided them respite from their relentless anxiety.

Despite her success, when the WDA offered Xiulan a second, larger loan, she declined. She couldn't handle the additional stress. However, she was willing to borrow RMB1000 for a second time. Expecting to purchase 300 chicks, she was dismayed when her loan yielded just 200, two-thirds the number she had been able to buy with her first loan. It was 2003. A disaster had hit China threatening to cripple not only tiny businesses like Xiulan's, but also the entire country – they had been struck by the deadly SARS epidemic.

Fortunately, she and China weathered nature's rage. Her flock remained

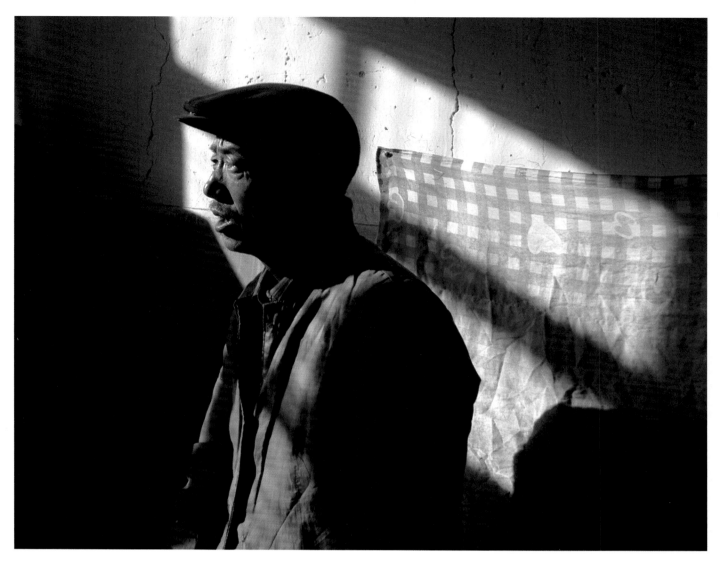

healthy, and while her profit was miniscule, Xiulan was able to sell her mature birds and repay her loan. Again she bought medicine for her son. Beyond that however, her family's food intake improved little. Xiulan's group encouraged her to take out a larger loan. But after the SARS scare, she was reluctant to take any chances. For the third time, she borrowed RMB1000. Luckily, a rebound in the market enabled her to again purchase 300 chicks.

Except for the few chickens pecking at the mound of golden yellow corn kernels drying in the sun, Xiulan's patio is unusually still. The rest of her flock has just been delivered to market and the couple is encouraged by their profit.

Together, Xiulan and her husband scan the windswept land stretched out in the distance like a worn tablecloth dotted with clusters of sand-colored homes resembling dried-out breadcrumbs. Yet within that view they see potential. Right behind their house there is room for a pen. If Xiulan were to take out a larger loan, they could buy some sheep. With profit from the sheep, they could buy an ongoing supply of medicine for their son. And more food. Perhaps some new blankets. And they could save even more for their future. And…

Du Xuilan's husband helps her raise chickens for a profit. Encouraged by their success, Xuilan is considering borrowing a larger loan so that the couple may raise sheep along with chickens.

Vietnam

DEMOGRAPHICS AND ECONOMICS	
Total Population (2004)	83,123,000
Gross National Income per capita (2004)	$550
Population below Poverty Line (2004) estimate*	19.5%
Health	
Fertility Rate (2004)	2.3
Maternal Mortality Ratio, (1990-2004), reported	170 (per 100,000 live births)
Annual Number of Under-5 Deaths (2004)	38,000
Life Expectancy at Birth (2004)	71 years
Orphans, Children (0-17) Orphaned by AIDS and other causes, (2003), estimate	2,100,000
HIV Prevalence: estimated number of people living with HIV, adults and children, 0-49 years, (2003)	220,000
Immunization of 1-year-old children (2004)	96% polio; 97% measles
Population using improved drinking water sources (2002)	67% rural; 93% urban
Population using adequate sanitation facilities (2002)	26% rural; 84% urban
Education	
Primary School Attendance Rate (2000-2004)	96% female; 97% male
Secondary School Attendance Rate (2000-2004)	57% female; 59% male
Total Adult Literacy Rate (2000-2004)	90%

Open Seven Days a Week

When it's raining, Mai's café is moved inside to the back of her always-bustling store.

HOA THI MAI'S DAYS of rising long before dawn and riding her rickety bicycle packed high with sticky rice cakes to sell in a market far from her parents' home are now but a remote memory. Without a doubt, the best if not the only good thing about her past life was the day her bike broke down. For, it was in a repair shop that she met her future husband and business partner. Nowadays, the couple simply walks together through their expansive new home's beautiful wood and glass front doors, down a few steps and straight into their always-bustling store and café.

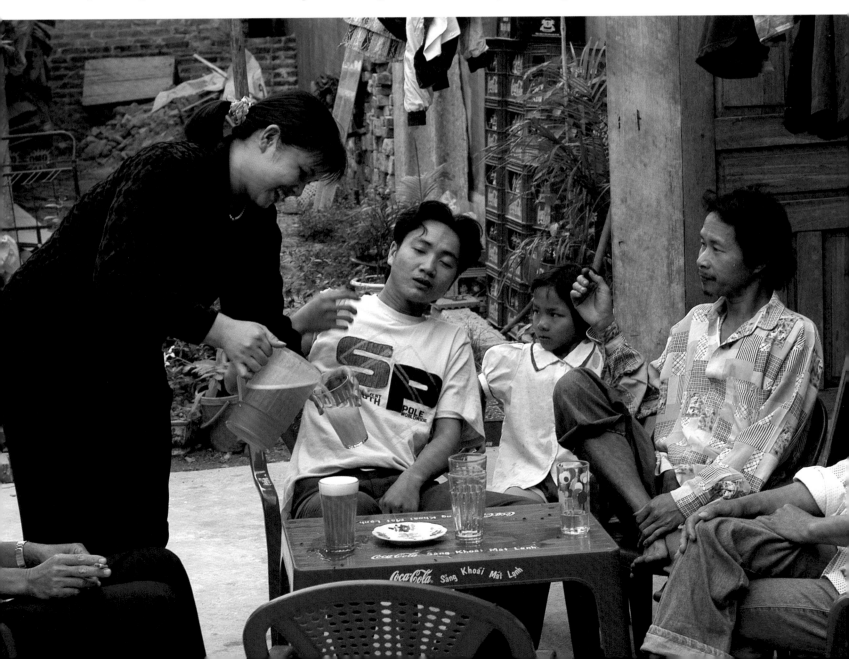

Like a brightly colored patchwork quilt, the shelves of Mai's store are impeccably packed, floor to ceiling with packages of every shape and size. "We offer over 100 items," Mai proudly announces as she realigns a box of cookies into its proper place. Every day, children crowd around the store's front glass case filled with candy, gum and freshly baked goods while their mothers shop for everything from crackers, fresh fruit, bottled sauces and juices to shampoo, cleansers, various brands of liquor and even an array of alarm clocks.

As her husband assists an elderly customer with her purchases, Mai fills a pitcher with ice-cold lager from a beer keg and exits the store through a door at the back left corner of the store. Out on a small patio, a group of men are gathered around a red plastic table enjoying each other's company in the afternoon sun. They lean back to make room for their cheerful host as she refills each of their glasses. Even when it's raining Mai's café is open for business; chairs and tables are simply moved inside the back of the store where there is plenty of room to savor a cool drink and a snack.

Customers are as satisfied with the store and café as is entrepreneur Mai who, with a series of ever-larger microloans from the Tau Yeu Mai Fund (TYM), literally, The Affectionate Fund, has developed her dual business to comfortably support herself, her husband and their two children, ages two and seven. Their doors are always opened between their marble-floored, high-ceilinged, two-story house and their café, financed with their business profits and a bit of help from some relatives, so that they can hear when customers arrive. "I work seven days per week," Mai states, " because I want my children to have whatever future they desire."

Besides the beautiful home that Mai and her husband have built for their family, their children are now assured a treat more delectably satisfying than anything they could ever find in the store's front glass case, something Mai's parents could not afford for her – an education. What's more, the children can have as much as they want.

Hoa Thi Mai is happy to work seven days a week in her store and café tha t she financed with help from the TYM. She and her business partner husband have built a new house and are saving so that their children may have whatever futures they desire.

Barnyard Bliss

ABANDONED BY HER HUSBAND and left to raise three children on her own, Le Thi Tho was often reduced to begging for food or borrowing from a moneylender whose exorbitant interest rates sent her into a black hole of debt. Then she heard about TYM, literally, the "I love you" fund. Today she tends a barnyard of animals, lives in a new house and has paid off all her debt.

A sea of women, each dressed in crisp white blouses, dark pants, their hair pulled back in a ponytail, braid or bun, descend the steps of the community hall in the Socson District, 40km from Hanoi, Vietnam. The Tao Yeu May Fund (TYM) borrowers' meeting (which literally translates to "I love you"), has just adjourned. Yet again, every woman paid her principal, interest and compulsory savings ($.80 per month) on time and in full. Somehow Le Thi Tho, who is the treasurer of her borrower group, is able to identify her bike amidst the mass of identical one-speed, black two-wheelers. Putting up the kickstand, she hops on and starts for home.

Along the way Tho passes by newly planted rice paddies, each guarded by ancestors' gravesites perched high around their edges. She rides past men in tall rubber boots who are guiding their rough-hewn wooden ploughs behind oxen as they dig deep furrows in the moist, brown soil, and by a young girl selling long sticks of sweet, suckable sugarcane. Arriving at her gate, Tho pushes it open, enters her yard which is shared by an assortment of animals, and then closes it behind her. She guides her bike up the gravel path and parks it beside her new house.

Tears still well up in Tho's almond-shaped eyes when she recalls the day her husband left her and their three young children huddled in their tiny mud and straw house whose roof was on the verge of collapse. With no savings, a negligible income from selling cupfuls of rice wherever she could, and a small plot of land allotted by the government on which to grow a few vegetables, Tho faced a constant dilemma – beg her neighbors for food or let her children go hungry. "Often they would not eat," she admits, her eyes downcast.

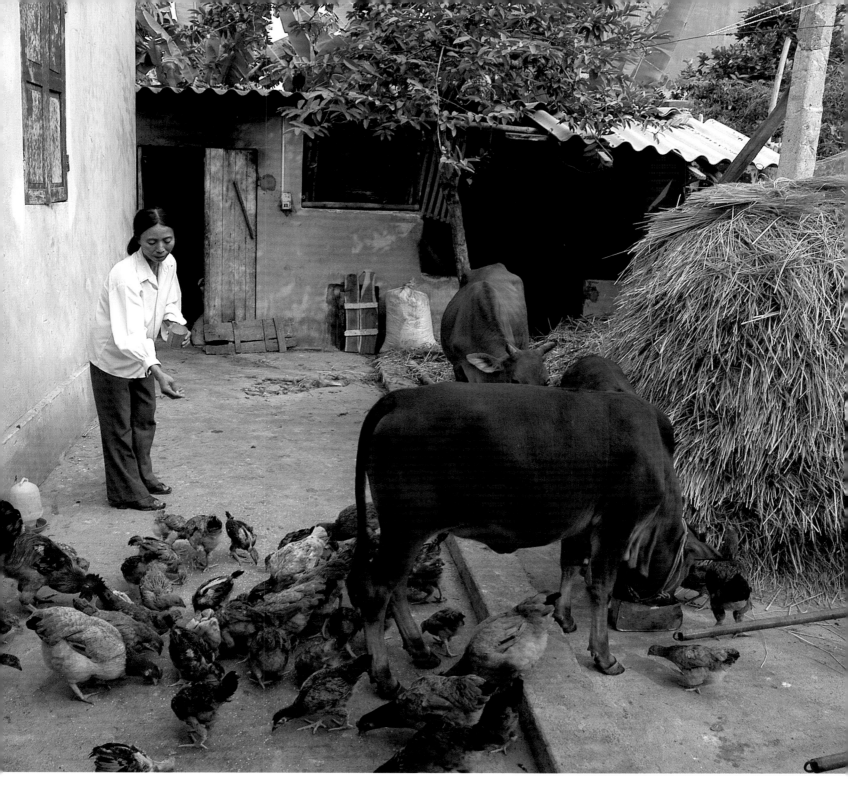

Then, when she thought her family could bear no more hardship, her eldest son became ill. So ill that he required hospitalization. As days turned into months, his medical bills escalated and his condition declined. Determined, like any mother, to save her son, but with no means of support, Tho was forced to borrow from the local moneylender. His exorbitant interest fees and her son's debilitating illness plunged her into a black well of debt and worry. Would she ever be able to repay her mounting loans? Would her son survive?

In 1994, a lifeline was extended to her – TYM Fund staff introduced the poor women in Tho's rural community to microfinance. Though worried that she would be unable to operate a profitable business and make the

Abandoned by her husband and left to raise three children on her own, Le Thi Tho was often reduced to begging for food or borrowing from a moneylender whose exorbitant interest rates sent her into a deep well of debt. Then she heard about TYM, literally, the "I love you" fund. Today she profits from a barnyard of animals, and has paid off all her debt.

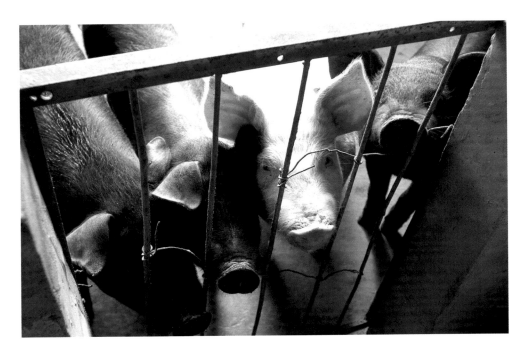

With her loans, Tho purchases piglets for VND200,000 ($13) and sells them for VND1M ($70), a VND800,000 ($57) profit per pig.

weekly loan, interest and savings payments, she had no other option. Her children were starving. They needed new clothes and they wanted to attend school. Her crumbling house required extensive repair. So Tho grabbed a hold, took out her first loan of VND3337 ($20), purchased a small flock of chicks, and launched a poultry business. Those chickens have been sold, as have many subsequent broods.

Walking around the corner of her house, a group of noisily clucking birds rush around Tho's ankles, urging her to scatter their feed. As soon as the corn hits the concrete pavement, a quick-tempoed peck-peck-pecking of sharp beaks replaces the birds' earlier banter. In exchange for the chickens' room and board, Tho collects and sells their eggs. Once a chicken stops laying, it too is sold for a combined profit of VND100,000 ($7) per month.

Carefully shuffling through her birds, Tho makes her way towards a caramel-colored cow and two calves munching hay from a six-foot high haystack. As soon as they hear her pouring corn (a supplement she feeds them to ensure their heft and health) into their trough, they plod over, dip their noses into their tasty meal and resume their methodical munching.

The calves earn Tho VND3M ($200) profit per year. Her 24 year-old middle son uses the mother cow's strength to pull a plow in their field where they grow rice, another product yielding VND300,000 ($20) per month.

Tho heads to a newly built concrete pen. Bundled together in a corner is what at first glance appears to be a tangle of pink and black fuzz. But at the sound of Tho's footsteps, the mass begins to unravel. First a group of legs squirm free. Then a group of rotund bodies emerges followed by a cluster of quivering snouts. As soon as they spot their owner, four adolescent pigs hoist themselves up and scramble over to the pen's gate. Their snorts reach a crescendo as Tho raises a cupful of food over their heads.

These four-month-olds, purchased when they were piglets for VND200,000 ($13) each, will fetch a price of VND1M ($70), a VND 800,000 ($57) profit

per pig, minus Tho's minimal expenses for food and water. Within seconds, their symphonic slurping joins the other contented voices on Tho's thriving backyard farm.

She walks up the steps to a concrete terrace fanning out in front of her four-room-home. "I decided not to repair my first house. Instead, I looked around, chose what I liked about other houses and then designed this one. I built it for VND37M ($3500)."

Lying at her feet are some tools and a bicycle turned upside down. Out of the glass front door limps a young man who looks down at his work in progress. With a few adjustments, the bike, like his life – the one his mother helped save – will run just fine. Though crippled from his yearlong illness, he opened a bicycle repair business to support his new wife, who now lives with him in his mother's home.

Tho follows her son into the airy front room that serves both as her bedroom and the family's primary living area. She turns on the overhead light and fan, two conveniences she had always dreamt about but never imagined having the money to afford. Taking a seat on her carved wooden couch, Tho pours tea into thimble-sized cups and offers one to her daughter-in-law who has joined her. Tho's son turns on the color television and flips through the channels before selecting a lively music and dance performance.

Tho picks up a red plastic photo album and thumbs through it. "I paid for two years of college for my middle son," she says pointing at his picture. "Now I'm saving to send him through his final year." If her 14 year-old daughter passes her high school exams, she will help her go to college too. "That will be easier," she smiles, "because I just finished paying off the last of my loan from the moneylender."

"I don't have as much as the other women in my branch," 49 year-old Le Thi Tho continues. "But that's OK. I did this all by myself."

Rather than repair a dilapidated house filled with bad memories, Tho used her profits to build a brand new one for VND37M ($3500). "I don't have as much as the other women in my branch," she says, "but that's OK. I did this all by myself."

ddle East

Jordan

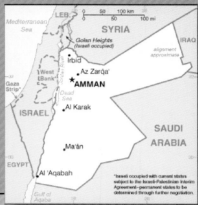

DEMOGRAPHICS AND ECONOMICS

Total Population (2004)	5,561,000
Gross National Income per capita (2004)	$2140
Population below Poverty Line (2001) estimate*	30%
Health	
Fertility Rate (2004)	3.4
Maternal Mortality Ratio, (1990-2004), reported	41 (per 100,000 live births)
Annual Number of Under-5 Deaths (2004)	4000
Life Expectancy at Birth (2004)	72 years
Orphans, Children (0-17) Orphaned by AIDS and other causes	No data
HIV Prevalence: estimated number of people living with HIV, adults and children, 0-49 years, (2003)	600
Immunization of 1-year-old children (2004)	95% polio; 99% measles
Population using improved drinking water sources (2002)	91% rural; 91% urban
Population using adequate sanitation facilities (2002)	85% rural; 94% urban
Education	
Primary School Attendance Rate (2000-2004)	99% female; 99% male
Secondary School Enrollment Rate (2000-2004)	87% female; 85% male
Total Adult Literacy Rate (2000-2004)	90%

Fertilizing the Family Tree

SO FAR, THREE OF MOHAMAD MUSA ABU ATTALLAH'S 15 siblings have completed community college, four others have earned four-year college degrees and one brother now holds an M.B.A. Another brother just celebrated a lavish marriage ceremony and recently, Mohamad's youngest brother received a computer to assist him with his studies. They each have their brother, Mohamad, who earned only a high school degree, to thank.

At age ten, Mohamad was the son at his father's side selling fabric for curtains to other Palestinian refugees at an outdoor table in a poor neighborhood in Amman, Jordan. As hard as his father worked, his income was insufficient to support his 18-member family. They lived crowded together in a small rented house where, due to lack of space and food, they never had the luxury of a sit-down family meal. But that has all changed since Mohamad decided to follow in his father's footsteps.

As far back as he can remember, Mohamad wanted to run his own business, and buy a car. After his father retired in 1999 and Mohamad learned about the Jordan Micro-Credit Company (JMCC), his dreams began to materialize. With his first loan of JD340 ($480), he was able to purchase a vast array of fabrics in hopes of broadening his customer appeal. With the remainder of his loan, he decided to take a calculated risk. Rather than selling only fabric as his father had, Mohamad paid a seamstress to make several sets of ready-made curtains. His business hunch was right – Mohamad's instant profit and growing demand both for his fabrics and finished curtains were solid proof. With the next two loans, he paid a second seamstress to make curtains, purchased more fabric, and watched his profits grow.

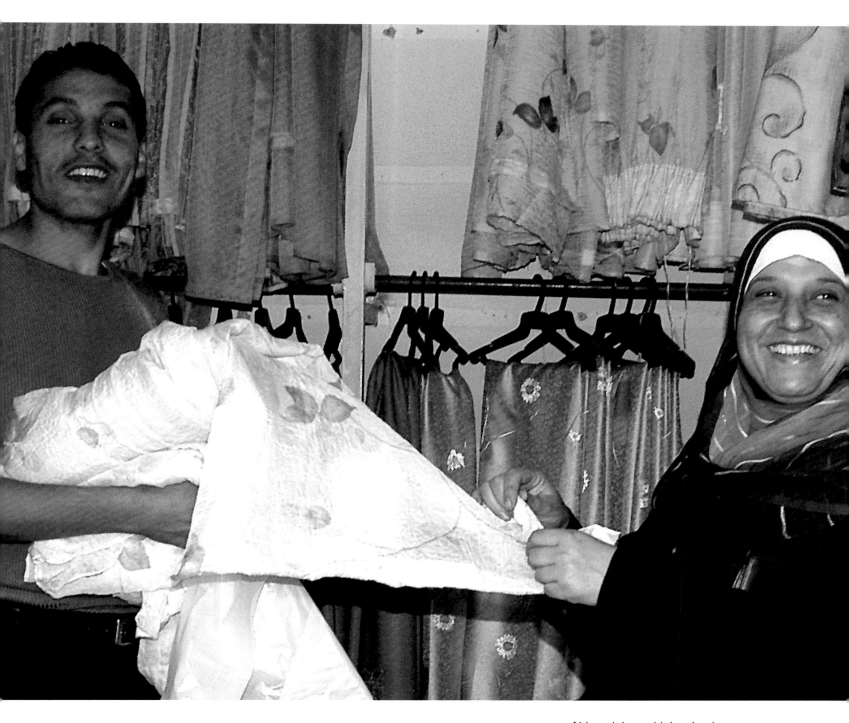

Although just a high school graduate, Mohamad Musa Abu Atallah is a shrewd yet fair businessman whose profits from selling fabric and readymade curtains support the educational and personal needs of his aging parents and 15 siblings.

Mohamad's second store, which he opened by combining profits and loans from the Jordan Micro Credit Company, is even larger than his first. The brother, whose MBA program was paid for by Mohamad, now runs it.

Emboldened by his success, Mohammad felt ready to try something his father had never been able to afford. Combining his JD2500 ($3,531) profit with a fourth JMCC loan of JD1500 ($2,118), he moved his business from his table on the street into an enclosed shop in a market teeming with customers. Now Mohamad has a place to assist his clientele six days a week, 9:30am-9pm, even when it rains. Profits from his ready-made curtains were so great, that, in combination with a fifth loan, Mohamad purchased five sewing machines, hired three fulltime employees and rented a space for them to sew curtains for his busy shop. As his customer base grew and grew, Mohamad decided to take another risk. He borrowed a sixth loan, and again combining it with a portion of his profits, he opened a second shop, but not until he had trained one of his brothers, the one with the M.B.A., how to operate a combination customer-oriented, profitable shop. Then Mohamad turned the responsibility for managing the new store over to him.

Many of Mohamad's dreams have already come true. "I now drive my own car. And I am so happy to support my family. I work 100% for them," he says, a deep contentedness emitting from his eyes. As for his future he muses, "When circumstances improve, I'd like to move to a larger store, marry someday and buy my own house."

Mohamad greets an eager customer as she enters his shop. She makes a straight line to a modern-looking fabric with a pale green leaf pattern. Pulling it down from its rod, he holds it in front of her so that she can feel its rich texture. "The price is JD17 ($24)," he says. She counters with JD15 ($21). Mohamad, shrewd yet fair, settles right in the middle at JD16, one sale closer to his future dreams.

The Home that Khadija Built

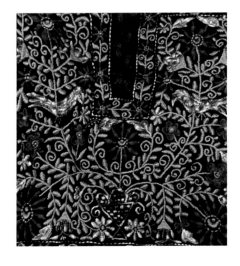

KHADIJA ESHASH'S PARENTS fled Palestine in 1948, finding what they thought would be short-term refuge in Jerico until they could return "home". Twenty years later, the Eshashs' were again on the move. With their two sons and six-year old daughter, Khadija, each with little more than a suitcase of belongings, the family went not to Palestine, but to Baqa'a, a barren, dusty refugee camp on the outskirts of Amman, Jordan. Like scores of Palestinian refugees, they were given a plot of land, some corrugated tin, asbestos blocks and wood to build a temporary house to live in until they could return "home". But as days turned into months and months turned into years, the camp's inhabitants realized their inevitable need to settle in. Stores opened, men found jobs – though oftentimes inferior to their levels of education and experience, children began to attend school, and a new generation was born.

As a young girl, Khadija realized her gifts for learning, both at school and at a neighbor's house where she spent every free moment practicing detailed embroidery both by hand and with a sewing machine. After completing secondary school, she was determined to become a teacher of Arabic, but that required a certificate from a community college with fees her struggling family could not afford. Recognizing her promise, Khadija's older brother somehow scraped together the JD50 ($70) she needed to begin her studies. In no time, Khadija moved to the top of her class. When not studying, she devoted her free time perfecting her passion – embroidering. Before long, she developed into such an expert embroiderer that a neighbor began paying her, albeit a very small amount, for each piece she completed. Her life was full and Khadija envisioned a bright future as a teacher.

Unfortunately, graduation was more bitter than sweet. Although Khadija scored 98 percent on her exams, she could not find a teaching position. And, while the doctors did all they could, they could not save her father. The family tragedy did not end there. Shortly after her father's death, Khadija lost her mother. As if that was not enough, her older brother became disabled, so he could no longer work. He and his wife became dependent on government welfare, the small income their younger brother was able to generate, and on Khadija whose hopes for starting a family of her own now had to be put on hold.

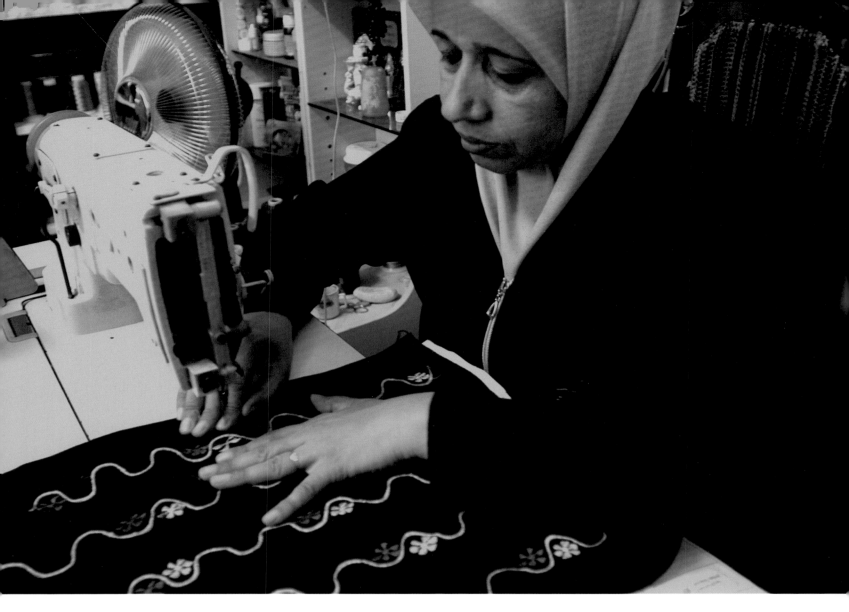

Unable to work in the career for which she had prepared, Khadija returned to embroidery. Hired by a sewing factory, she soon excelled in everything she was taught and began designing her own patterns. After five years of what had become for her a dead end job in terms of challenge and income, she convinced her boss to let her take a sewing machine home and to get paid per piece. "No one could embroider like I could on a machine, " Khadija proudly admits as she completes a golden-yellow flower of her own design on a growing row of embroidery. She worked quickly on the factory orders, spending the rest of her time designing one-of-a-kind pieces for her own growing list of customers. But, even with her supplemental income, Khadija could not earn enough to support her extended family. And the house her parents had built, along with most of its contents, were in dire need of replacement or repair.

In 1997, staff from the Microfund for Women (then known as the Jordanian Women's Development Society), a brand new program initiated by Save the Children, came to Khadija's community offering no- and low-income women business loans so that they could open or expand a small business. As one of its first clients, Khadija borrowed JD75 ($105) and with it purchased an array of dress fabrics of velvet, cotton and wool,

When Palestinian refugee Khadija Eshash's parents passed away and one of her older brothers became disabled, Khadija became the family's primary breadwinner, turning her hobby, embroidery, into a profitable career.

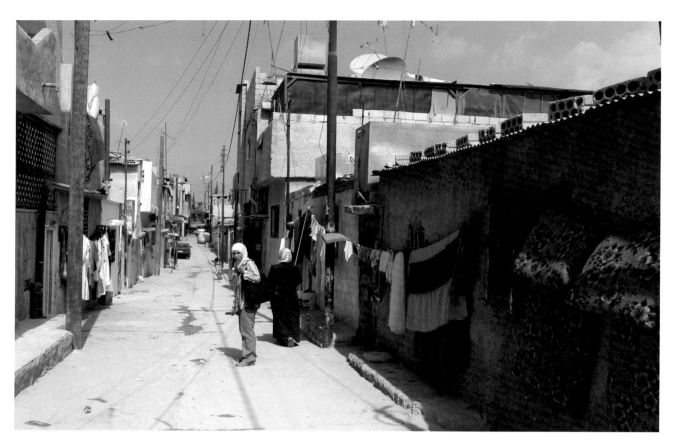

Khadija's family, like those of thousands of other Palestinian refugees living on the outskirts of Amman, Jordan, have turned their temporary dwellings into permanent neighborhoods.

and high quality threads in a kaleidoscope of colors. Loan after MFW loan over the past seven years have yielded profits that Khadija never could have realized on her own. "I am now so famous in Amman that I don't need any advertising. I sell my pieces to an exclusive store for JD25 ($35) each and they sell them for JD100 ($140)."

Just as she can turn spools of thread and plain fabric into a beautiful embroidered dress, so has Khadija, through her hobby-turned-profession, transformed her family's life into one of bounty and comfort. At 43, she, her brothers, their wives and children, live together on the same plot of land her parents were given 37 years ago. The house, however, bears nothing of its original appearance. Almost single-handedly, Khadija paid for its reconstruction, complete with electricity, running water and all the comforts of "home". Food too is plentiful, and she has even created an education fund for her nieces and nephews.

After all her hard work for her family, Khadija still has dreams, and the energy to help others. "I want to have my own shop and sell my pieces at the market price. I also want to teach girls to sew because teaching and embroidery bring me such happiness." And still, she holds out hope for a husband and children of her own some day.

Opposite: Khadija used profits from her embroidery business to completely rebuild and refurnish a home she shares with her brothers and their families. Some day she hopes to have a family of her own.

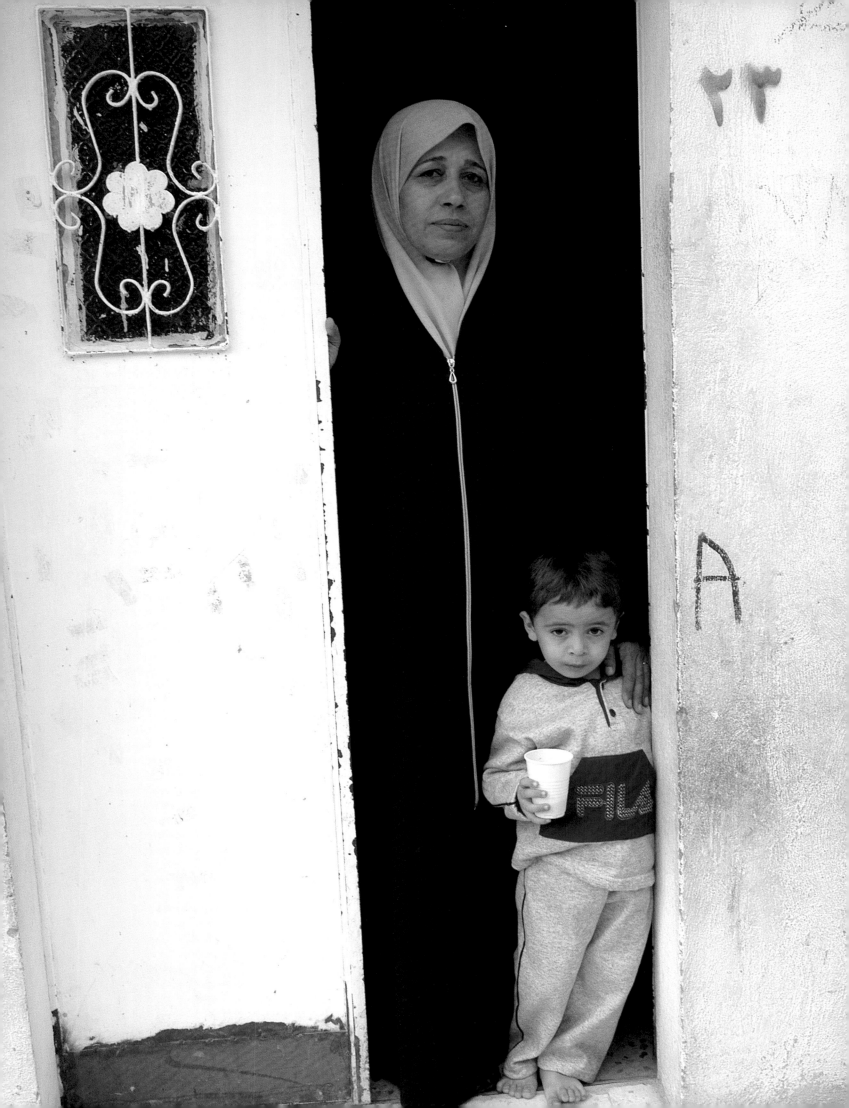

ndent States

Republic of Georgia

DEMOGRAPHICS AND ECONOMICS	
Total Population (2004)	4,518,000
Gross National Income per capita (2004)	$1040
Population below Poverty Line (2001) estimate*	54%
Health	
Fertility Rate (2004)	1.4
Maternal Mortality Ratio, (1990-2004), reported	52 (per 100,000 live births)
Annual Number of Under-5 Deaths (2004)	2000
Life Expectancy at Birth (2004)	71 years
Orphans, Children (0-17) Orphaned by AIDS and other causes, (2003), estimate	No data
HIV Prevalence: estimated number of people living with HIV, adults and children, 0-49 years, (2003)	3000
Immunization of 1-year-old children (2004)	66% polio; 86% measles
Population using improved drinking water sources (2002)	61% rural; 90% urban
Population using adequate sanitation facilities (2002)	69% rural; 96% urban
Education	
Primary School Attendance Rate (2000-2004)	100% female; 99% male
Secondary School Enrollment Rate (2000-2004)	61% female; 62% male
Total Adult Literacy Rate (2004) estimate**	100%

Leavened Hope

THERE WAS NO OTHER CHOICE. As soon as their babies were born, Khatuna and Irma planned to abandon them. One woman's husband was in jail. With no skills, job or income of her own, she had already made the heart-wrenching decision to send her 11 year-old daughter to live with her sister in a town hours away. How could she afford a second child? The other mother-to-be had gotten pregnant out of wedlock, a stigma her family would not tolerate. Their babies were doomed to join the estimated 5200 children (according to official statistics from the Ministries of Education and Science) in the Republic of Georgia who live in orphanages, children who are abandoned for a number of reasons: they are a financial burden, or, if handicapped or born to an unwed mother, they are a shame to their families. Both women felt desperate. Hopeless.

But just after their babies' delivery at a maternity house in Georgia's capital, Tbilisi, these women were approached by a social worker from The Prevention of Infant Abandonment and Deinstitutionalization Project (PIAD), whose primary implementing partner is World Vision International. Each new mother was offered a life-changing alternative – the opportunity to keep her baby by moving into PIAD's Mother/Infant Shelter, a program dedicated to keeping mothers and their newborns together. The social worker explained that each mother would be given a room of her own, three healthy meals a day, any necessary medicines, clothing and supplies, such as diapers and blankets, and even a crib for her baby. Before departing from the shelter into her own affordable home, each mother would also receive business training, as well as personal and health counseling. And the women would be given both a grant and a loan from PIAD's Project Employment Services Center in order to open a business to support herself and her baby.

In the Republic of Georgia today, there are an estimated 5,200 children who are abandoned for a number of reasons: they are a financial hardship, or, if handicapped or born to an unwed mother, they are a shame to their families.

Both Khatuna and Irma chose to accept PIAD's offer. Already their lives have blossomed and become intertwined in ways they could never have imagined. "If I had not met the social worker, I would have had to abandon my baby because no one could help me. Now I'm sure I won't abandon Anri no matter what," Khatuna declares as she nurses her contented baby boy.

"I was so stressed that my milk wouldn't come. I prefer breast feeding, but I can't," Irma says softly as she sits on her bed attentively watching her plump two-month-old, David, drink from a bottle. "But I've acquired such hope in this shelter with these women, we've planned not to abandon each other, but to help each other. We've become friends." As the two babies fall asleep, their mothers place them side by side, something they'll be doing often, given the plans they've made.

Khatuna and Irma have decided to open a bakery together once they leave the shelter. With PIAD's help, they have developed a business plan whose implementation will, they believe, exceed the GEL260 ($150) per month each will need to care for herself and her child.

"We're going to bake and sell our goods from the same location. I'll be Irma's assistant since she has experience. We have a good relationship with each other so we're filled with hope," Khatuna joyfully explains. "And the first thing I plan on doing is bring my 11 year-old home."

"At first, we're going to live together. We'll work seven days a week from 9am to 9pm. Khatuna's mother-in-law has offered to take care of our children," Irma says. "We'll start by selling khachapuri (the ubiquitous Georgian bread), hopefully 300 per day at GEL.57 ($.33) each, cheese bread and lobiani (a bean-filled bread). Once we're established, we'll add sweet baked goods. In the future, we plan on hiring two more employees – single mothers!"

As the lunch hour approaches, mothers begin filtering into the dining room that Khatuna has just swept. One snuggles with her one-month-old while another feeds her son who stares intently at her from his stroller. Although it's Khatuna's turn to prepare lunch and dinner for the nine other mothers in the shelter, Irma joins her in the sun-filled kitchen. Standing next to Khatuna, her new friend, new business partner and new mother, Irma takes up a knife. "We're just counting the days," she says as she begins slicing a loaf of bread. The oldest of the children in the shelter toddles up to her, his hand eagerly outstretched. "Here you go, Levan," she says, handing him a piece of bread.

Opposite: Irma and Khatuna decided to keep their newborns David and Anri when they were invited by PIAD, a program supported by World Vision, to receive housing, food, baby supplies, business training and loans. They've decided to open a bakery together. "In the future," Irma announces, "we plan on hiring two more employees – single mothers!

Singing a New Tune

AMIRAN ADAMADZE used to be a happy man. He sang for his supper and supported his wife and three teenage children by entertaining customers in restaurants every night.

But in 1992, a time of violent political upheaval, corruption and near economic collapse in the post-communist Republic of Georgia, Amiran was kidnapped. His captors demanded payment of everything his family owned, that is, if they ever wanted to see Amiran back home alive. Within ten days, his terrified yet determined family had sold everything they owned: a car, jewelry, furniture, clothes. Eleven days after his capture, Amiran walked through his farmhouse door, a free, but now penniless man. Unlike six others who had been randomly kidnapped that same day, he alone was spared. Since singing was his only trade, and his family needed to eat, Amiran had no other choice but to return to performing cheery songs to unknowing customers, a Herculean effort in the face of the trauma he had just undergone.

Today, Amiran's brilliant smile defies his painful past. Instead, it speaks to the present life that his son, Gogita, has orchestrated for the entire family. Now a husband and father of two, Gogita decided to become a client of World Vision International (WVI) so that he could begin taking care of the extended family. The entire Adamadze family got into the act; together, they turned to farming, and now they're turning a profit.

With his GEL 5293 ($3000) loan, Gogita and his father purchased supplies to refurbish two dilapidated greenhouses on their property. After tearing out the rotten boards, they built sturdy new wooden frames and encased them in plastic sheeting. On a bare piece of land at the back of their property, they constructed a third, brand new greenhouse, this one 100 meters long. Then Gogita's wife, mother and sister pitched in, securing line after vertical line of string from the ceilings' rafters down to the thin wooden boards lying in a grid pattern on the dirt floor. Finally, they planted row upon row of cucumber and tomato seeds. They watered, carefully tended and waited.

In 1992, a time of violent political upheaval in the post-communist Republic of Georgia, Amiran, husband, and father of three teenage children, was kidnapped. His family was forced to sell everything they had in order to secure his release.

Amiran's son Gogita decided it was time to take care of his extended family. He borrowed GEL5293 ($3000) from World Vision, and with the family's help built three hot houses bursting with ripe green cucumbers and clusters of juicy tomatoes.

The Adamadze family's hard work in their new business endeavor is paying off. Thick vines, wrapping around each string, climb from floor to ceiling, each hanging heavy with ripe green cucumbers or clusters of juicy tomatoes. Retailers who have discovered the Adamadze's bounty buy directly from the family farm, reselling the fresh produce from their stalls and small stores. If things continue to go Gogita's way, his customers will also be able to buy chickens once he receives a second WVI loan. The family plans to restore an old chicken house where they'll raise 2000 meaty birds.

Amiran now sings a new tune – one of joy and hope – particularly for his grandchildren. "They are clever," he says proudly, "so we're saving all we can to send all three of them to the best schools in Kutaisi, rather than to the local village school."

Deeply rooted in devotion to family, watered by a strong work ethic and fertilized by WVI loans, reaching the Adamadze's goal for the children is, like any well-tended crop, just a matter of time.

"My three grandchildren are clever," Amiran says proudly, "so we're saving all we can to send them to the best schools in Kutaisi, rather than to the local village school."

Europe

France

DEMOGRAPHICS AND ECONOMICS

Total Population (2004)	60,257,000
Gross National Income per capita (2004)	$30,090
Population below Poverty Line (2000) estimate*	6.5%
Health	
Fertility Rate (2004)	1.9
Maternal Mortality Ratio, (1990-2004), reported	10 (per 100,000 live births)
Annual Number of Under-5 Deaths (2004)	4000
Life Expectancy at Birth (2004)	80 years
Orphans, Children (0-17) Orphaned by AIDS and other causes, (2003), estimate	No data
HIV Prevalence: estimated number of people living with HIV, adults and children, 0-49 years, (2003)	120,000
Immunization of 1-year-old children (2004)	97% polio; 86% measles
Population using improved drinking water sources (2002)	No data rural; 100% urban
Population using adequate sanitation facilities	No data
Education	
Primary School Enrollment Rate (2000-2004)	99% female; 99% male
Secondary School Enrollment Rate (2000-2004)	95% female; 93% male
Total Adult Literacy Rate (2000-2004)	No data

A Queenly Calling

LIKE A QUEEN in her palace, Sandra Laurence sits surrounded by her subjects. Sandra is not of royal lineage, however, and she does most of the work. She prefers it that way. For, her palace is her own office space where she runs her new business as Director of Privilege Marketing. Her subjects are her multi-line phone, portable computer, busy fax, organized stacks of client files and three eager employees. Her life today is anything but what she thought it would be.

Born in Martinique, a commonwealth of France, Sandra thought her life was mapped out: she would complete a baccalaureate degree and repair washing machines for a living. But after a few years, restlessness set in. Feeling stymied by her dead-end job, Sandra immigrated to Paris hoping to enhance her opportunities. She decided to pursue a higher-level baccalaureate so that she could advance her career, but that took money that she did not have. Determined, Sandra took on various jobs during the day in order to attend school at night.

Then, like a twist in a good fairytale, it was not her schooling she says, but "ten years of the little jobs that helped me understand myself and come to be good at what I'm doing now." For, in managing a pizza parlor, helping orchestrate conventions as a hostess, working for a company selling goods door-to-door, and telemarketing individual insurance software, Sandra's keen communication, marketing and sales interests and skills were awakened.

So, even though she had spent time, effort and money in order to earn a second degree, Sandra realized that her true calling was working with people rather than machines. Spinning her life into a totally different direction, Sandra put her degrees behind her, picked up the phone in a communications consulting company and has held it close to her ear ever since. But after two years as an employee finding clients for the agency, Sandra again became restive. She decided she wanted her own agency with her own clients, but again there was the issue of money; she lacked startup capital and had no collateral for a bank loan.

Then she heard about Adie, a microfinance organization in France dedicated to helping low-income individuals create their own businesses. Adie saw Sandra as an ideal client. Like a queen's trusty advisor, Adie helped

Sandra write both a business plan and a three-year financial plan and gave her a start-up loan of 5,000EUR($6395).

Initially working from home, Sandra landed her first client and then a second. But after all her work, her second client refused to pay and when she attempted to take him to court, he simply disappeared. Again Adie came to her aid, giving her an interest free "honor loan" of 2,000EUR ($2558) so that her business wouldn't fold. Far from it; within three months, Sandra had built up a client base of 10 advertising agencies for which she now finds clients. She's leased her first office space and hired employees whose job it is to identify business leads. "Then I do all the negotiating which I'm successful at because I offer quality service at the highest level," she says confidently.

Working an average of 12 hours a day, Sandra is not yet netting more money than she did working for someone else. "But it's worth it because I'm so happy to have my own firm. I'd rather pay my employees well and invest the rest of my income directly into my business." She also repaid her 12-month loan plus 7-1/2 percent interest in just ten months.

She fantasizes about a bigger office with additional employees, owning her own house and providing all the education her two children could ever desire. With Sandra on her throne, her dreams-come-true are nothing but believable.

Once an appliance repairwoman, today, like a fairytale come true, and with the help of Adie, Sandra Laurence is director of her own company, Privilege Marketing.

More than
Skin Deep

PASCALE FRANCOIS MARRIED and divorced. She managed a high-end cosmetics business for six years with a staff of 30, but was forced to resign due to medical problems brought on by over-work and stress. She invested all her savings in six health food stores from Paris to Cannes, but lost it all. She owned her own esthetician salon, but was robbed by an employee and had to abandon the business. With neither capital nor job, Pascale survived for six months on welfare provided by the French government. Though her life was fraught with inconsistency, one thing remained unswerving: her passion for the beauty care industry.

After all her losses and letdowns, Pascale was at a complete loss about how to pursue her passion: owning her very own esthetician salon, catering to a steady clientele, and selling the highest quality beauty products on the market. Her opportunity arrived during a conversation she had with a friend who told Pascale about Adie, a 15-year old microfinance organization in France.

With the help of one of Adie's fleet of volunteer business executives, Pascale wrote a business plan. Adie then ushered her through the labyrinthine system of forms and innumerable government office visits required to register a new business in France,. Adie then gave her two start-up loans of 1350EUR ($1737) each, one interest bearing, and the second interest free.

While Pascale overflowed with enthusiasm, she had nothing she needed to run her business. So she used a portion of her loans to purchase the essentials: an esthetician's table, special lights, and a small quantity of high quality skincare products. Next she needed to find somewhere to set up shop. During her search, she found a tiny, excellently located space with a high volume of pedestrian traffic that she could rent two days a week.

Today, in a much larger established salon, Pascale is downstairs where she has escorted a repeat client into a brightly lit room. "Lie back and relax," she says with a soothing voice. She tucks a strand of wavy brunette hair behind her ear, adjusts her glasses, and pulls the broad, saucer-like lamp in close. With both gentleness and speed, Pascale first applies warm lotion, followed by strips of muslin tape that she then pulls away from her client's legs, leaving them smooth to the touch. "I'll see you next time," her

client says to Pascale before returning to the dressing room. Rather than depending solely on an unpredictable walk-in business at her own shop, Pascale is patiently building a solid base of repeat clientele (one that she plans on taking with her), at an established full-service beauty salon where she pays her employer 20% of the daily income she earns from waxings, facials, and other skin enhancement services.

Unlike her business experiences of the past, Pascale believes that with Adie, she has finally found the right partner. "Now I'm not afraid. I'm very optimistic!" she declares. Pascale is already looking ahead. "I have a vision of working in a loose partnership with a plastic surgeon, a nutritionist and a physical fitness coach so that we can provide a full-spectrum of health services and refer our clients to one another."

Pascale represents Adie's definition of wealth, both in her growing bank account and in her heart. *"J'adore, j'adore, j'adore!"* (I love, I love, I love [what I do])) she says, a brilliant smile emitting from her glowing face.

After suffering physical ailments due to overwork, being robbed by an employee, and losing all her money in an investment that went bankrupt, Pascale finally found a promising match with Adie, an MFI in Paris, France. A trained esthetician, she is now on the path to owning and operating her own skincare business.

United States

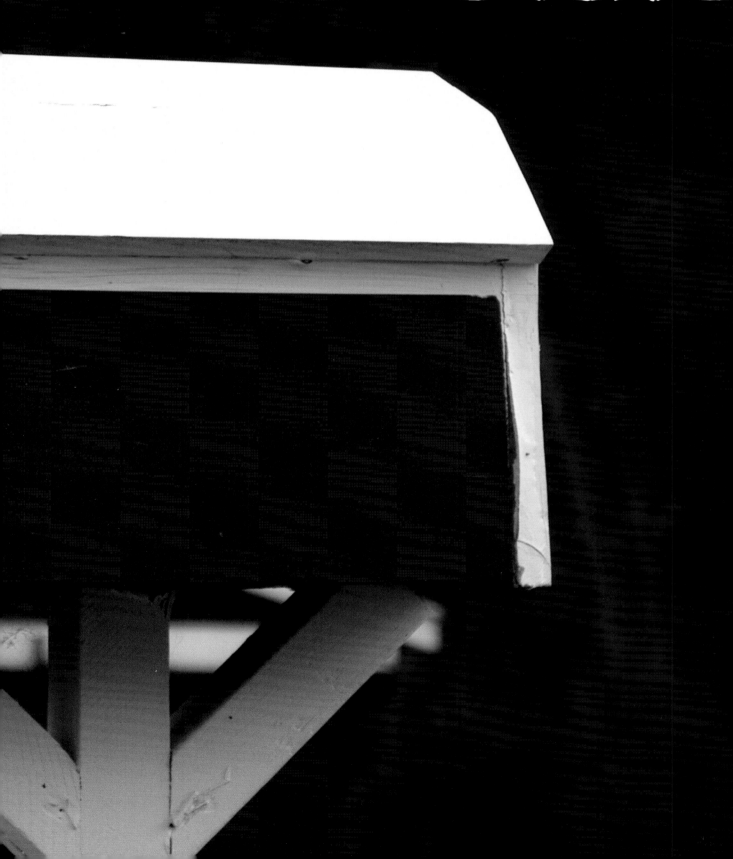

United States

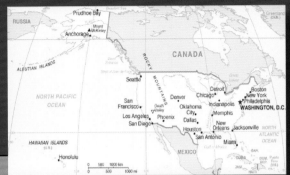

DEMOGRAPHICS AND ECONOMICS

Total Population (2004)	295,410,000
Gross National Income per capita (2004)	$41,400,000
Population below Poverty Line (2004) estimate*	12%
Health	
Fertility Rate (2004)	2
Maternal Mortality Ratio, (1990-2004), reported	8 (per 100,000 live births)
Annual Number of Under-5 Deaths (2004)	33,000
Life Expectancy at Birth (2004)	78 years
Orphans, Children (0-17) Orphaned by AIDS and other causes, (2003), estimate	No data
HIV Prevalence: estimated number of people living with HIV, adults and children, 0-49 years, (2003)	950,000
Immunization of 1-year-old children (2004)	92 polio; 93 measles
Population using improved drinking water sources (2002)	100 rural; 100 urban
Population using adequate sanitation facilities (2002)	100 rural; 100 urban
Education	
Primary School Enrollment Rate (2000-2004)	93% female; 92% male
Secondary School Enrollment Rate (2000-2004)	89% female; 88% male
Total Adult Literacy Rate (2003)**	99%

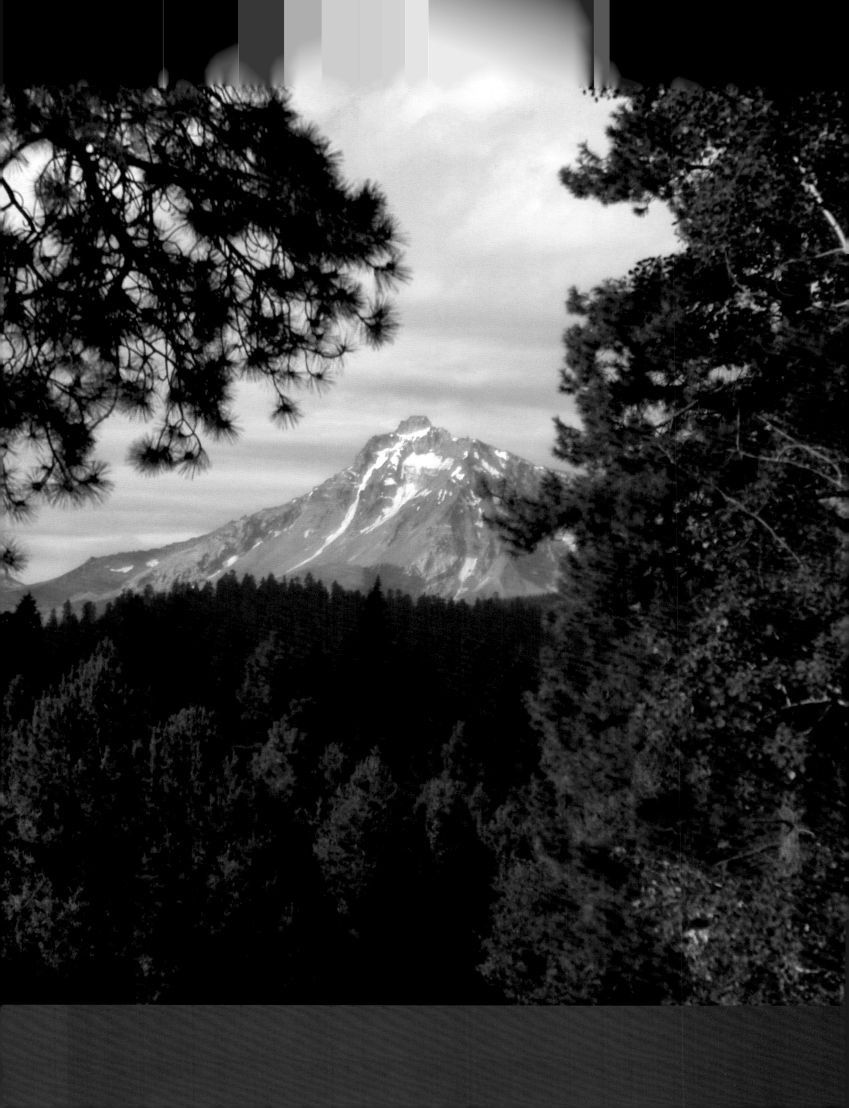

Holisitic Wellness 101

"STAND UP, OPEN YOUR ARMS, take in all that is around you, and smile," Asara Tsehai urges a group of headstrong professional women. Spreading her long, sinewy arms out wide, she takes in a deep breath and wraps her arms around herself. "Now I want you to embrace yourselves." Though self-conscious at first, by Asara's second appeal, every woman in the circle is standing, following her lead. "Place your palms together in gratitude for all that you are." By the time the women sit down, their shoulders are visibly relaxed and smiles have emerged on every face.

Asara has been hired to bring unity among a disparate group of business leaders who have been reluctant to share power or work together on a city enhancement project. "The more powerful individuals become, the more susceptible they are to isolation and imbalance, both in their professional and personal lives. I see my value as bringing wellness to the workplace so that everyone has abundant energy for their work, for themselves, and for their families." Whether working with a group of leaders, an individual business or a non-profit, Asara teaches groups how to become caring, inclusive communities where everyone is appreciated. "Open doors, honest, respectful communication, and a commitment to taking full advantage of everyone's strengths to reach common goals," Asara asserts, "are key to creativity, productivity and profitability."

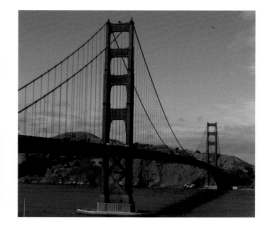

At once open, encouraging and directive, Asara is a model leader for her clients. "Today I offer eight principles of holistic wellness that I have gathered from personal experience and from my heart," she says to the women. "If any of these principles resonate with you, I am honored to have made a difference; what does not resonate with you, I am just grateful to have been heard, because being heard is a gift."

"Are you ready for our journey together?" she asks. After receiving a unanimous nod, she lists and explains each principle:

1. *Have the courage to put your voice in your life.*
2. *Be willing and courageous enough to have difficult conversations.*
3. *Recognize that feminine energy is naturally healing and supportive.*
4. *Have a plan for radiant health to exist in your life.*
5. *Don't compare yourself to anyone else.*
6. *Define what success looks like for you.*
7. *Be generous.*
8. *Have fun!*

Even as a baby, Asara mirrored her grandmother's dynamism. Nicknamed "Happy," she was a favorite of Mom's friends who gladly babysat for her free of charge. "I have always been a natural influencer and a healer. Because of that I can live and work comfortably in any world and with any type of person," explains Asara who has done so in France, Nigeria and Jamaica. An "A" student throughout her high school years, Asara was elected the first African-American student body president of her predominantly Caucasian high school. She was also hired as the first black waitress in Ocean City, New Jersey. Her naturally friendly and attentive service earned her so many more tips than her co-workers, that in order to keep the rest of his staff content, the restaurant manager decided to pool and divide everyone's tips equally. Like her grandmother, Asara abided by her employer's policies, however unfair they were to her.

As an adult, Asara trained to become a holistic health educator, initially providing massage treatments and nutritional advice to her clients. She soon discovered, however, that they wanted more, and her clients discovered that Asara was able to provide it. "When a client complained of aching knees, I would ask what she was afraid to move forward with." Such thoughtful, straightforward conversations with all her clients catapulted Asara's practice into a calendar full of individualized 9-week therapeutic programs for professionals aching to integrate their physical, mental and emotional selves. For a while, her business boomed. "I was happy teaching people to

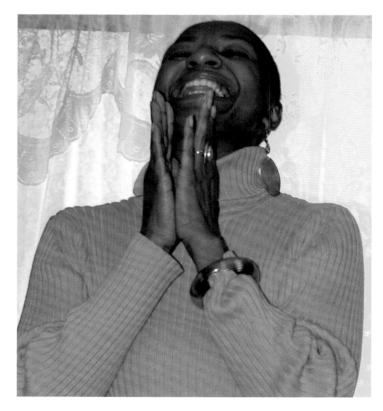

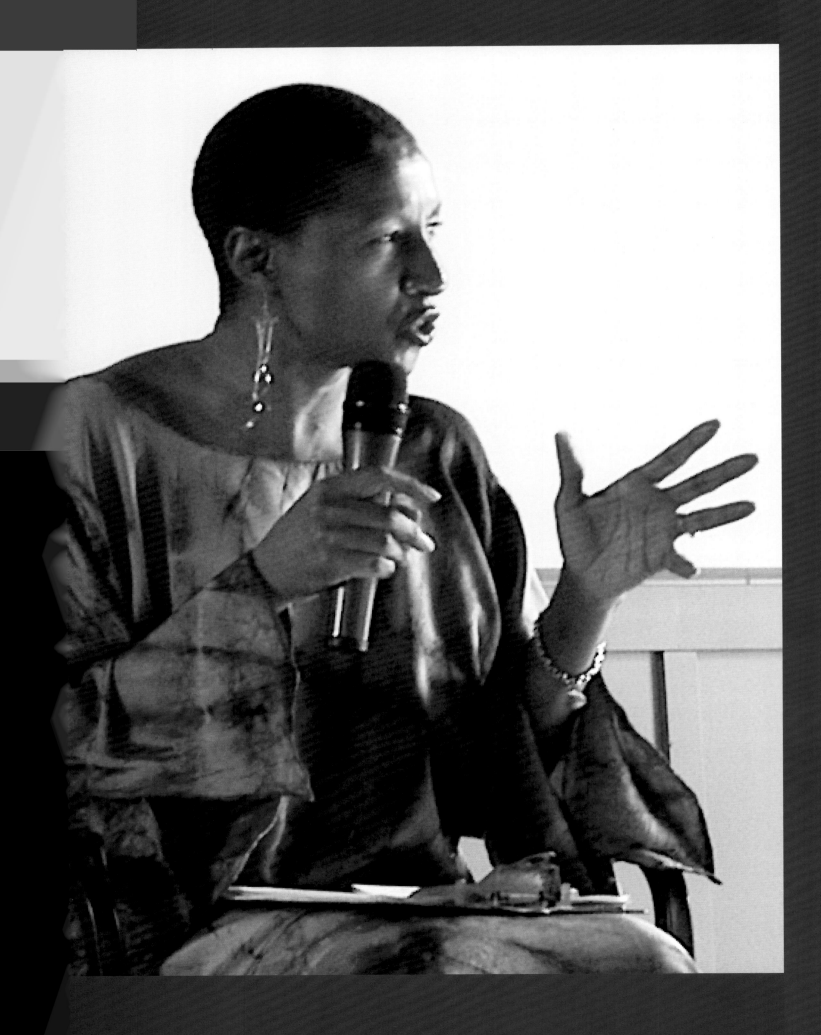

embrace their entire selves. But I realized that I wasn't charging enough for all the hours and energy my work required. My only role model had been Mom who had worked so hard, but never pushed her employers to pay her what she was due." Asara found herself depleted and divorced, with a young son dependent on her for support. "I was caught in a trap that many females find themselves: I didn't know how to demand commensurate pay for the quality and quantity of work I produced. I overworked to compensate and lost myself in the process."

Fortunately she discovered Women's Initiative for Self Employment, a microenterprise organization in the San Francisco Bay Area. It was their staff and volunteer mentors who gave her the hope and help she needed to begin again. Asara enrolled in their 10-week business management course and emerged with a business plan, creative marketing tools, and sound record keeping and cash flow instruments. Perhaps most valuable, Asara learned how to formulate pricing strategies commensurate with her worth and work.

Revitalized and confident, she opened her one-on-one leadership development consulting business. This, she believed, was the business she'd have until retirement. But at the conclusion of a group leadership-training weekend she was asked to co-facilitate with a friend, a participant's comment propelled her into the career she has today. "You've transformed my life in two and one-half days!" she declared to Asara. "Can you do that for my business in New York?" Although Asara had worked solely with individuals, something inside told her to say yes. Not only did her client's company experience a transformation, Asara did as well. During her consultancy, she realized that her passion and keenest abilities lay in working with groups.

Soaring as high as the jet carrying her back to California, Asara reoriented her business plan, exchanging her focus on individual clients, with a focus on groups of primarily female leaders, as well as leaders and their employees working in non-profits and start-up businesses. By the time her plane touched down, Asara had outlined two training modules: Leadership Through Transformation Signature Series, and Employee Wellness Training, for her new company, *A Touch of Life*.

Enlivened by her budding success, Asara decided to rekindle a second venture, one that she had helped spawn years earlier while working as a natural health consultant. Using the business-building model she learned from Women's Initiative, she devised a formal business plan for a line of high-end, all-natural, hair and skin products. Asara calculated production and promotion costs, and set up a timeline for each step in the process of getting her products to market. Her next step will be to apply for a business start-up loan from Women's Initiative.

Opposite: "Open doors, honest, respectful communication, and a commitment to taking full advantage of everyone's strengths to reach common goals," business consultant, Asara Tsehai asserts, "are key to creativity, productivity and profitability."

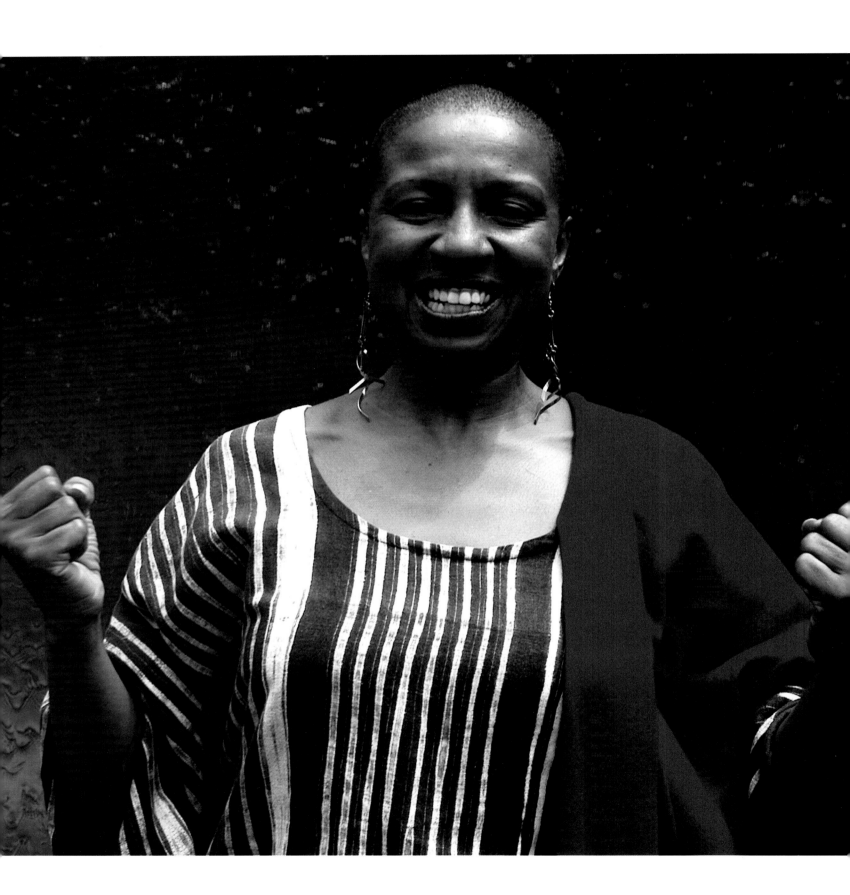

Clearly, an entrepreneurial spirit runs through Asara's family. Accompanying her to each of her business classes was her ten year-old son who decided to use what he was learning to initiate his own business. With encouragement and a small loan from his mother, this young entrepreneur purchased and repackaged bundles of incense, which he sold out of at each class meeting. Next he decided to tap into his culinary passion. After paying back his mother, he used his remaining profit to purchase various vinegars, oils and spices. His secret salad dressing was so popular that again, he sold out at every class. Today, a salad with his dressing has become an undisputed "must" at every family gathering.

Women's Initiative for Self Employment has reaped the benefits of Asara's involvement as well. Speaking at their conferences and training meetings, Asara inspires women to take themselves seriously and to take calculated risks in order to live fulfilling lives.

"What does it take to live a life of wholeness?" Asara asks the women. "Courage," proposes one.

"Yes!" Asara responds. "And what else?"

"Commitment," offers another.

"Yes again!" Asara replies. "Courage and commitment. That's what it takes."

A graduate of Women's Initiative for Self Employment, Asara knows what it takes to succeed – courage and commitment – both of which she emulates and inspires in her clients.

Standing Up for Herself

HER BONES SHATTERED in a car crash caused by her mother driving under the influence; at age 15, she was forced to leave her unhealthy home environment and fend for herself; severe trauma, neglected and botched post-accident surgeries triggered fibromyalgia syndrome (FMS), myofascial pain syndrome (MPS), and chronic fatigue syndrome (CFS); nursing school administrators demanded that she drop out after two years of study because of her permanent disability – a fused wrist (a few months prior to the passage of the Americans with Disabilities Act), thus surrender her dream of becoming a nurse; modifying her focus, she earned a B.A., followed by an M.S. in Vocational Rehabilitation and Gerontological Management, but immediately after completing (and passing) the board exams, she collapsed in exhaustion and severe pain; restricted to a wheelchair, near-penniless and all alone, she moved into public housing for the elderly and people with disabilities; doctors stated unequivocally that she would never again walk. As with every other obstacle she had encountered throughout her life, Judith Pothier put her foot down. "Yes I will," she announced, "just watch me."

But as the reality of her devastating prognosis set in, compounded by her agonizing existence reduced to moving from bed to recliner and back to bed, Judith wanted to die. Until, that is, someone recognized the potential behind her pain and despair and urged her to become a representative for hundreds of voiceless residents living in Oregon's Public Housing. During her four-year tenure, Judith became an unflagging advocate for residents' rights. "I realized that I was winning the way for all of us," she says proudly.

Like an oxygen mask, this position resuscitated Judith's will to live. "Even though I didn't know how I was going to do it," she recounts, "I became determined to take care of myself so that I could become free of the 'system'." The first thing she did was go shopping at various medical supply stores. Unsatisfied with what she found, Judith designed a custom walker and applied for a grant to get it built. Although not very far, nor very fast, Judith again began to walk.

One gray-skied afternoon, Judith, still partially dependent on her motorized wheelchair, rode down the ramp from her single-story, government-subsidized house. Flanking her on the left was Higgins, her cat-

Opposite: At age 15, Judith Pothier's bones shattered in a car crash, followed by years of physical pain, personal letdowns, and poverty. Doctors told her that she would never walk again. Not only did she walk; she invented and now manufactures The Ultimate Blanket, a fleece-lined, water resistant blanket now being used by sports enthusiasts, seniors and people with disabilities.

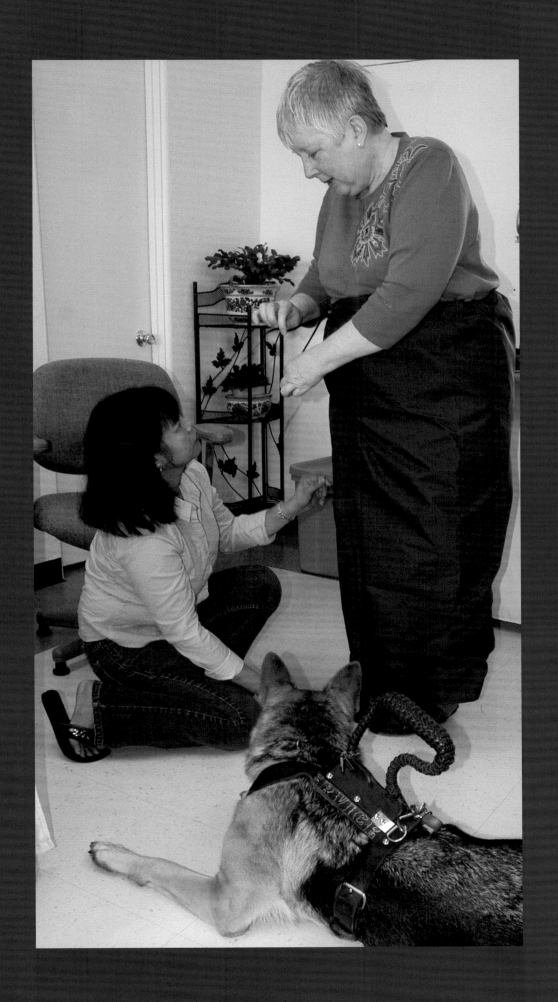

loving service dog, tugging excitedly at his leash, anxious to begin his brisk daily walk. On her right was one of her friends who, unlike Judith, could keep pace with Higgins on foot.

While she didn't like to complain, Judith needed someone to confide in. With a $603 monthly SSI check and a food card worth just $152, Judith admitted to her colleague that she was barely able to survive. Out-of-pocket expenses for Higgins' needs, plus the high cost of natural supplements and a specialized diet (that Judith found to be the only way to successfully regulate her health) often left her with nothing to eat at the end of the month but dry cereal and protein powder. Of immediate concern was an unwieldy blanket that had yet again become caught in the wheels of her wheelchair. "I need to stop," she said, bending over at an uncomfortable angle to assess the problem. In that instant of frustration it came to her – she would design a blanket to accommodate her wheelchair.

Little did Judith realize that that moment would mark the genesis of a CEO, a burgeoning company, a small-business award winner, and a spokeswoman devoted to helping others realize that there really IS life after a disability.

"Let's make sure that the fabric tapers out from the ankles all the way up to the waist so that there's ample 'give' around the hips when people sit down," Judith instructs Terry and Julie of T & J's Custom Design, her local manufacturer of *The Ultimate Blanket*. Originally designed exclusively for wheelchair users, Judith's wrap-around, water-resistant, fleece-lined blankets soon discovered unanticipated and profitable niches. One afternoon when a University of Oregon alumnus saw Judith at a grocery store, he asked her where he could buy a blanket like the one she was using – in U of O's green and yellow colors – to wear during their often cold and rainy athletic events. Prompted by his request (which she fulfilled), Judith ordered bolts of fabric in a rainbow of colors representing colleges throughout Oregon. Once her state's athletes and fans have been outfitted,

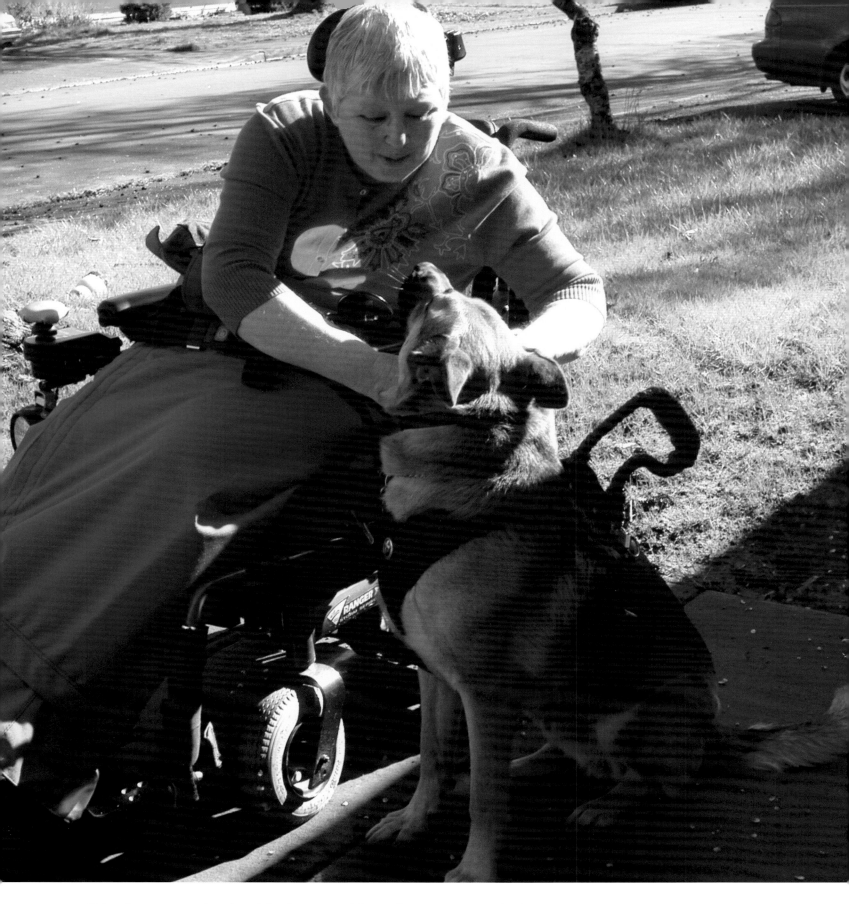

Judith plans to market her blankets to athletic departments and alumni associations across the nation.

After a fisherman purchased her $150 blanket before departing on a camping trip, Judith realized the potential of a third market – sporting goods stores – and added them to her burgeoning customer base.

Although Judith can now walk, she must use her wheelchair to go long distances, especially when taking her cat-loving service dog Higgins for a walk. On cold days she wears one of her Ultimate Blankets, complete with foot piece.

Given her background, Judith was keenly aware of the escalating population of senior citizens both in the United States and around the world. So it took her little time to recognize that with their cozy interiors, easy to manipulate Velcro closures, and detachable foot pieces, her blankets had another huge market waiting to be wrapped up. Her first significant sale came from across the Pacific. After three months of negotiating, passing a strict product evaluation, and sending five specifically sized free samples, a Japanese wholesaler placed an initial order for 20 blankets, advertised Judith's *Ultimate Blanket* in his company's catalogue of care products for seniors and people with disabilities, and profiled it at two of Japan's major trade shows.

"My business is at the tip of the iceberg. It's going to go wild!" Judith exclaims. "But getting my business started and keeping it running has been like taking 30 business majors all at once," she adds. "I never could have done it without all the support I've received. Now I'm committed to speaking, especially to people in vocational rehabilitation programs, about their boundless business possibilities, regardless of their financial situation or disabilities. When I relate my personal story to them and tell them about all the organizations that have assisted me every step of the way, they realize what's achievable."

"I took my blanket idea to Lane MicroBusiness (LMB) and they believed in me and my potential from the start," she always begins…

Established to assist low-income individuals in Lane County, Oregon, (LMB) began by teaching Judith how to write a business plan. When her disabilities prohibited Judith from attending their regularly scheduled classes, they offered her a weekly, one-on-one business-counseling program. Anxious to get up to speed technologically, Judith came up with the idea of using a Housing and Community Services Agency Ross Grant to pay for additional software, in combination with business equipment training from LMB, at her home office. After helping her devise ways to save $1,334 in an Individual Development Account (IDA), LMB staff also ushered Judith through the application process for a federal grant that tripled her savings.

At last she was ready. Nervous but committed, Judith took her first official step as a CEO – she purchased business insurance. Next she bought several bolts of fabric, cording, cord locks and Velcro, and had her first blankets commercially made. With her remaining grant money, she hired a professional copywriter who made the final edits for a glossy, bright green and yellow, photo- and fact-filled brochure announcing Judith Pothier, Owner/Operator of Pothier Innovations, Outdoor Comfort Gear.

Now Judith had a product, but she needed office equipment and supplies to run her business. The Abilities Fund, an organization that promotes the economic advancement of people with disabilities, coordinated with LMB

to help Judith apply for a $700 grant from the Trickle Up Program. She was a perfect candidate; the program offers small business financing and training to the poorest of the poor, and allots 10% of its grant monies to individuals with disabilities. Soon Judith's office was equipped with an HP Photosmart All-in-One (printer, fax, scanner and copier), a connecting cable, ink cartridges, a box of paper, general office supplies, and a professional digital camera.

"Then I discovered that I could receive a computer from the Oregon State Vocational Rehabilitation Program. I also realized that my office needed to be adapted to accommodate my physical limitations." Padded armrests on her chair, a heightened desk with adequate lighting, and a voice-activated software program on her computer provided Judith with just the right equipment and comfort she required to function. Now she could work at the professional level she has always expected of herself.

When Judith answered the phone in the spring of 2006, she nearly leapt out of her chair. In recognition of her persistent hard work despite her dire financial situation and debilitating disabilities, Citicorp's Women and Company® Microenterprise Boost Program along with The Abilities Fund had selected Judith as an Outstanding Female Entrepreneur with Disabilities. She was being honored with a gift of $2,500. With a racing heart and trembling hands, Judith pulled out her business plan. She couldn't believe her great fortune; without delay she could develop her much anticipated website, TheUltimateBlanket.com, and she could hire a part-time salesperson to help her market her blankets. It seemed too good to be true.

"Although I live with constant physical pain and stamina problems, mentally I feel healthier and more hopeful than ever before. I've realized that I can do more to help others than I ever could have as a nurse or vocational rehabilitation counselor. I'm actually supplying a useful product, and paying people to help me. And I'm delighted to be a "poster child," inspiring the 65% of people with disabilities in the United States who are not presently working."

Slowly yet deliberately, Judith pushes herself out of her chair and leans forward to look at a photo of a house she's cut out of a magazine and taped to her office wall. "Higgins," she says turning around. Jumping up from his bed, Higgins stands directly in front of her, staring attentively at Judith's face. "We're going to move out of subsidized housing and have a house of our own someday."

Central
America

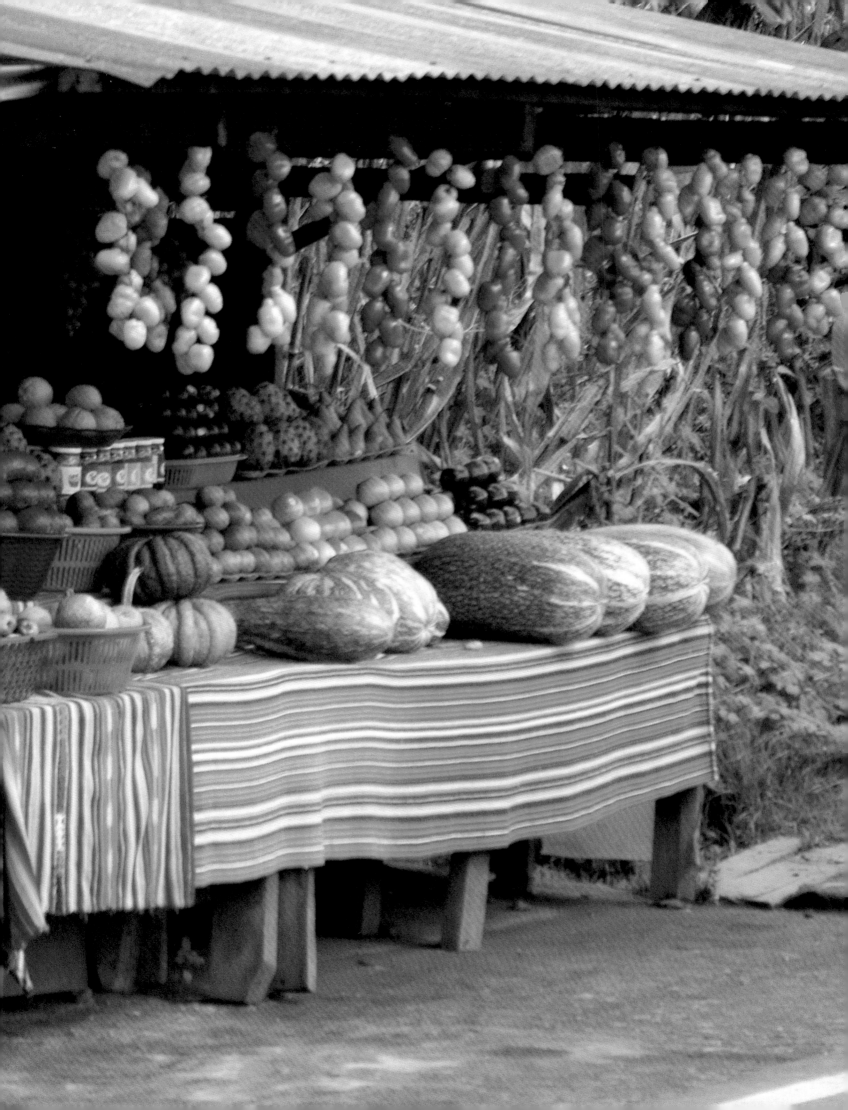

Guatamala

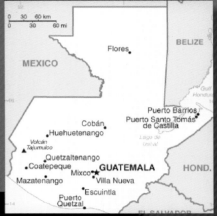

DEMOGRAPHICS AND ECONOMICS	
Total Population (2004)	12,295,000
Gross National Income per capita (2004)	$2130
Population below Poverty Line (2004) estimate*	75%
Health	
Fertility Rate (2004)	4.5
Maternal Mortality Ratio, (1990-2004), reported	150 (per 100,000 live births)
Annual Number of Under-5 Deaths (2004)	19,000
Life Expectancy at Birth (2004)	68 years
Orphans, Children (0-17) Orphaned by AIDS and other causes, (2003), estimate	510,000
HIV Prevalence: estimated number of people living with HIV, adults and children, 0-49 years, (2003)	78,000
Immunization of 1-year-old children (2004)	84% polio; 75% measles
Population using improved drinking water sources (2002)	92% rural; 99% urban
Population using adequate sanitation facilities (2002)	52 % rural; 72% urban
Education	
Primary School Attendance Rate (2000-2004)	76% female; 80% male
Secondary School Attendance Rate (2000-2004)	23% female; 23% male
Total Adult Literacy Rate (2000-2004)	69%

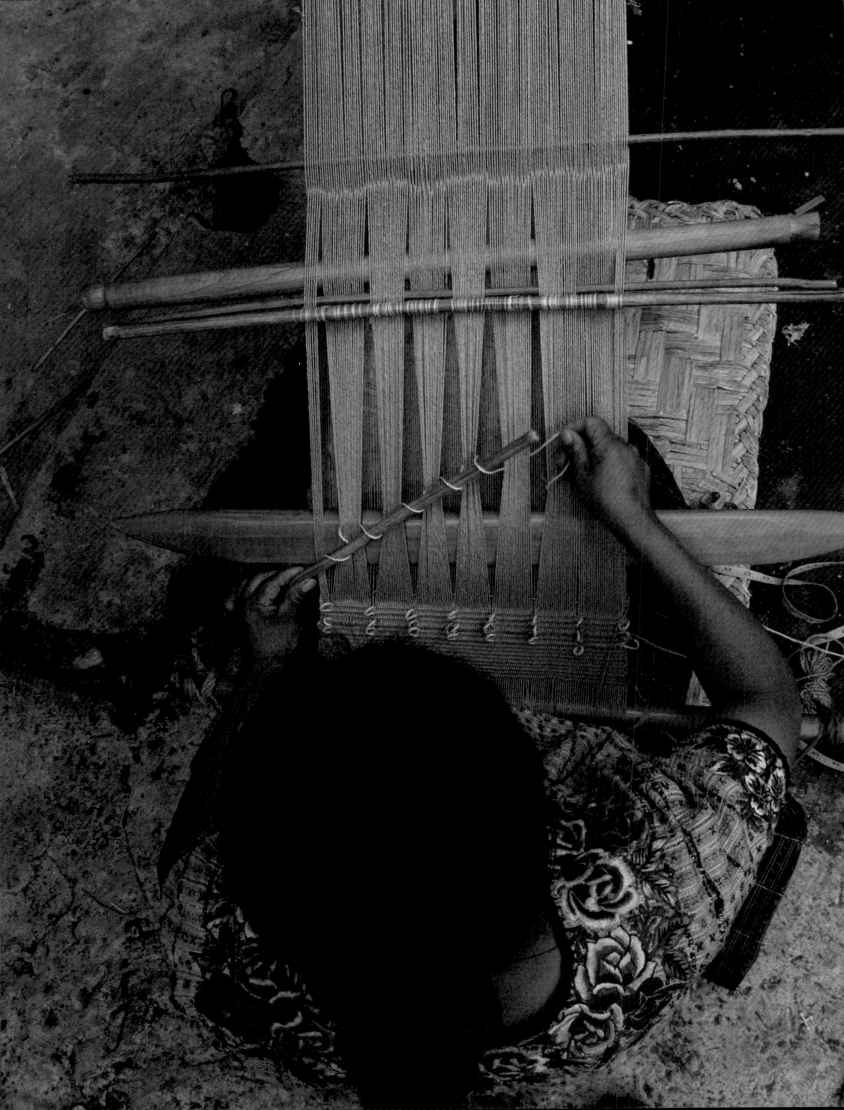

Practical Beauty

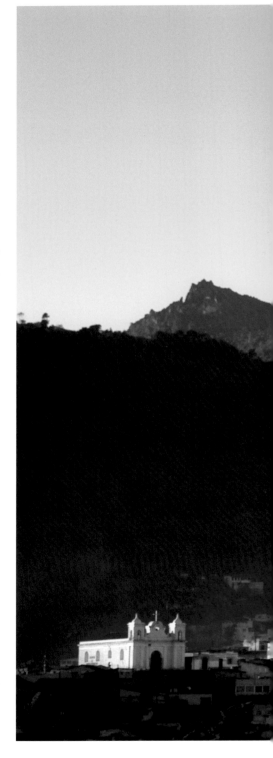

Ceramicist Bertha Lauriana Baneno rests in her patio surveying the day's work surrounding her: oversized pots and platters, rotund pitchers, spaceship-shaped bowls. After drying for a day in the sun and before being fired in her kiln, each piece of pottery will be glazed the traditional glossy, golden-green color echoing the rolling terrain of Guatemala's highland region above the city of Totonicapán. Sharing her patio is a scattered pile of freshly picked frijoles (beans) in their light-green pods that are also beginning to harden in the day's heat. Once dried, shucked and cooked, Bertha will have nutritious beans and an array of homemade dishes in which to serve them. That is, if they are not all sold first.

When Bertha's husband was alive, he was the one who dug deep into the nearby hillside, extracting its pliant, rich, brown clay – the foundation of their hand-wrought wares – the sole source of income for his family of eight. After he died, Bertha had no one to supply her with clay so that she could provide for her two daughters still living at home. Though they have become potters like their mother, without clay or money to pay someone to dig for it, the three women could not work or earn an income to support themselves.

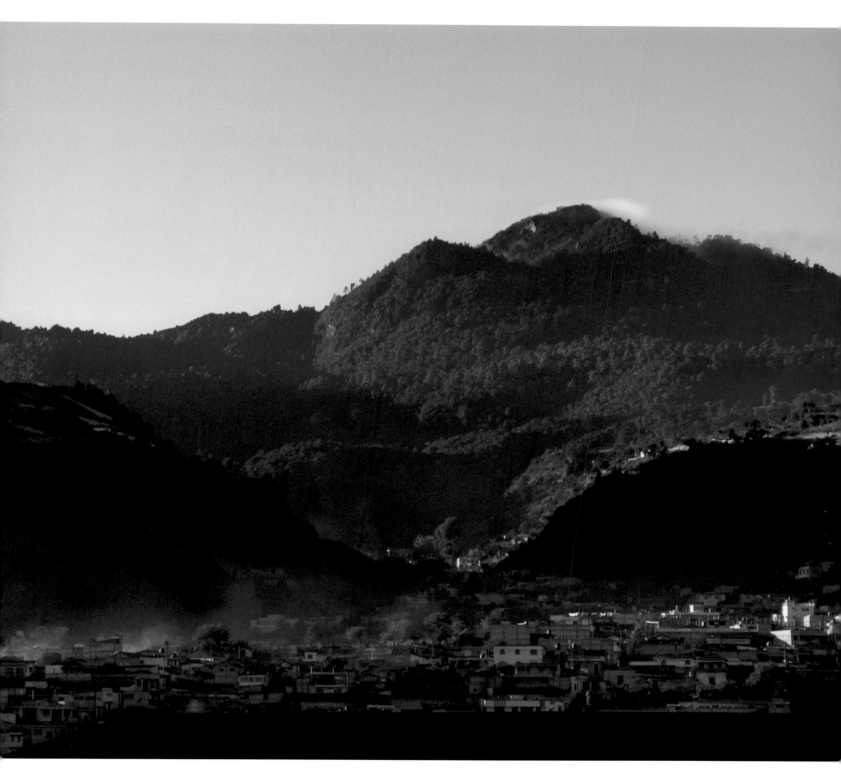

Each of Bertha Lauriana Baneno's
ceramic pieces is made from
clay dug out of the hills above
Totonicapán, Guatemala.

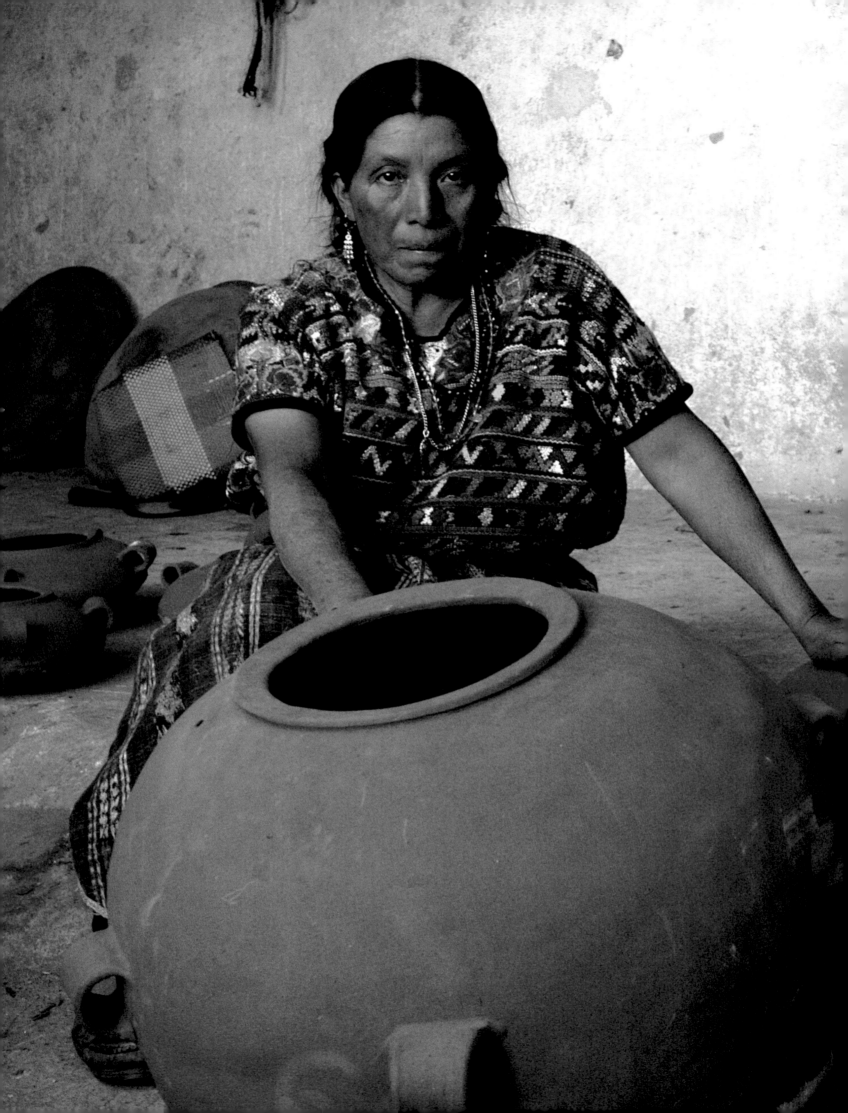

Then, like the taste of sweet corn after an exhausting day, Bertha heard about the Cooperatives for Western Rural Development (CDRO), a community-based development organization committed to helping poor but working individuals with small business loans and training. They offered her a GTQ3900 ($500) collateral-free loan and the opportunity to set up a savings account (10% of each loan) for any emergencies she might encounter. She contacted two friends, also potters, and as a group, they joined CDRO's 3000 borrowers. She immediately hired a day laborer to bring her a steady supply of clay. With the remainder of her loan, she stocked up on glazes. Again Bertha's pottery wheel started to spin.

Their pieces are in such demand, particularly during festivals and holidays, that Bertha and her daughters contracted with a market vendor who purchases their ceramics wholesale as fast as they complete them. And each morning, as soon as she rises, Bertha unlocks her patio gate. That way, the constant flow of local customers has easy access to her beautiful and practical works of art.

Bertha spent her entire life living hand to mouth. Now, for the first time, she has some savings held in a secure place; financial security is a luxury that most poor individuals never know. "I plan on applying for another loan as soon as I've paid this one off, " she says. If her business keeps growing at its current rate, there is no question that Bertha will need another loan, followed by another, just to keep her customers happy.

Bertha spent her entire life raising her family hand to mouth. With help from CDRO, a community-based development organization in Guatemala, she now has crucial access to small business loans so that she can pay someone to dig in the surrounding hills for clay, the essential ingredient for her pots and her livelihood. And for the first time in her life, Bertha has some savings and a secure place to keep them.

Threads of Life

SWISH — THE SHUTTLE'S FLIGHT through the tunnel of taut black threads is swift and precise. Click – the lanzadera (wooden batten) is pulled close, securing row after row of green thread to the growing cloth. Swish. Click. After 14 passes and without a pause, the green shuttle is deftly replaced by shuttles of red, then blue, then turquoise, creating a rainbow of color on a black sky of thread. After fifteen minutes, Rosa leans back to take a break.

A shaft of light from a two by two-foot window illuminates Rosa and her fastidious work. This fifteen year-old daughter of master weavers, Theresa and Santos Augustin, muses about a future weaving she has on her mind.

Rosa comes by her ambition naturally. Her parents are driven, devoted and forward thinking too. In 1992, Teresa Augustin applied for a GTQ989 ($125) loan from Cooperatives for Western Rural Development (CDRO). Borrowing eleven loans over eleven years, the most recent GTQ7912 ($1000), Teresa has purchased ever-increasing quantities and higher quality hilo (thread). Profits that Santos, their two oldest children, Rosa and Manuela, and she have earned from selling their brilliantly colored rebosos (shawls) have yielded a kaleidoscope of changes for the family.

Santos first invested GTQ1582 ($200) in a plot of land on which he now plants enough maize to feed his family of six for six months. And the family now earns enough income to eat a nutritious, balanced diet of vegetables and fruit on a daily basis. On special occasions and when sales have been particularly good, they treat themselves to meat.

The children have reaped lifelong benefits from their mother's loans. "I like studying everything," Rosa announces. Her sister, Manuela and younger brother, Isaias, nod in agreement. While the children are being trained as weavers, after completing high school and perhaps college, each plans to seek non-traditional work outside the cramped home where their family's two looms and two beds are housed. "I'm going to be a professional!" Rosa exclaims, radiating a sense of confidence and certainty as bright as the weaving before her.

Such a goal is one that Teresa and Santos could never have conceived of for themselves. But, as if threads of cotton could turn to gold, their children have already begun to weave designs for their lives dazzling with possibility.

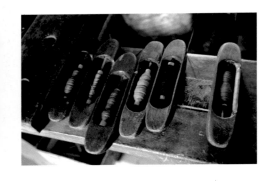

Although Rosa has been taught to be an expert weaver of Guatemalan rebosos (shawls) by her parents, ever since they were able to afford to send her to school she has set her sights on a different future. "I'm going to be a professional!" she declares.

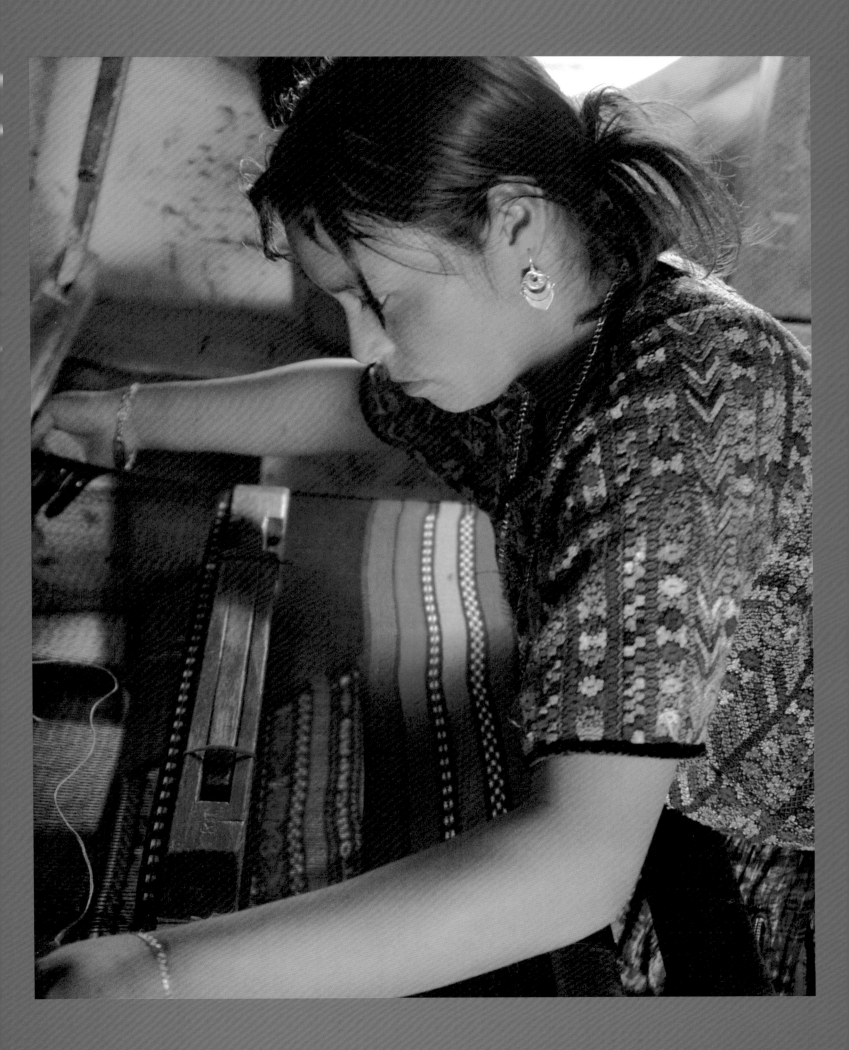

Life Between a Rock and a Hard Place

As THE SUN begins to rise, Gaspard Quieju Mendoza climbs into his hand-carved boat, kneels on a cushion of dried cornhusks and pushes off. He paddles towards a dense grove of tule reeds growing along the privately owned shoreline of volcano-ringed Lake Atitlan.

Gaspard is a fortunate man. Until today he has been prohibited from entering these waters. But his wife, Magdalena Mesia, just used her most recent GTQ1320 ($165) microloan from Friendship Bridge to buy the rights to harvest reeds from this area that is thick with growth. She is an expert weaver of petates (reed mats). Soon she will need more reeds to keep up with the ever-growing market she has developed for her magic carpets.

Though illiterate, Magdalena and her husband chose their dual-career well. Petates are found in every Guatemalan home where people cook, eat, work, study, sit or sleep on the floor. A family of six owns an average of three mats. Each large mat, which serves as a double bed, fetches GTQ15 ($1.90), while small mats used for sitting cost GTQ3 ($.40). If one of Magdalena's mats is well taken care of, it will last between 10 months and a year; if not, or if the mat is not made as meticulously as Magdalena's are, it will last just six months. There is a constant demand for petates, Magdalena's in particular.

At home, Gaspard's family is preparing for another busy day. Magdalena straightens the single bed she shares with her husband and wakens her five children lying here and there on the floor, each atop one of their mother's cushy, hand-crafted petates. The children select something to wear from the few items of clothing hanging from nails on the wall. Magdalena heads outside to her lean-to kitchen. She lights a criss-crossed pile of sticks in the rock fire-pit, fills a blackened pot with water from a recently installed tap and puts it on to boil.

Her three sons emerge from the house, turn on the tap, and wash their faces at the ridged stone sink their mother now uses – instead of the lake – to wash clothes. Magdalena's youngest son looks longingly at his school-aged brothers who are readying their school books and supplies. One of them has reached 8th grade, an extraordinary accomplishment among the indigenous Tztujil people where 80% of the population is illiterate. As a borrower who consistently pays back each 6-month loan, plus 10% interest, and contributes 10% of each loan to a savings plan, Magdalena has been

Opposite: Magdalena uses her hands and feet, a rock and the hard concrete floor of her one-room home to create expertly wrought petates (reed mats), an item found in every Guatemalan home where people cook, eat, work, study, sit or sleep on the floor.

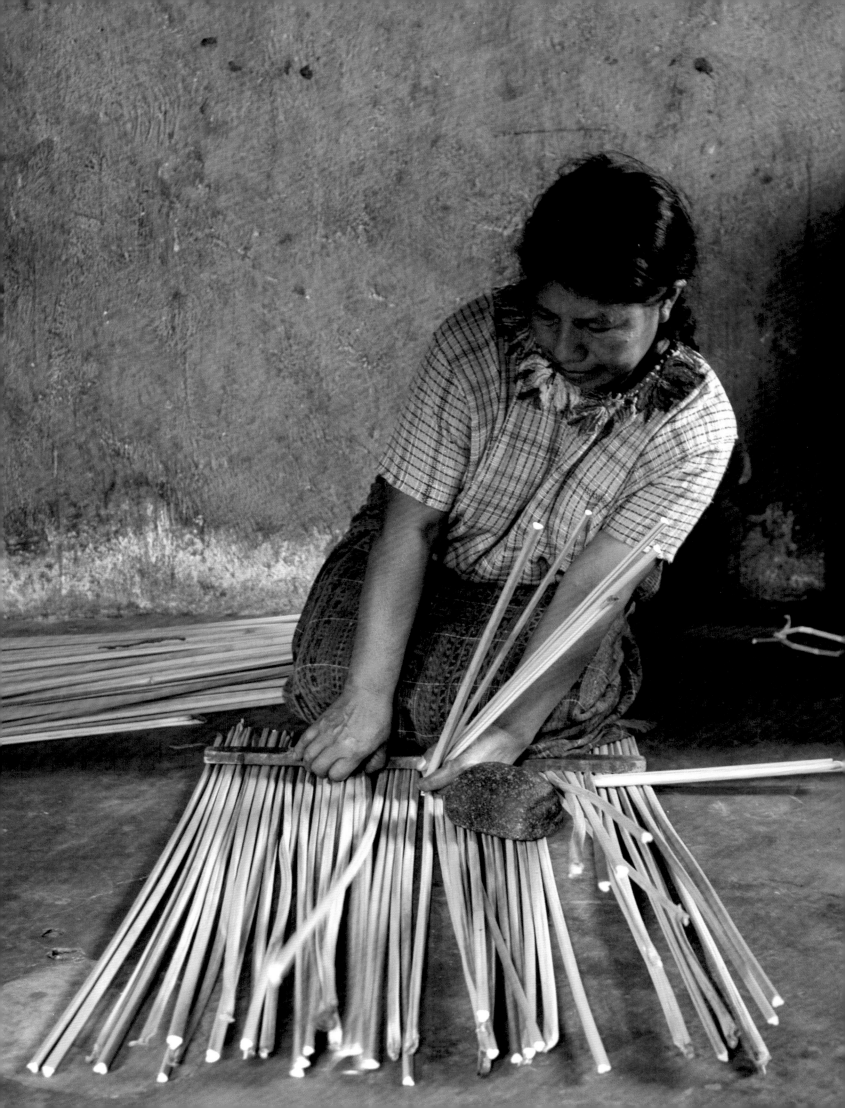

Gaspard, Magdalena's husband and business partner, uses her loans from Friendship Bridge to buy the rights to harvest reeds from a private portion of Lake Atitlan.

awarded education grants from Friendship Bridge for each of her school-age children.

As soon as she's dressed, Andrea, Magdalena's daughter, helps prepare and serve the morning porridge. Her older sister Maria appears last. After eating breakfast, the boys head off to school and Maria departs for work. Inspired by her mother's success, Maria approached Friendship Bridge for a loan to start her own small business. She exhibited such potential during her interview that Friendship Bridge offered her a job assisting borrowers. While she readily accepted the position, it was not enough for someone with her inherited ambition. Maria enrolled in adult school, beginning at the 4th grade level, and plans to increase her skills so that she can advance in the organization.

Out on the lake, Gaspard is enveloped by a water-born forest. It doesn't take him long to fill his boat with tall, healthy stalks. On his way back to shore he glides past groups of women scrubbing clothes on the rocks at the water's edge. Dressed in their brilliantly colored, embroidered huipils (blouses), the women resemble a glorious garden of Spring flowers bending back and forth in the day's gentle breeze. After docking his boat, he hoists the heavy load onto his shoulder, carries it up the steep hillside and fans the reeds out to dry in his dirt backyard.

Gaspard and his wife exchange smiles as they survey his latest haul. Magdalena hands him a bowl of porridge, takes a load of dried reeds into her arms and enters the house where Andrea is preparing her own workspace. She pushes a low-lying table close to the room's only window. Settling into a child-size chair, Andrea pulls out various packets of multi-colored beads and arranges them by color into piles on the table. Today she plans to complete a purse with a zigzag pattern of iridescent purple and red beads. If there's time, she'll start on a green, silver and black beaded cuff bracelet. She lays out some of her completed pieces too, ready for any customer who might stop by, rather than waiting to purchase a piece from her on market day. Like her mother's, Andrea's business has been so lucrative that she has already received and repaid three loans.

No longer does Magdelana have to wash clothes at the bottom of the cliff in the waters of Lake Atitlan; she now has running water and a sink right outside her one-room home.

Magdalena sets down her load and kneels down on the floor next to her daughter. Selecting two handfuls of reeds, she places them in front of her at right angles. Using only her hands, her feet, a rock and the concrete floor of her family's one room house, she quickly transfers one group of reeds over and then under the other, carefully pushing each completed row down, straight and flat with a heavy rock. One of her bare feet holds the emerging petate in place until she has securely tucked in the ends of each reed on all four sides. She weaves mat after mat until every reed has been used.

Tomorrow the stack of petates will be sold for a profit by Magdalena – entrepreneur, financial provider, devoted mother, role model – to families living in Santiago and other villages dotting the shores of Lake Atitlan.

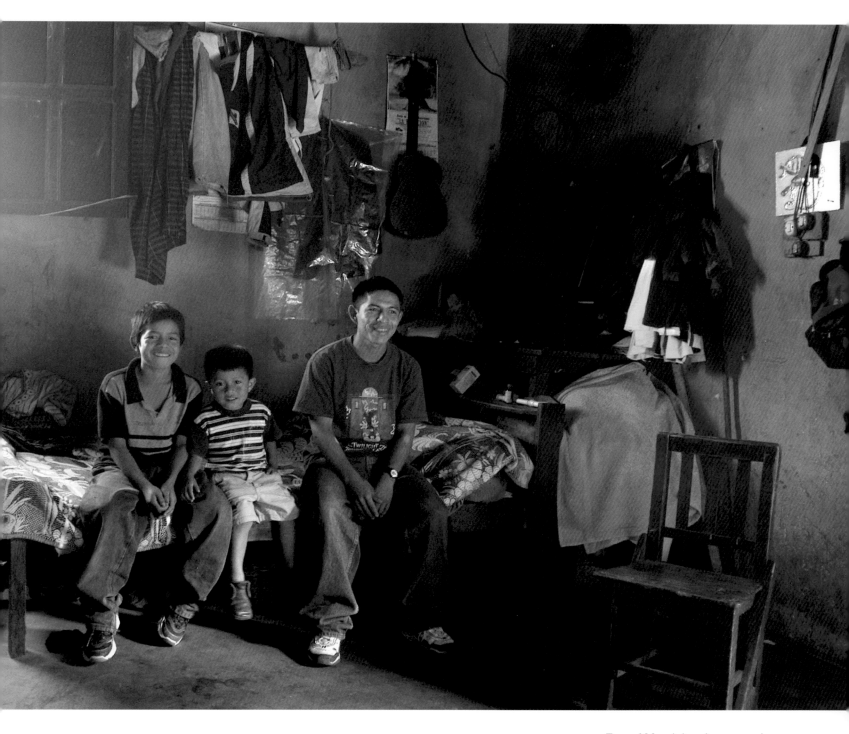

Two of Magdalena's sons and a grown daughter are in school. One son has reached the 8th grade, an extraordinary accomplishment among the indigenous Tztujil people where 80% of the population, including Magdalena and her husband, is illiterate.

SOUTH AMERICA

Bolívia

DEMOGRAPHICS AND ECONOMICS

Total Population (2004)	9,009,000
Gross National Income per capita (2004)	$960
Population below Poverty Line (2004)*	64%
Health	
Fertility Rate (2004)	3.8
Maternal Mortality Ratio, (1990-2004), reported	230 (per 100,000 live births)
Annual Number of Under-5 Deaths (2004)	18,000
Life Expectancy at Birth (2004)	64 years
Orphans, Children (0-17) Orphaned by AIDS and other causes, (2003), estimate	340,000
HIV Prevalence: estimated number of people living with HIV, adults and children, 0-49 years, (2003)	4,900
Immunization of 1-year-old children (2004)	79% polio; 64% measles
Population using improved drinking water sources (2002)	68% rural; 95% urban
Population using adequate sanitation facilities (2002)	23% rural; 58% urban
Education	
Primary School Attendance Rate (2000-2004)	77% female; 78% male
Secondary School Attendance Rate (2000-2004)	56% female; 57% male
Total Adult Literacy Rate (2000-2004)	87%

Staircase
to the Top

It is 9:15AM in El Alto, Bolivia, an impoverished city inhabited by a predominately rural-gone-urban population of indigenous Bolivianos. Women with traditional, ankle-length polleras (skirts) draped over their rotund hips, hand-woven shawls wrapped around their square shoulders, and bowler hats balanced on their heads, begin filing through the front door of Pro Mujer's central office building on the city's torn-up main street. A symphony of female voices fills the staircase as the women make their way up to one of the office's four floors. By 9:30am the halls are empty; the microentrepreneurs are engrossed in meetings covering a variety of business and personal matters.

It's payday on the first floor. Members of one of Pro Mujer's communal banks are huddled in groups of three to five around wooden tables in a sun-dappled room. Coins clatter and bills are shuffled as each borrower counts out the principal plus interest she owes today. Before long, the sounds of soft laughter, conversation and a fast-paced click-click-click of knitting needles join the room's chorus as the women catch up on each other's lives while they loop, weave and pull yarn taut, adding row upon precise row to a child's sweater or a colorful shawl.

It takes just half an hour for each group's treasurer to collect, record and tally her members' payments. Today marks yet another success for this communal bank – everyone's biweekly loan has been paid on time and in full. It's no wonder that Pro Mujer claims a 98% loan payback rate by its 100,000+ borrowers throughout Mexico and South America, whether

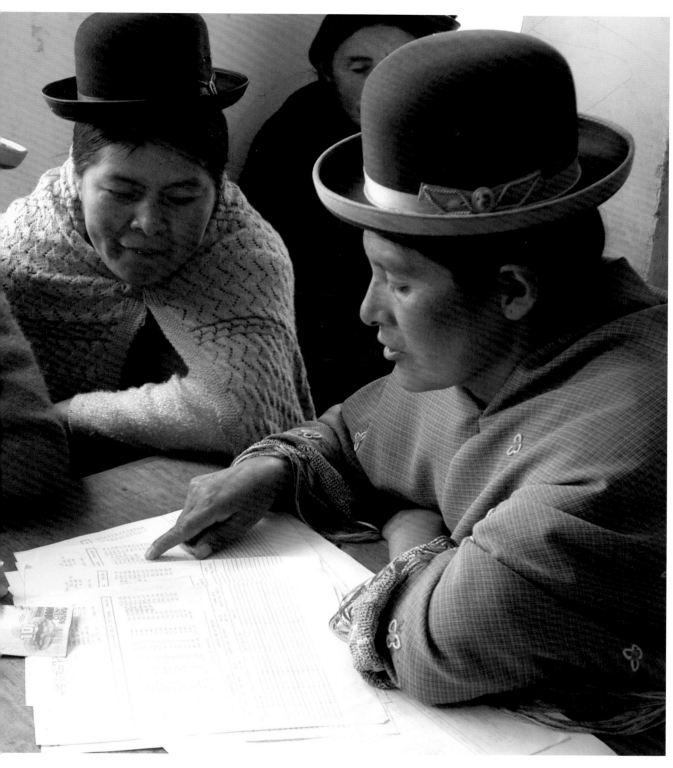

they're paying off a BOB400 ($50) or a BOB12,792($1600) loan.

Gathering up their knitting needles and balls of yarn, the women head to the second floor. They will exchange places with clients who have been involved in what Pro Mujer considers a key component of their clients' financial stability and happiness – compulsory health training focused on both their physical and mental well-being.

White-coated nurse Victoria Carvajal Huanca paces up and down the length of a second-story room between two rows of women, some holding children on their laps, others whose hair is streaked with gray. "If your husband hits you when you are pregnant," she declares matter-of-factly,

It's payday, so members of one of Pro Mujer's communal banks calculate the principal plus interest they each owe before the treasurer records the payments in the group's ledger.

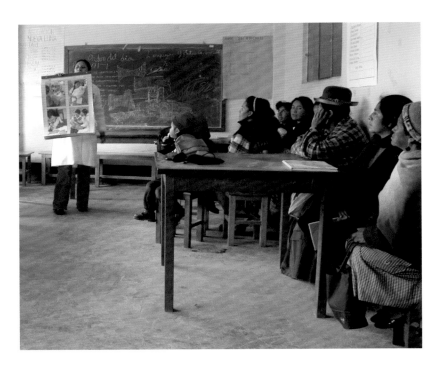

Because many of Pro Mujer's borrowers are illiterate, the medical staff uses photos and demonstrations to teach courses in nutrition, family planning, HIV/AIDS prevention, and other health-related issues.

"your baby won't be safe," A few women look down, while others sit up and listen attentively.

"You should not drink alcohol when you're pregnant; it's not good for your baby," she goes on. "If you have HIV/AIDS, you could transmit unhealthy microbes to your baby, causing it to go blind." One woman who is spinning loose wool into yarn stops her spindle in mid-air, but does not speak. She knows that the medical staff is always available to discuss any matter – privately and confidentially.

Moving to the topic of infant care, Nurse Huanca begins, "If you have a premature baby, it needs to be kept warm in order to develop properly." Putting her arm inside her coat to simulate a child, she continues, "Carry your baby under your shirt, sweater or jacket just like a kangaroo." With great emphasis she adds, "Your husbands need to do this too!" The women laugh, enthusiastically nodding in agreement.

Unfurling a poster of photos, she points to one of a nursing baby. "Why is it important for your baby to drink your milk?"

"Because it is healthy for the baby's growth," one woman volunteers.

"Yes, and it's cheap!" Nurse Huanca exclaims, knowing how money drives every decision these very poor women make.

Pointing to a photo of a baby in a shallow tub of water she goes on, "Make sure to wash your baby regularly so it will not become ill. And to avoid eye infections, wipe your baby's eyes from the inside out." Taking a corner of her lab-coat, the nurse demonstrates by wiping her eye from the bridge of her nose out to her temple. Her audience winces at the sight of the next photo. "If its eyes look anything like this," she says, displaying a picture of an infected eye, "you must bring your baby to our clinic or take it to a hospital. Then it can be treated and cured."

Down the hall, Dr. Maria Teresa Ruiz is in Pro Mujer's clinic attending to an array of clients' needs. After administering a cancer screening to one woman, she treats another borrower's child for diarrhea. Next, she assesses the development of a woman's pregnancy while discussing proper nutrition to ensure the health of both the mother-to-be and her newborn. It doesn't take Dr. Ruiz long to realize that her next patient has medical issues beyond the capabilities of the clinic. Fortunately, Pro Muter has financial arrangements with local hospitals and clinics that provide optimal care at reduced rates for borrowers and their families. Dr. Ruiz refers her patient to

a specialist, assuring her that her care will be safe and affordable.

On the floor above, Martha A. Ramos Munoz, one of Pro Mujer's credit assistants, leads the women of *Flor Boliviano*, a well-established communal bank of bakers, knitters, sweets and furniture sellers, macramé weavers and chicken raisers, in a lively discussion about how and where to more effectively market their businesses. In the depressed local economy of El Alto, they are not making the financial gains they want and need.

"We haven't tried hard enough to sell our goods to tourists," offers one.

"Maybe we could ask some hotels to carry our things in their shops," suggests another.

"I wonder how we talk with the hotels?"

Two knitters begin an animated side conversation. "Yes, we could start with children's sweaters and see how that goes!"

There is a bustle of activity on the fourth floor as well. Inside a bright room, curtained to keep out the sun's penetrating rays, a young woman, her lips pursed in deep concentration, is trying unsuccessfully to force layers of fabric past a sewing machine's bobbing needle. Her sewing teacher, Adelaida Quisberth, puts her hands next to her student's and together they guide the fabric under the needle in a clean, straight line. Seeing the result, the student's face and shoulders relax; she turns the fabric around, and begins sewing the next seam all on her own.

A group of women have decided that it's well worth the BOB37 ($4.50) it costs to receive sewing classes from Pro Mujer. Once they have completed the course, they'll be equipped to open sewing businesses of their own.

Adelaida moves on to her other three students, advising them on how to pin a seam, push a needle through a series of miniscule tucks and sew a contrasting border onto a skirt's hem. Pro Mujer clients find the BOB37 ($4.50) cost for a series of classes well worth it; when they're finished, they'll be equipped to open a sewing business of their own. Then, like the women on the floors below, they'll be able to better feed, clothe, house and educate their children.

At 10:30am, the stairway is again overflowing with women. This time however, they're heading down the stairs and out the door. While they may not know what the day will bring, there is one thing these women can be assured of: they are not alone.

Pewter Palace

THE NEAR-VERTICAL HILLSIDES surrounding La Paz, Bolivia seem virtually impossible to climb. Yet the steep slopes are precariously packed with tens of thousands of red brick structures in which many of the city's denizens live and work.

Perched high on one of the hills in the Zona Alto Las Delicias, Florentino Quelca and his son Gustavo, both microcredit borrowers of BancoSol, are discussing ways to grow their pewter handicraft business both here and abroad.

Today they have a full agenda:

1. *Sales manager (Florentino's oldest daughter) attendance at the upcoming trade fair in Chile – continue developing a niche market there*
2. *Continue research into business potential in Argentina, Venezuela and Peru*
3. *Current BancoSol loan expenditures – BOB3000 ($360):*
 a. *additional tools*
 b. *raw materials for producing pewter (tin, silver, antimony)*
 c. *onyx (to increase profitable new product line combining onyx and pewter)*
4. *Education expenditures: BOB16,000 ($1920) per month:*
 a. *Gustavo – 1 more year of college (International Trade)*
 b. *Brother – 2 more years of college (Electrical Engineering)*
 c. *Sister – 4 more years of college (Applied Science)*
5. *Savings: continue aggressive savings plan for construction of new factory*

After concluding the meeting, father and son head downstairs to their temporary factory to check on the progress of their seven permanent employees. Gustavo heads back to the finishing rooms where four men, their backs bent over various machines, are trimming, detailing and polishing a current order of pewter candlestick holders. Florentino stops in the first room that is painted a cotton candy pink. He peers over the shoulder of a female employee who is carefully stirring flawed and excess pieces of pewter

Pewter mice are just one of the items Florentino Quelca, his son, Gustavo, and their seven employees make to sell not only in Bolivia, but, thanks to loans from BancoSol, to countries throughout South America.

in a blackened pot over a small flame. As the shards begin to liquefy, she takes a two-sided mold, screws it together and secures it in a vice. Then she slowly ladles some of the molten liquid into the opening at the top of the mold. After counting out 30 seconds, she opens the mold. Inside sits a small metal mouse. With gloved hands, she removes the smiling, large-eared creature and places it on the table to cool. She re-secures the mold, and begins the process once again. Florentino picks up the mouse with a pair of needle-nosed pliers and turns it so that he can thoroughly inspect it from every side. Satisfied, he puts it down before moving to an adjoining table where two other employees are engaged in similarly painstaking steps of the process.

He watches as a second fulltime female employee skillfully solders five flattened clusters of grapes together to form an upright cylinder. She quickly heats the bottom tips of each cluster and then presses them onto a small pewter disk that has been subtly decorated around its outer edge. After waiting a moment to let the solder harden, Florentino picks up a slender cordial glass and places it inside the new holder. It's a perfect fit. Dozens of these holders will eventually go into the back room to be smoothed of any rough edges. After being polished, packed and exported to Chile, Florentino's daughter will market them to retailers at the upcoming trade fair.

The Quelca's pewter factory turns out 120 distinct pieces, including key rings that sell for BOB8 ($.30) each and huge, intricately designed punch bowls that sell for BOB500 ($20).

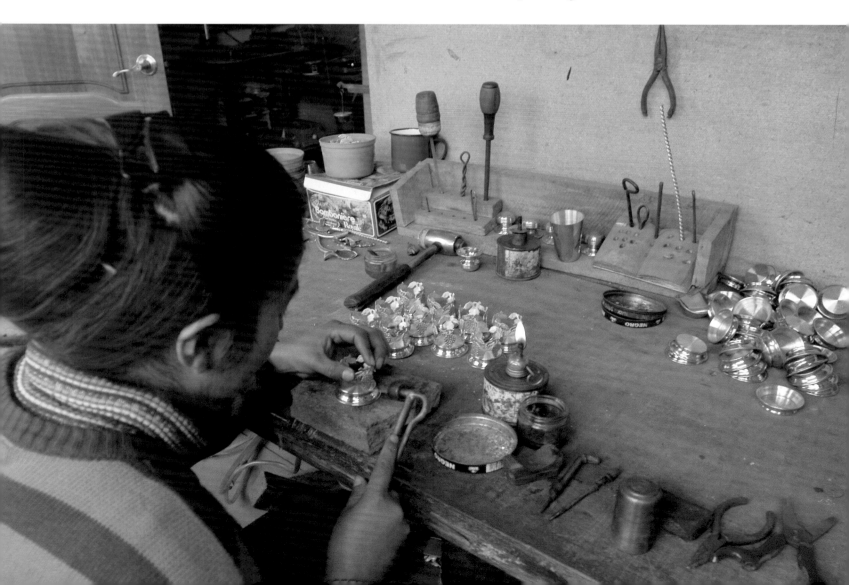

One by one, the hardened mice are transferred to the soldering table. Another employee grasps each with a pair of pliers and turns it upside down. Using a soldering gun, he attaches a pointed pewter stick to the middle of its base. Once packaged in individual plastic bags, these whimsical decorations will fetch BOB25 ($3) apiece.

Gustavo reappears from the back, followed by four employees, and announces lunch. Flames are extinguished, gloves are removed and the group sits down together, as they do everyday, to enjoy a hearty meal prepared by Florentino's wife. Lunch and an afternoon snack are welcome additions to each employee's BOB4153 ($5) per diem salary.

Florentino is committed to quality control. Until fifteen years ago, he struggled to support his family of six by selling Cracker Jacks and other snacks on a street corner in downtown La Paz. One fateful day, he met the world-famous Carlos Shohouse, a master pewter handicraftsman from Germany, who helped Florentino say farewell to the streets.

Initially hired to perform just one of the many processes involved in completing a pewter piece, it soon became obvious that Florentino was gifted in his newfound trade. Carlos rotated him from machine to machine, training him in the particularities of each. He also taught him a multitude of intricate handwork techniques, which have been practiced by craftsmen for hundreds of years, and are required to create pieces of the highest quality. When Carlos retired, he was confident that his trade would continue to flourish; Florentino had developed the passion, commitment and talents necessary to succeed.

Florentino has proven his boss and mentor right. He has nearly tripled his initial working capital of BOB49,850 ($6,000) to BOB141,242($17,000). With his first BancoSol loan of BOB5000 ($600), he launched into the international business arena. And he expanded his offerings to 120 distinct pieces, ranging from a pewter key ring costing BOB8 ($.30) to a beautifully wrought punch bowl selling for BOB500 ($20). Three popular shops in La Paz now carry Florentino's work.

After repaying his initial six-month loan in just two and one-half months, Florentino decided to bring his son Gustavo into the business. Gustavo borrowed BOB3000 ($360) from BancoSol so that the family could introduce a new, and what turned out to be an instantly popular and profitable product line – onyx and pewter pieces, such as a stone crucifix holding a Jesus figure wrought of pewter.

Florentino and Gustavo climb the stairs from their compact workshop that is already crowded with seven permanent employees. During busy times, the shop is packed with up to twenty-two temporary employees. And that does not include Florentino's eldest daughter and sales manager, or his two youngest sons who are working part-time while completing college.

Only one of Florentino's daughters decided to pursue a different career; she is studying to become a college math professor. Their children's level of education is an advantage that neither parent enjoyed; each was forced to drop out after high school because their families couldn't afford the fees.

The two men stand together on a vast concrete floor that is bare except for the 24-foot high brick walls around its periphery. Stomping his foot on the floor as if to prove its solidity, Florentino explains, "This is the base of our three-story factory where 50 employees will eventually work. We're going to build a showroom at street level and a small apartment on the top floor where a fulltime security guard will live."

He and Gustavo walk over to an opening in a wall where a window will eventually be installed, and gaze out over the city sprawling above, below and alongside them. "It was a blessing meeting Carlos," says Florentino. "And even though the international competition is fierce, with our loans, we are building a business throughout Latin America."

A business, like the sky overhead, immense with opportunity for his family, his employees and their families. And a boon for customers who adorn their homes with one or more of Florentino's meticulously crafted, creative items, such as a hand-made pewter mouse to perch atop a thick wedge of queso.

The Quelca family has gone far since their initial BancoSol loan of BOB5000 ($600). The sides of their new factory have been constructed, they have expanded their product line, launched into the international market, hired seven fulltime employees, and are paying for three college educations.

Hat of a Different Color

A group of elderly women clad in Bolivia's traditional bowler hats, ankle-length skirts and hand-knit wool shawls sit in a loose circle on the grass, just like they have once every two weeks for the past 15 years, waiting for their CRECER borrowers' meeting to begin.

A GROUP OF ELDERLY WOMEN clad in Bolivia's traditional bowler hats, ankle-length skirts and hand-knit wool shawls sit in a loose circle on the grass, just like they have once every two weeks for the past 15 years. Through the garden gate hurries a much younger looking woman sporting a blue denim hat with the letters 'LA' embroidered on the front. Everyone smiles at the site of Fabiola as she takes her place on a colorful mantilla (blanket) and pulls out the group's loan payment ledger.

"There were customers at the store and I was the only one there to help them," she explains. Just as Fabiola had been locking up, four young girls wearing white cotton smocks over their dresses had scrambled into her family's 8' x 10' snack shop eager for an after-school treat. Scanning the candies displayed on a small wooden table, they had each settled on one, popped them into their mouths, paid Fatima a 10 centavo coin each and bounded out the door, their shiny black ponytails bouncing against their backs.

Fabiola Suxo was not much older than these girls when at age 13 she became the youngest member of "Ahorro y Credito" (Credit and Savings), one of Crédito con Educación Rural's (CRECER) solidarity groups in Janko Amaya, an impoverished rural community situated between Lake Titicaca and the country's capital, La Paz, Bolivia. Eleven years ago, Fabiola's mother realized that despite her dependence on CRECER to expand her family's businesses and raise seven children, she was too tired and busy to maintain her commitment to the group. So she asked her group members if Fabiola could take her place. The women welcomed this eager teen. She was sweet, mature for her age, and had something that the group needed: the ability to read and write. They have continued to employ her skills to this day.

One by one, the women pass Fabiola their loan payments. With the help of the group's elected president and secretary, she recounts and records the amount next to each borrower's name. As usual, every member has paid her principal plus interest in full.

Now is the time for feasting. The women begin by hoisting brightly colored cloth-covered bundles into the middle of their circle and untie them one-by-one. Inside are mounds of homegrown potatoes in every color and size: yellow, red and black, skinny, long and round. A pile of fresh, pale-green broad beans is also unveiled and added to the organic array, well within everyone's reach. Finally, a small package is unwrapped revealing a bowl filled with 3-inch long, salted fish in oil. These delicacies never make it to the center of the group; they are passed around and devoured whole from head to tail. The women wash down their banquet with sodas brought by Fabiola.

Now 24, Fabiola has spent the past 11 years balancing her time between her studies, her family's store, helping raise six siblings, and borrowing, managing and repaying larger and larger loans for the family's four businesses.

Fabiola's family was able to use profits to build a new, more expensive, two-story home. The first level is made of mud bricks, while the top floor, more visible to neighbors, is faced with a more aesthetically pleasing, pricey brick.

Her father now operates the family's most profitable enterprise, cattle trading, which nets BOB300 ($37) per head. He keeps a few cows whose milk and meat he both sells and uses to feed his family. The family also purchases large volumes of local potatoes for resale in La Paz, and they receive additional income from selling irrigation hoses to local farmers. When Fabiola's mother isn't working at the store, she's busy at their new house cooking protein-rich quinoa, vegetables, chicken, beef, and on special occasions, pork for her nine-member family. Typical of the roomy, more expensive two-story homes in the area, and which cost them BOB19,780 ($2500) to construct, the first level is made of mud-bricks, while the top floor, which is more visible to neighbors and passers-by, is faced with a more aesthetically pleasing, pricey brick. The Suxo's house is especially quiet each weekday because all the children, except for Fabiola, are attending school, an opportunity neither of their parents ever had.

Fabiola was a very enthusiastic student, but when family finances got stretched too thin, her parents had to ask her to drop out of school. They needed her to work fulltime at the store. Even with their four-business income, they didn't earn enough to cover the expenses for food, schooling (Fabiola's being the most expensive), the new house and occasional medical care. However, with their income on the upswing, Fabiola's life is about to change.

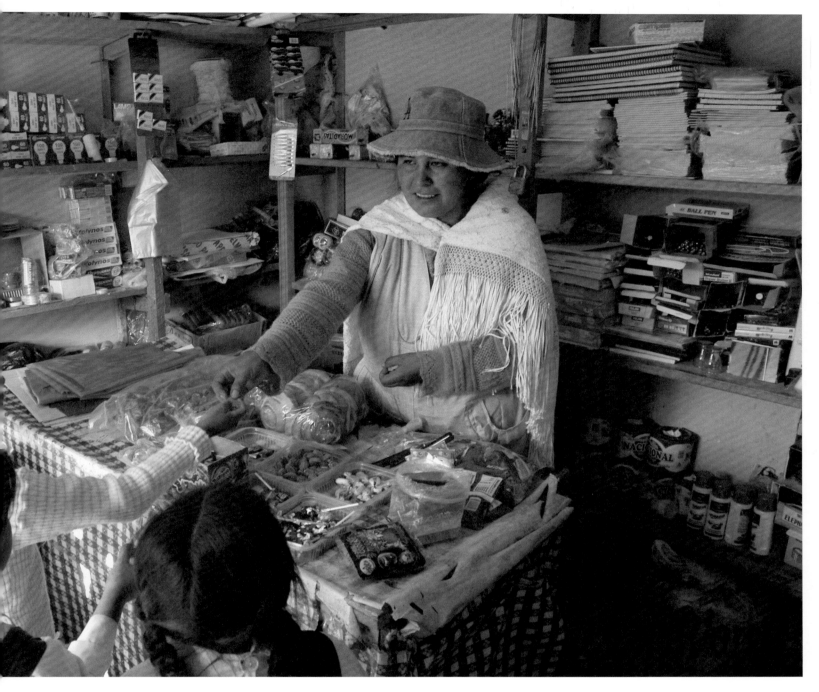

"I'm going to return to school soon. I only have one year to go, but I want an advanced degree which will take two additional years at the university." Fabiola has witnessed firsthand the prevalence of malnourishment, diarrhea and infant mortality due to a lack of medical care in rural Bolivia where 70-80% of the population is impoverished and 50% live on less than $1 per day. "My dream is to be a nurse," she declares. "I don't care how much money I earn, that's what I'm going to do." She pushes back her blue hat, revealing a pair of passion-filled eyes. When her dream comes true, Fabiola will be removing that hat altogether. She'll be exchanging it for a cap, a crisp white one to match her nurse's coat.

Fabiola has spent the past 11 years balancing her time between her studies, her family's store, helping raise six siblings, and as the youngest member of CRECER's solidarity group in Janko Amaya, borrowing, managing and repaying larger and larger loans for her family's four businesses. Her dream is to become a nurse. Now that her family can afford it, she plans to complete school.

Argentína

DEMOGRAPHICS AND ECONOMICS

Total Population (2004)	38,372,000
Gross National Income per capita (2004)	$3720
Population below Poverty Line (2005.)*	38.5%
Health	
Fertility Rate (2004)	2.3
Maternal Mortality Ratio, (1990-2004), reported	44 (per 100,000 live births)
Annual Number of Under-5 Deaths (2004)	12,000
Life Expectancy at Birth (2004)	75 years
Orphans, Children (0-17) Orphaned by AIDS and other causes, (2003), estimate	750,000
HIV Prevalence: estimated number of people living with HIV, adults and children, 0-49 years, (2003)	130,000
Immunization of 1-year-old children (2004)	95% polio; 95% measles
Population using improved drinking water sources (2002)	No data rural; 97% urban
Population using adequate sanitation facilities (2002)	No data
Education	
Primary School Attendance Rate (2000-2004)	No data
Secondary School Enrollment Rate (2000-2004)	84% female; 79% male
Total Adult Literacy Rate (2000-2004)	97%

Family Toy Chest

MONICA PESCARMONA SMILES with anticipation as she drives along tree-lined streets, past gated homes, manicured lawns and modern shopping malls. Even fall's bone-chilling air and overcast sky can't take away from the subtle elegance of Mendoza, a city in the middle of Argentina's prime wine-growing region.

Just past the intersection at the corner of Mendoza's largest park, however, Monica's surroundings make an abupt and dramatic shift. Trees all but disappear. The smooth pavement below Monica's tires turns to mud and potholes filled with last night's rain. Homes are constructed of cinderblock, rough-hewn logs, corrugated tin and sheets of plywood hanging at odd angles. Only a very few houses are made of brick, and these stand protected behind locked metal gates. What is most startling is the trash. As if the community has been built in the middle of a dump, rusting appliances, broken bottles, torn mattresses, soggy cardboard boxes and old clothes lie strewn in chaotic heaps around almost every home.

After sloshing her way around several unmarked streets of Barrio La Favorita, Monica, founder of the Grameen Mendoza Foundation, finally finds her way to *C Chile Lot E94*. Two boys wearing royal blue sweat suits, a woman holding a baby girl and a pleasant-faced man all smile as she approaches. Leo and his wife Marisa welcome her into their unkempt front yard, graced only by a few grey-green shrubs and a leafless tree. She enters through a wooden gate, though it would be just as easy to step over the sagging wire fence.

Leo's peach pit carts fetch ARS12-18 ($4-6) apiece. With loans from Grameen Mendoza, he has purchased more tools so that he can begin making furniture that will yield far greater returns.

Opposite: Using peach pits which he gets for free from the local cannery, Leo painstakingly crafts tiny toys which he sells in markets throughout Mendoza, Argentina. His profits have sent his wife back to nursing school and his three sons to private school.

While the family strides confidently along the side of the house on the way to Leo's workshop, Monica must walk gingerly in order to avoid tripping over the menacing piles of garbage in her path. She only looks up when she notices a brick structure between their house and the next — it's the outhouse the family shares with Leo's parents, who live next door.

Leo's workshop is loosely attached to the back of his house, and has been constructed with a mishmash of materials. Its back wall is cinder block, the left wall is brick and mortar, while the right and front walls are a combination of peeling wallboard, various pieces of plywood and sheets of hard plastic. The tin roof is battened down with a few rusty metal poles. While there is a door, it leans unhinged against an outside wall. Like a vacuum, the shop sucks in gusts of cold wind that scatters litter and sawdust across the dirt floor. Inside, two worktables are crowded with tools, partially completed handicrafts and various supplies. "As soon as I can, I'm going to rebuild my shop," Leo reports. "But first, we decided to pay for Marisa to finish nursing school so she could go to work."

"With my ARS640 ($210) monthly salary from the hospital and Leo's ARS400 ($150) income selling his toys, we're now sending our three boys to private school," Marisa chimes in.

Leo picks up ten peach pits, which he gets for free from the local cannery, from one of the crudely constructed tables and walks over to a sanding machine. "I used to sell small toys for someone else. But my Grameen Mendoza loans changed all that. Now I make my own toys to sell. This was the only machine I owned until I became a borrower." He turns on the sander, sands one side of each pit smooth and then returns to his workbench.

Pouring thick glue out of a plastic Sprite bottle, he dabs the edges of five pits, glues them together in a circular pattern resembling a wheel, and attaches them to the side of a small, wooden horse-drawn cart he has built. He repeats the process with the other five pits. While the wheels dry, Leo painstakingly cuts tiny strips of leather and fashions them into a bridle and reins that he glues around the muzzle of a horse, which is also fashioned from peach pits. He then glues the ends of the reins to the hands of a peach pit man sitting on the cart. Finally, he cuts a rectangle of leather and glues it in an arc over a tiny pile of twigs in the back of the cart. He'll repeat the twenty-step process again and again before selling his toys in bulk for ARS12-18 ($4-6) apiece, depending on the vendor. Leo earns ARS9-12 ($3-4) for each of his card players and guitarists, also made from peach pits, and ARS6 ($2) for his peach pit mice.

Holding her one year-old daughter in one arm, Marisa uses her free hand to place a range of electrical drills next to a small table saw for Monica to see. "Leo purchased these tools with his loans. He's begun making light

fixtures," she says, holding up a wooden box with designs cut out of each side.

"Soon I'm going to start making tables," Leo adds. "And I'm ready to hire an employee to help me."

"So you know how to build furniture, too?" Monica asks.

"I'm going to learn," Leo responds. "I had to leave school when I was 12 to help my father build houses, so I know how to build things."

Leo ushers Monica to the front of the house. "I built this house," he says. "But I didn't have the money to finish it until recently. Come inside and I'll show you what we've been able to do." Their one-room home is divided into three sections. To the left of the door is a large bed with a bunk bed next to it. On the right are a table, a few plastic chairs, and a T.V. sitting on a shelf against the far right wall. Open shelving above a countertop divides the sitting area from a small kitchen where there is a sink, a stove and two old refrigerators. Straight ahead is a fireplace.

"I recently finished it," says Leo. "Now we have heat." Pointing to one of the walls, he adds, " And I was able to seal the bricks so cold air can't seep through our walls anymore." Monica smiles at Leo as she ticks off in her mind all the improvements this ambitious family has made.

Marisa hands their baby daughter to Leo. "It's time to go to work," she says. The boys come inside, put down the soccer ball they've been playing with, and pick up their school backpacks.

"We consider education a long-term investment," Leonardo Javier Arce says as he watches his family walk out the gate.

Leo's family now stays warm; with a portion of his income he purchased materials to build a fireplace. He also bought sealant to cover the brick walls, thus preventing winter's frigid air from seeping in.

Chile

DEMOGRAPHICS AND ECONOMICS

Total Population (2004)	1,6124,000
Gross National Income per capita (2004)	$4910
Population below Poverty Line (2005) estimate*	18.2%
Health	
Fertility Rate (2004)	2
Maternal Mortality Ratio, (1990-2004), reported	17 (per 100,000 live births)
Annual Number of Under-5 Deaths (2004)	2000
Life Expectancy at Birth (2004)	78 years
Orphans, Children (0-17) Orphaned by AIDS and other causes, (2003), estimate	230,000
HIV Prevalence: estimated number of people living with HIV, adults and children, 0-49 years, (2003)	26,000
Immunization of 1-year-old children (2004)	94% polio; 95% measles
Population using improved drinking water sources (2002)	59% rural; 100 urban
Population using adequate sanitation facilities (2002)	64% rural; 96% urban
Education	
Primary School Enrollment Rate (2000-2004)	84% female; 85% male
Secondary School Enrollment Rate (2000-2004)	81% female; 80% male
Total Adult Literacy Rate (2000-2004)	96%

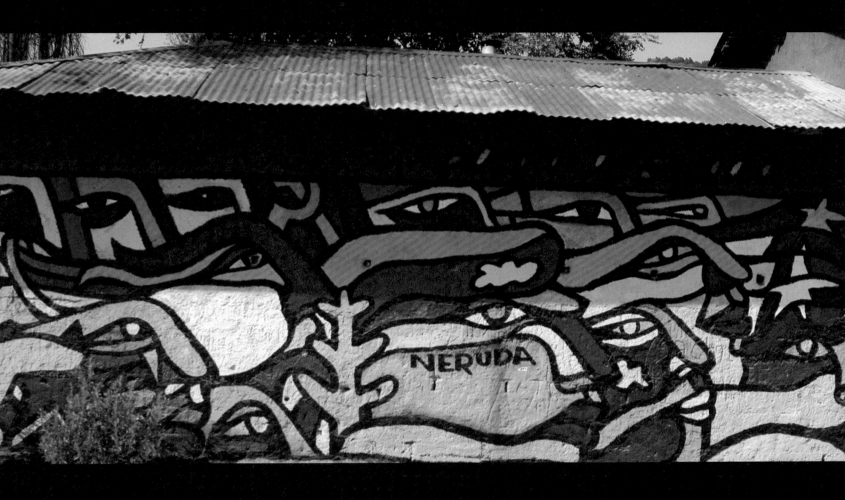

Renaissance Woman

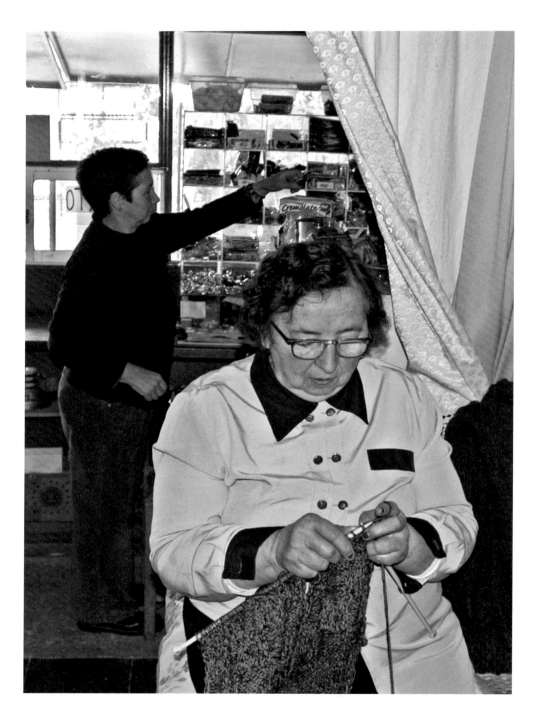

Juana Rojas Araya is determined to equip her 55 year-old mentally disabled daughter, Teresa, with the business management skills she will need to run their convenience store once Juana is gone. With 13 loans from FINAM (an MFI serving women in and around Santiago, Chile) between them, they have continued to enhance the store and increase their offerings, resulting in increasingly profitable returns.

"Independencia," her father used to tell her. "Nothing is more important than being independent." For a father who had just lost his wife, this meant that his five year-old daughter, Juana Rojas Araya, would need to take care of herself because he couldn't manage. For Juana, it has meant just the opposite: a life of devotion to her own family, no matter what the circumstances.

HER EYES ARE TRAINED on the midnight T.V. news, and her fingers are busy knitting a bright green and red sweater, but Juana's ears are ever alert to customers who might arrive at her convenience store window. Even though it means keeping the store open from 6 a.m. to 1 a.m., seven days a week, she can't afford to lose a sale to other shops in her neighborhood situated on the northern fringe of Santiago, Chile. Juana has obligations and she plans on meeting them.

Fifteen minutes before closing, Juana hears footsteps on the pavement outside and gets up to greet one of the regulars. "A bottle of Coke and a bag of chips, por favor," says the late-night worker, peering through the small open glass window. "Nice new awning," he adds looking up at the metal sheeting extending over his head.

"We just installed it," Juana smiles, gratified that he's noticed. "Now when it rains, you'll stay dry when you're here buying things from us."

Just then, Teresa, Juana's 55 year-old daughter, enters the shop from the adjoining living room, rubbing the sleep from her eyes. "Go to bed, mom. I'll lock up tonight." As Teresa heads outside to put down the awning, Juana realigns the soda bottles on the counter so that their labels face the street. Then, stepping up the stair into her house, she walks down the hall past the bedrooms of Teresa's two children – a second family that Juana helped her daughter raise. Now that they're grown and each earns an income, her 26 year-old grandson, a successful auditor, and her 23 year-old granddaughter, a budding chemical analyst, they rent these rooms from her.

Juana switches on her bedroom light and shuts the door behind her, confident that even with mental disabilities, Teresa is capable of sharing the responsibilities of running the store.

Juana has never needed much sleep. Married at age16, she soon became pregnant with one and then another and another child until she had a brood of eight under her care. As a tailor, her husband's income was not enough to support the family. So, while raising her children, Juana somehow found time to take classes in sewing, crocheting and knitting. With each class, she discovered not only a hobby, but also an essential source of income for her growing family. Soon she was selling handmade dresses, sweaters and doilies for the arms and backs of sofas and chairs. When the women in her neighborhood saw her work, they asked if she would teach them her skills. So Juana launched a mini-school in her home. Energized by her financial success, she took more classes and expanded her class offerings to include painting, paper-maché and floral design. Juana and her husband were prudent with their profits, and over time were able to purchase a few homes, rent them out and use the income to clothe, feed and educate their children.

When she was just 46, Juana suddenly became a widow solely responsible for raising her children. Never one to give in, she turned her tragedy into another creative venture: cooking. After taking a class to hone her skills, Juana began a business baking Pan de Pasqua, a sweet bread relished by Chileans during the months of October, November and December. Immediately successful, she decided to add a variety of homemade fruit marmalades that also became instant sellers to individuals and to a number of stores and restaurants.

Juana watched as one by one, her children graduated from high school, completed college and began careers and families of their own. Only Teresa, after completing a few years of schooling, stayed home to be taught and cared for by her mother. When Teresa bore first one followed by a second child, Juana knew that she would be needed to take care of them too, because like Juana's father who had not been able to care for her, Teresa was not equipped to raise her children on her own. Juana also knew that in order to do so, she would need additional financial support.

Fortunately she discovered FINAM, an MFI based in Santiago, Chile. After reviewing her work history and discussing her business idea, a FINAM loan officer extended Juana her first business loan. With it, she purchased a variety of snacks and sodas, placed them on a table outside the front door of her house, and opened a convenience store for business. It was instantly profitable. So, as soon as Juana paid back her loan, she applied for a larger loan, using it to add a wider selection of goods so that she could be competitive with other stores in her neighborhood. Thoughtfully dividing her profits between her family's needs, additional stock, and savings, eventually Juana had enough cash to construct a compact yet light-filled addition to the front of her home. She had deep counters built behind a large window so that her customers could easily select from a full assortment of candies, cookies, crackers and chips. She also installed a refrigerator for cold drinks, fresh cheeses, milk, eggs and ice cream.

Although an eternal optimist, Juana is also a realist. Both her time and her daughter's abilities are limited. She knows she will need money for her own retirement, and a sizeable savings account for Teresa so that she will not be dependent on her siblings or her children. A few years ago, Juana proposed a solution.

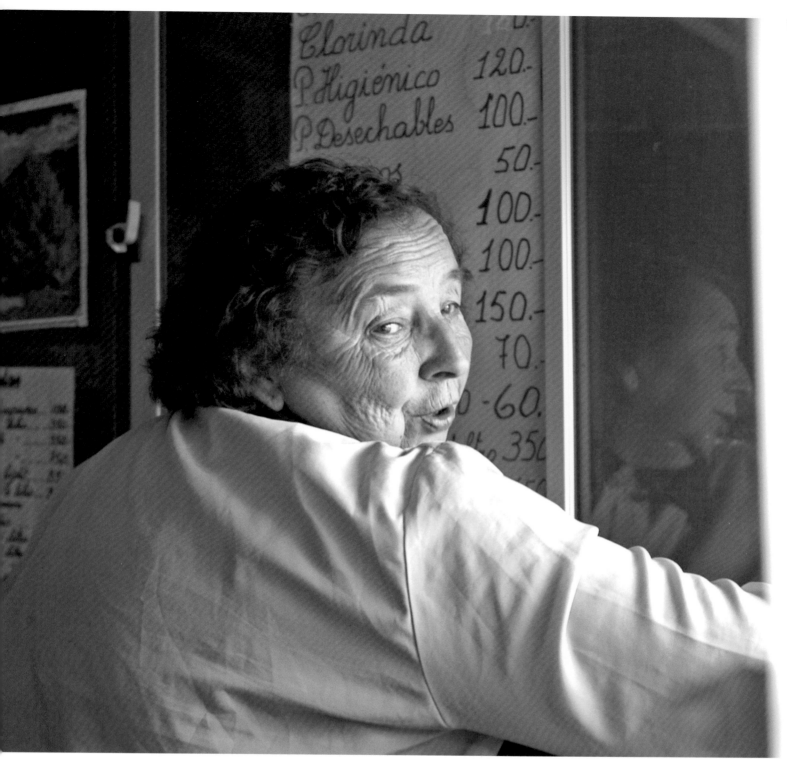

She approached FINAM asking if Teresa could become a borrower. Teresa and Juana would pool their loans and run the store together. Given Juana's successful loan history, and her promise to support Teresa should she need help with her repayment requirements, FINAM agreed.

The two women have borrowed and repaid 13 loans between them, and they have developed a profitable snack shop together. And now that Juana has a capable business partner, she has time to pursue her newest hobby. Showing no signs of slowing at age 77, this Renaissance woman recently completed a series of poems. Poems of struggle, hope and love.

At age 77, Juana shows no signs of stopping. When she isn't working in the store, knitting, crocheting or cooking, this Renaissance woman is busy pursuing a new hobby – writing poetry.

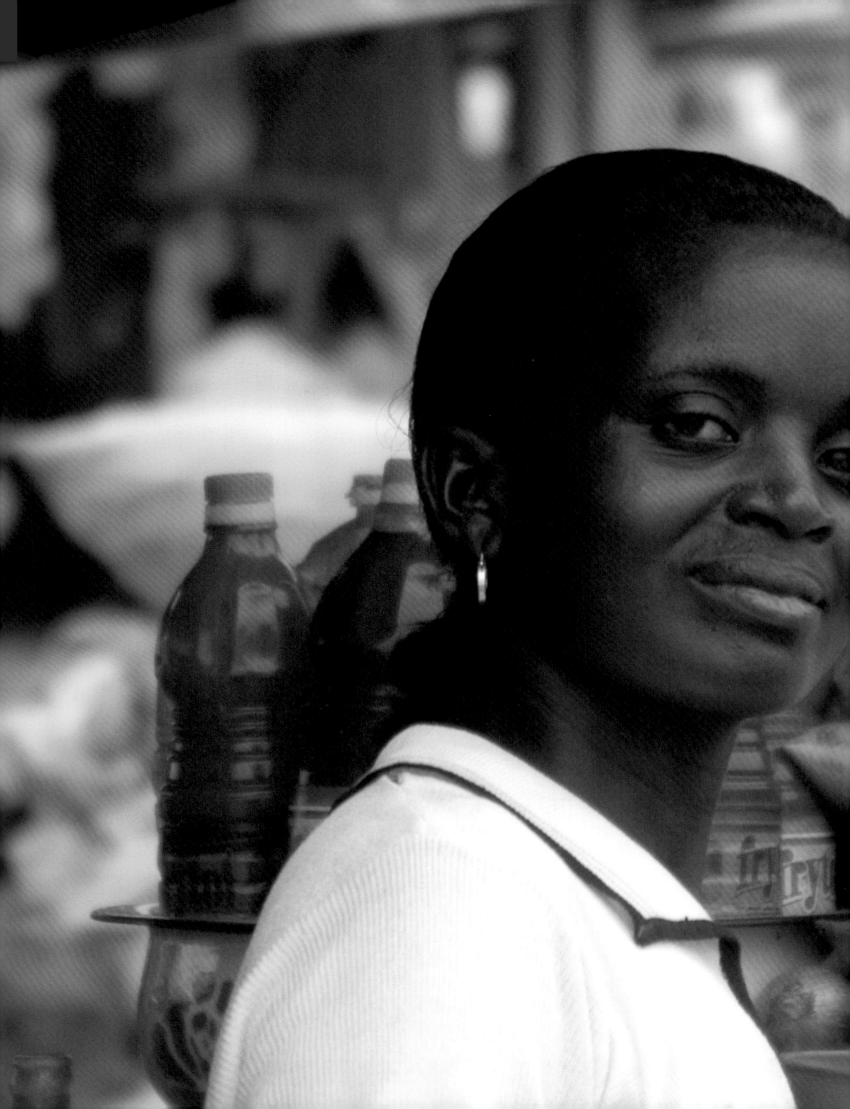

Africa

Ghana

DEMOGRAPHICS AND ECONOMICS	
Total Population (2004)	21,664,000
Gross National Income per capita (2004)	$380
Population below Poverty Line (1992) estimate*	31.4%
Health	
Fertility Rate (2004)	4.2
Maternal Mortality Ratio, (1990-2004), reported	210 (per 100,000 live births)
Annual Number of Under-5 Deaths (2004)	76,000
Life Expectancy at Birth (2004)	57 years
Orphans, Children (0-17) Orphaned by AIDS and other causes, (2003), estimate	1,000,000
HIV Prevalence: estimated number of people living with HIV, adults and children, 0-49 years, (2003)	350,000
Immunization of 1-year-old children (2004)	81% polio; 83% measles
Population using improved drinking water sources (2002)	68% rural; 93% urban
Population using adequate sanitation facilities (2002)	46% rural / 74% urban
Education	
Primary School Attendance Rate (2000-2004)	60% female / 62% male
Secondary School Attendance Rate (2000-2004)	35% female / 34% male
Total Adult Literacy Rate (2000-2004)	54%

Notions of Success

GHANA'S MIDDAY HEAT pulsates against Akosia's sandaled feet as she makes her way up the hard-packed dirt road to her house. She smiles at the sight of its new, pale pink exterior walls, remembering when this plot of land was more soil than structure. That was when her husband deserted her and their two sons, leaving them with no more than a cramped one-room home and a food cupboard as barren as the parched land surrounding them. Akosia was forced to work seven days a week trying to sell enough zippers, lining and thread to feed her hungry boys and cover their school expenses.

That's behind her now and the turn her life has taken makes her almost giddy. Before going inside her house, Akosia (*Sunday-born* in Ghana's Akan language) can't help but peer through the window into her sons' new bedroom that is roomier than the entire home they used to share. She doesn't mind the clothes they've haphazardly thrown over a beam, or their schoolbooks strewn on their beds. Now they're no longer sleeping beside her on the floor, they have a selection of shirts and pants to choose from, and they're both doing well in high school.

Opening the door, Akosia steps into a kitchen of eternal spring. Grass-green walls surround her and sunlight streams in, casting its rays on her sparkling new two-burner gas stovetop. She turns the heat on under a pot filled with one of her family's favorite, and most expensive meals – rice ball soup. Tonight's dinner can simmer while she has some lunch and cleans the house. Then she'll head to her Trust Bank meeting before going back to work. Akosia feels blessed to have such competent apprentices tending her stores while she's away. This dual sense of security – owning two income-generating businesses and trusting others with them – is something she could never have imagined before staff of Sinapi Aba Trust, Opportunity International's microfinance organization in Ghana, offered her and other poor women in her village working capital to launch businesses of their own.

Before then, Akosia was in a constant state of anxiety over her sons' well-being because she could never get ahead. Even when she earned extra income during the Christmas and Easter holidays sewing outfits for women in her community, it was never enough to sufficiently feed her boys, replace their tattered clothes and send them to school on an ongoing basis. Upon hearing

Sinapi Aba Trust's proposition, Akosia was both elated and apprehensive. What an opportunity of a lifetime – she could actually become a fulltime seamstress with her own shop. But would her business survive? Could it actually prosper? Would she be able to repay her loans? After weighing her options, Akosia's resolve to support her sons eclipsed her self-doubt.

During the ensuing eight-week orientation, Akosia was assigned to a Trust Bank with 29 other women. It didn't take her group long to realize Akosia's financial abilities. Elected treasurer of their group "Emmanuel", she became responsible for collecting her group members' first GHC425,500 ($50) loan payments plus interest, and she's held the position ever since.

Akosia had a long-range goal, but she knew she had to reach it incrementally. With her first GHC425,500 loan, she purchased an array of sewing notions that she added to her meager stock. Within days, her income increased. At the end of the first sixteen-week loan cycle, she and her group not only made final payments on their loans, plus interest, but they each established their first-ever savings accounts of GHC23,622($2.50), equal to 5% of their loans. Because of their prompt and full repayment record, the hard-working women of Emmanuel were eligible for a second round of larger loans.

This time Akosia invested most of her GHC850,400 ($90) loan in brilliantly colored fabrics and additional sewing supplies. In order to secure immediate working capital, she sold the majority of her stock to established seamstresses in her community. Combining these profits with the remainder of her loan, Akosia knew she was ready.

She paid for the construction of a small yet sturdy concrete and wood

Akosia Addai's life is nothing like it was when her husband abandoned her and their two young sons. With hard work, keen business acumen and loans from Sinapi Aba Trust, she has built two successful businesses, a sewing shop where she is training eight apprentices so that they may open their own businesses, and a fully-stocked hardware store that she named the "Eye of God."

stall on the dirt thoroughfare of her village. On its interior walls, she hung up posters of dress patterns that she could sew. Then she hauled her sewing machine and basket of sewing notions down from her house. Hoping to entice customers, she draped her remaining assortment of patterned fabrics over the store's metal doors. With great expectancy, Akosia opened up her sewing shop for business.

In just 24 weeks, Akosia transformed her life as a poor petty trader into a profitable business owner. And as her business grew, she took on eight apprentices, each eager to learn how to become an expert seamstress like their boss and mentor. After three years of training, they are eligible to take an exam; those who pass Akosia's high standards depart to open shops of their own. Up the street, one of her first graduates has done just that.

Akosia's business success was not the only change occurring in her village after the arrival of Sinapi Aba Trust. Not long after she opened her shop, she noticed that individuals, particularly fellow borrowers, were upgrading and adding rooms to their homes. When she realized that supplies had to be ordered and delivered, her brain's business-wheels started to turn.

The day she received her third loan, Akosia boarded a bus to Kumaisi, the closest city to her village. A few days later, stacks of plywood lay neatly outside her sewing shop door. Her business hunch was right. Neither the convenience she provided nor her prices could be matched by any outside vendor. She could barely keep pace with the demand as neighbors flocked to buy her wood.

Before long, however, a complaint arose in the community. The builders needed more than plywood. Akosia had a solution that satisfied everyone. Combining profits from her plywood sales with subsequent cash loans, Akosia built a second stall next to her sewing shop. She began stocking nails in bulk, then saws and hammers, next shovels, paint and corrugated tin, until she had a thoroughly stocked building supply store. The two shops were so busy that she trained one of her sewing apprentices to help run this new business. She named this store, "The Eye of God."

Akosia changes out of the blue and white dress and black headscarf she has worn since daybreak, and puts on a loose-fitting sleeveless dress of her own design. Its vibrant orange background, dotted with large squares of rich brown encircling squares of lighter brown, echo the splendor of an African sunset over the land. She combs her shoulder-length hair so that it flips up at the ends. Before leaving her bedroom, she straightens the bed she shares with her new husband. Why did he ask her to marry him? "It's because I'm a successful business woman!" she laughs. Akosia turns off the burner under the thickening soup, tucks her loan payment into a purse, picks up her trust group's ledger and heads out the door.

Opposite: Light streams into Akosia's brand new, light-filled kitchen, which is equipped with a coveted two-burner stove. No longer wondering where her family's next meal will come from, she now has an income allowing her to serve one of their favorite, and most expensive meals, rice ball soup.

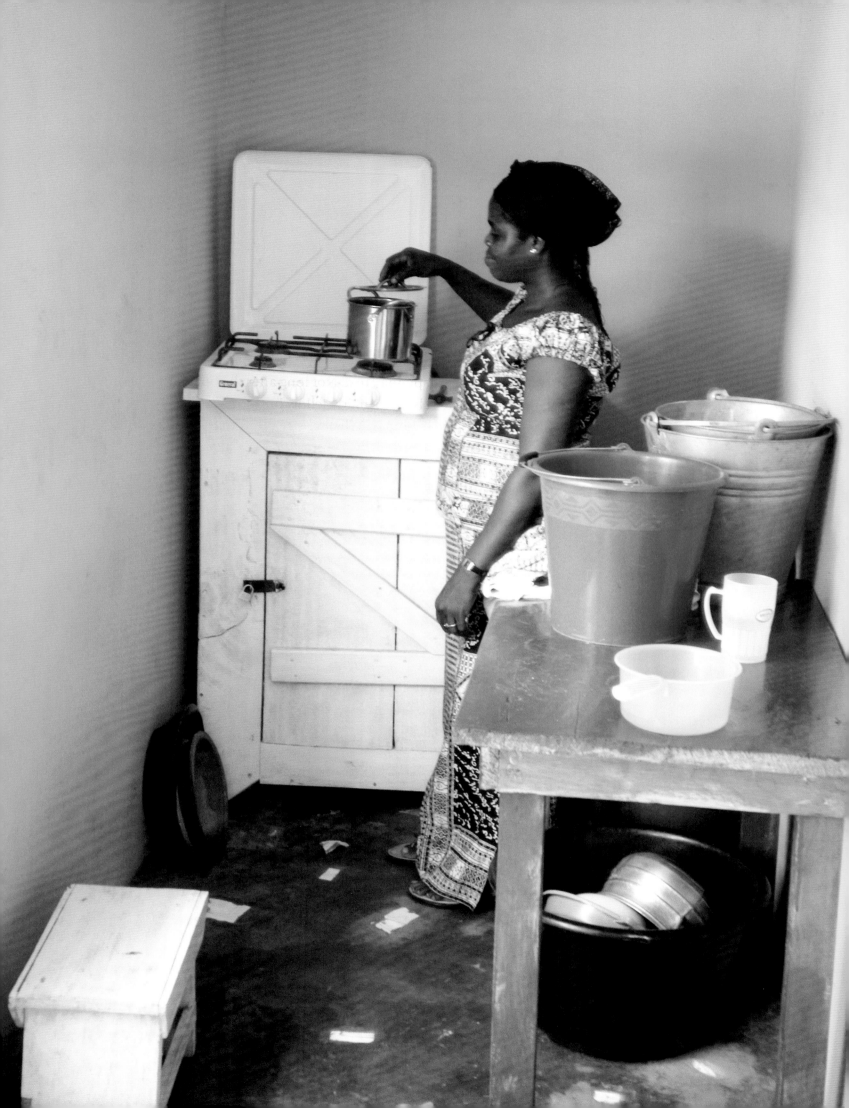

I Have Pride

THE WOMEN ARE WAITING. Sitting on backless benches, some recount the money they owe, others talk and laugh. One mother nurses her baby. Another dances through the church's doorless opening, effortlessly balancing her cassava-filled basin on her head. Francisca, their trust bank credit officer, arrives and the women stand, expectantly.

"Sinapi!" (Mustard Seed!) she calls out.

"Sinapi Aba pa!" (Good Mustard Seed!) the women chant back excitedly.

"Sinapi! " Francisca repeats insistently.

"Sinapi knosoo!" (Development!) the group declares from memory.

"Sinapi!" she announces for the third time.

"Sinapi nyengye sika sen!" (We don't take partial payments!) they shout.

This ritual marks the opening of every Opportunity International Trust Bank meeting across Ghana, affirming three truths: Trust Banks are for the working poor; they are for economic and personal growth; and the weekly meetings include dispersing and collecting group-guaranteed loans – in full.

Standing in front of them, Francisca begins to clap her hands and sing. A beautiful chorus of voices joins her, sending God's praises out of the windowless church and into the surrounding fields of maize, cassava and yam. With arms raised and heads bowed, the women's prayers and praise to God transform the roughly hewn building into a glittering cathedral. A transformation of poverty into radiance shines through the women of the Nyame ne Yen woho (*God is with Us*) Trust Bank.

There are no lights to switch on, or faucets to turn for water in Sereboaso, this scorched, dusty village on the outskirts of Kumasi, Ghana. Prior to forming their trust bank, the women's purchasing power was virtually nonexistent. Income from their crops was so insignificant that they were forced to buy most of their household needs on credit. Or they were forced to borrow cash from a moneylender whose excessive interest rate kept them locked in poverty's grip. Malnourishment plagued the community. Children attended school only when there was money for school fees, books, uniforms and shoes. The women of Sereboaso sweltered in stress.

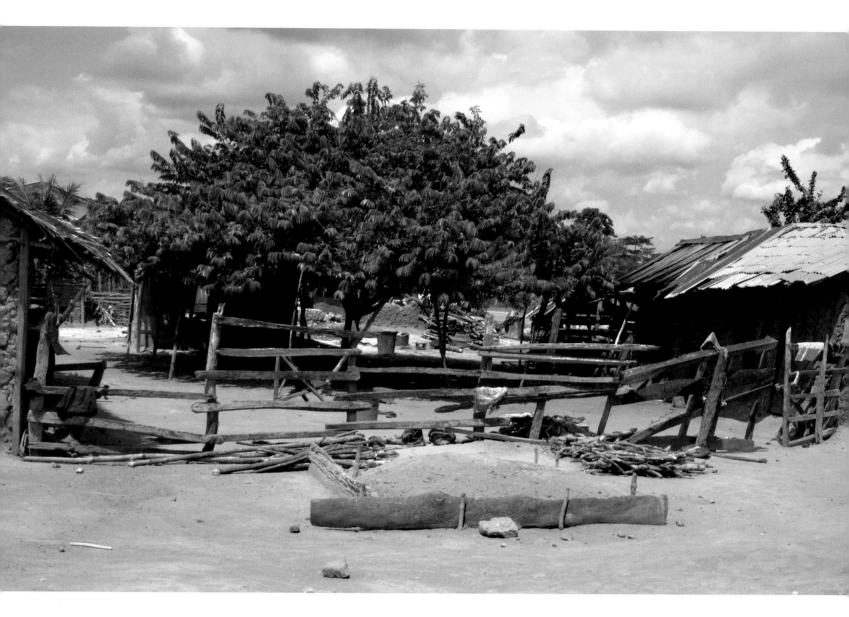

Adwoa (*Monday-born* in Ghana's Akan language) strained to support her family by harvesting a tiny crop of maize and selling it door to door. But since the moment she joined Sinapi Aba Trust, she has become a different woman. Using her cash loans, Adwoa now purchases large bags of maize. She sells a portion of her product directly to her customers; the rest she sells to impoverished women who repackage it into smaller quantities for resale. In no time, Adwoa went from being a poor petty trader to a profitable wholesaler.

There are no lights to switch on, or faucets to turn for water, but the women of Seraboaso, Ghana are using their loans from Sinapi Aba Trust to make bulk purchases of products such as maize and corrugated tin, and reselling them to each other and neighboring villages for a profit. Now the borrowers children are eating more nutritious meals and attending school.

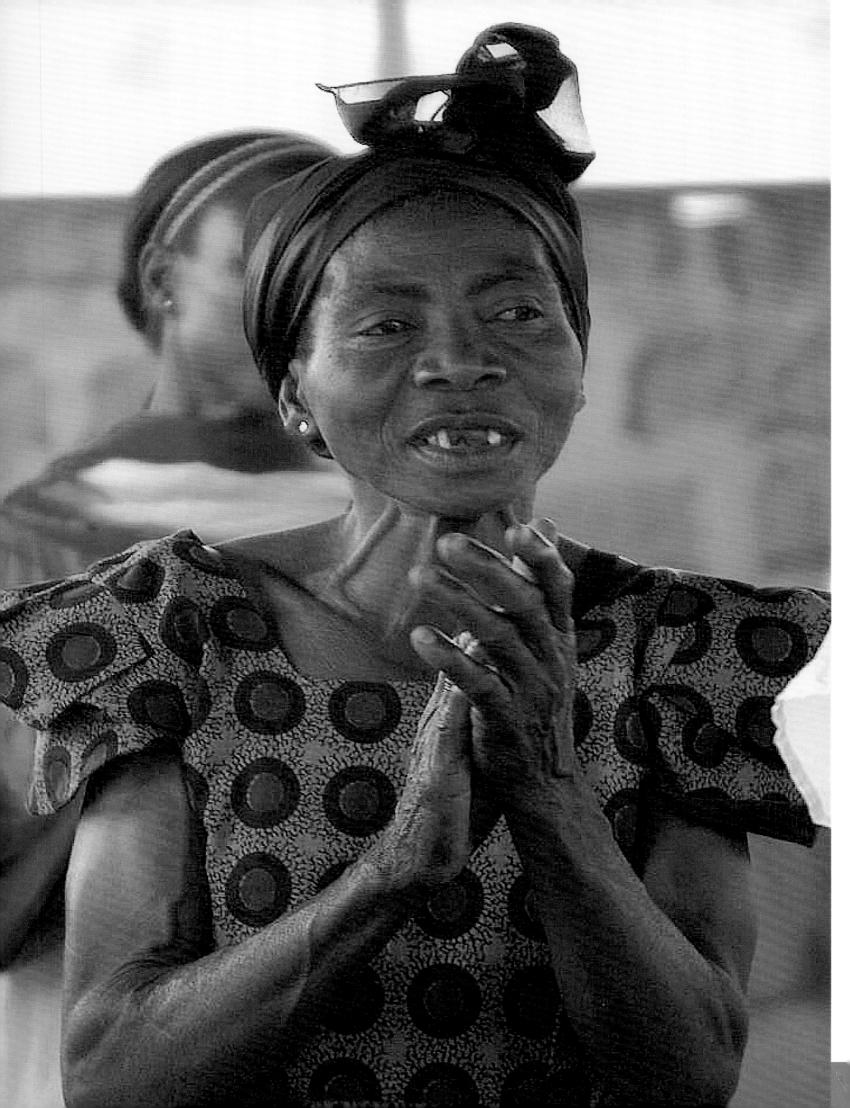

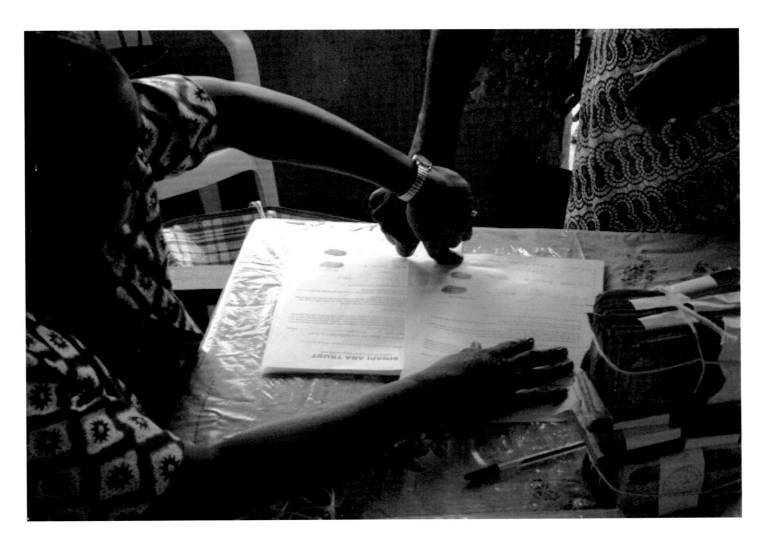

Her children are reaping benefits too. Their stomachs no longer ache with hunger. And unlike their illiterate mother, whose signature is no more than a thumbprint of purple ink on a page, they are now in school learning how to read and write.

Adwoa looks up at the corrugated tin roof spanning from wall to wall of her community's church. "With my cash loans I now also buy tin sheeting in bulk." Throughout the village, evidence of her trust bank's business success gleams in the sun. Many women have used their profits to replace the gaping straw roofs covering their mud and stick homes with shiny tin sheets that they purchased from their fellow borrower, Adwoa.

Like the other Sinapi Aba Trust clients in Sereboaso, Adwoa has become the primary financial provider for her family. She straightens up her shoulders. "Now I want for nothing, " she says, "I have pride."

Though illiterate, women in Seraboaso, Ghana, like millions of women around the world, use their thumbs as signatures on their loan agreements pledging to work towards a better life for their families.

Opposite: With melodious voices, members of Opportunity International's Sinapi Aba Trust Bank in Seraboaso, Ghana send God's praises out of their windowless church and into the fields of maize, cassava and yam, transforming their roughly hewn building into a glittering cathedral.

From Palmnuts to Oil

BUY PALMNUTS. HAUL palmnuts in 70-kilo bags to dirt drying ground. SPREAD OUT palmnuts. LEAN OVER and TURN palmnuts with a wooden scraper to dry them in the sun. REPEAT for three days or until dry. HAUL load after load of palmnuts into the barn to be machine-husked. PAY the machinist. HAUL palm kernels and chaff out of the barn. MAKE two piles: one of palm kernels, the other of chaff. SHOVEL kernels into a large basin. LIFT the heavy basin high above the head and SHAKE so kernels drop into a pile and loosened chaff is blown by the wind into a second pile. REPEAT. When most of the chaff has separated HAUL kernels to the wash barrel. SCRUB small amounts of kernels in water and clay to loosen remaining chaff. REPEAT until all kernels have separated from the chaff. REMOVE any remaining chaff. RINSE scrubbed kernels in a second barrel of water. PLACE each cleaned batch of kernels into a basin. CARRY each filled basin over to the cooking area. POUR cleaned kernels into a huge metal pot. HAUL chaff and place it under the pot for fuel. ADD dead palm fronds and any other available fuel as needed. REPEAT. Keep the fire burning. STIR kernels with a long wooden paddle until they are well fried. POUR each batch of cooked kernels onto the ground to cool. BAG and haul kernels to a hired truck. Wait for them to be milled into paste. PAY THE DRIVER AND THE MILLER. HAUL the paste back and POUR it into the huge metal pot. POUR some water into the pot. HAUL chaff and place it under the pot for fuel. ADD dead palm fronds and any other available fuel. REPEAT. Keep the fire burning. STIR, STIR, STIR with the long wooden PADDLE until the paste liquefies into palm oil and sinks to the bottom of the pot. DRAIN off the water from the top of the oil. POUR the palm oil into basins to cool. POUR the palm oil into plastic containers. LIFT. CARRY. SELL. REPEAT.

At age 60, Ramatu Moro-Muhammad took on the responsibility of single-handedly raising a second family—her four grandchildren. Through the grueling work of converting palmnuts to oil and the help of four microloans from Sinapi Aba Trust, Opportunity International's MFI in Ghana, this illiterate widow was able to clothe, feed and educate the children, pay off a huge debt and save $400 towards her own retirement.

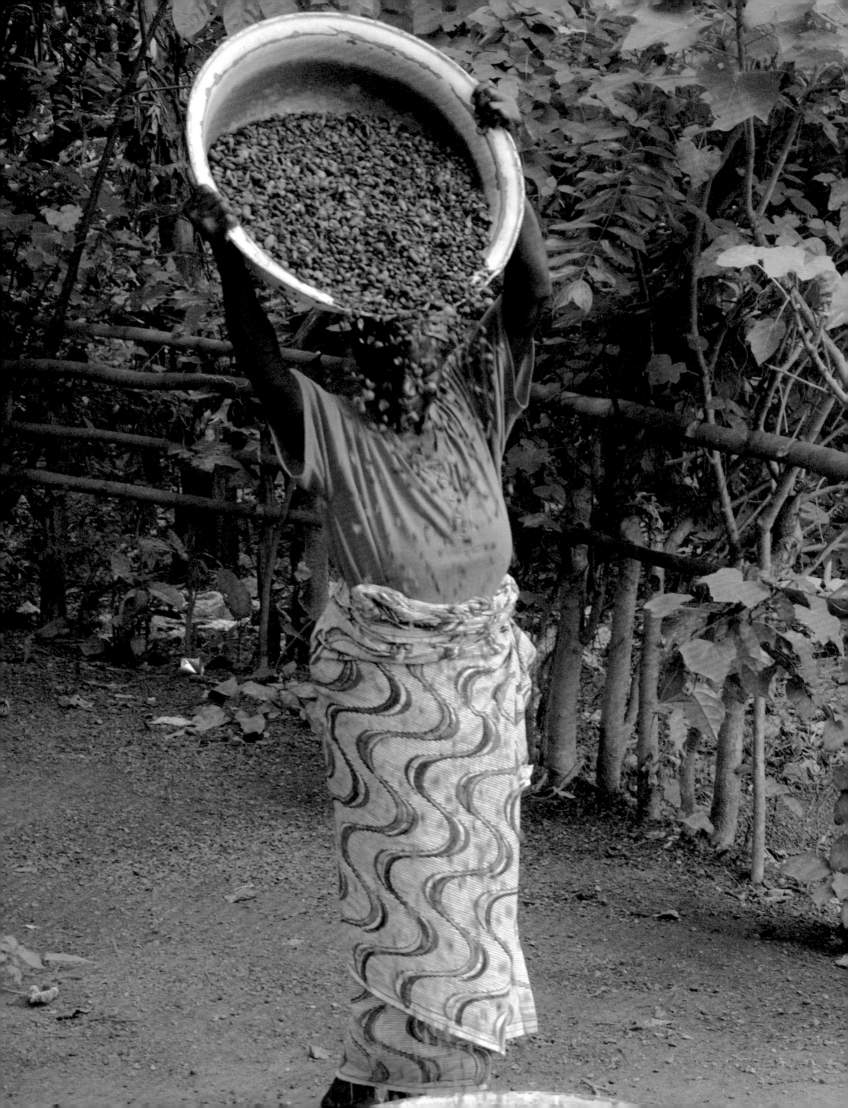

Such was the traditional work of Ramatu Moro-Muhammad's people from northern Ghana. Such was the skill she learned as a child and brought with her when she moved to southern Ghana in 1958 with her husband and two young children. Such was the part-time labor she undertook to help support their six additional children. And such was the grueling, full-time work thrust upon her at age 60. Still, ten years later, Ramatu is working.

"I didn't have money. How could I eat three meals a day?" she rhetorically remarks.

Ten years ago, her husband died, and with his death went her primary source of income. Soon thereafter, one of Ramatu's daughter's, a mother of three, fell ill. Putting her widow's grief aside, Ramatu poured all her money and attention into helping her daughter regain her health. But her illness only increased as Ramatu's meager income from making and selling small amounts of palmnut oil diminished to nothing. Borrowing at first, Ramatu finally resorted to begging friends and customers to help her pay her daughter's mounting medical bills. Debt besieged her. Often when she went to bed, Ramatu's empty stomach growled with hunger. Her unstinting efforts were to no avail. Her daughter died.

Ramatu was engulfed in double grief and debt. She felt alienated from her community. She refused to attend weddings, baby naming ceremonies or funerals because she did not have money to purchase a gift and she couldn't afford the appropriate attire. She was all on her own to try to put her life back together again. But not for long.

Another daughter living in northern Ghana needed help from her mother. She could not take care of her four children. As overwhelmed as Ramatu was, she would never refuse to take care of a family member. So, at age 60, the recently widowed, mourning grandmother was given a second family to raise. But how would she feed, house, clothe and educate these children?

Ramatu feeds her four grandchildren from her kitchen.

Ramatu had drained every resource. No one wanted to sell her palmnuts on credit. Again and again she pleaded for help. Finally, a few people agreed to extend her some credit, so once again Ramatu began selling her oil one cupful at a time. Making a living was exhausting, and the financial returns, after paying back as much debt as she could, were woefully inadequate, and barely enough to feed her grandchildren even a single meal a day.

Then one day, a customer asked Ramatu a question that transformed her life and that of her grandchildren. She asked Ramatu why her life seemed so difficult. After hearing Ramatu's heart-wrenching story, her customer told her about Sinapi Aba Trust, Opportunity International's microfinance institution in Ghana. Anxious to get any help she could, Ramatu interviewed for a loan. Because she was severely economically disadvantaged yet working, Ramutu was invited to join a newly forming trust bank group. After eight weeks of orientation, she and the other women in her group received their first loans.

With her GHC322,000 ($35) loan, Ramatu purchased six bags of palmnuts. Though punishingly exhausting, each bag she processed and sold filled her with hope. With the GHC110,400 ($12) per bag that she earned, she could now feed her grandchildren. And she was able to make her weekly loan payments, plus interest. She even began paying off her debts. At the end of her first loan cycle, Ramatu was ready for a larger loan.

With one of her four grandchildren at her side, Ramatu must stand while stirring one batch after another of palmnut oil over a hot fire until they are thick and smooth.

With this loan she purchased 10 bags of palmnuts, with the third 14 bags, and with her fourth loan of GHC920,000 ($100), she bought 20 bags of nuts. Now overflowing with palmnut oil, Ramata became a wholesaler selling her rich, dense product to individuals, traders and foodsellers.

While the daily backbreaking labor remained the same, everything about this illiterate woman's life has changed. Properly dressed and with gifts in hand, she happily attends all her community functions. She now pays the $10 per month rent for her one-room row house on schedule and in full, just like she had when her husband was alive. And three times a day she tends a flame under a large, blackened metal pot at her kitchen, a barren plot of red-packed dirt outside her door. For breakfast she serves her grandchildren tuozefi, a typical northern Ghanaian dish made of maize; for lunch she cooks yams; and for dinner they eat rice, sometimes with fish or meat. Ramatu has also set her grandchildren on a course she was never able to take – they are getting an education.

Not only has Ramatu erased her enormous debt, but she has replaced it with over $400 in savings. The final payment of her fourth loan has been paid in full. "I'm tired," she rightfully admits, "and I'm going to return to the north, where my children will take care of me."

One cherished afternoon each week, Ramatu, like millions of microentrepreneurs around the world, leaves her labors behind in order to attend her Trust Bank meeting, gathers with friends, pays off a portion of her loan (or receives a new one), and takes a much-deserved rest.

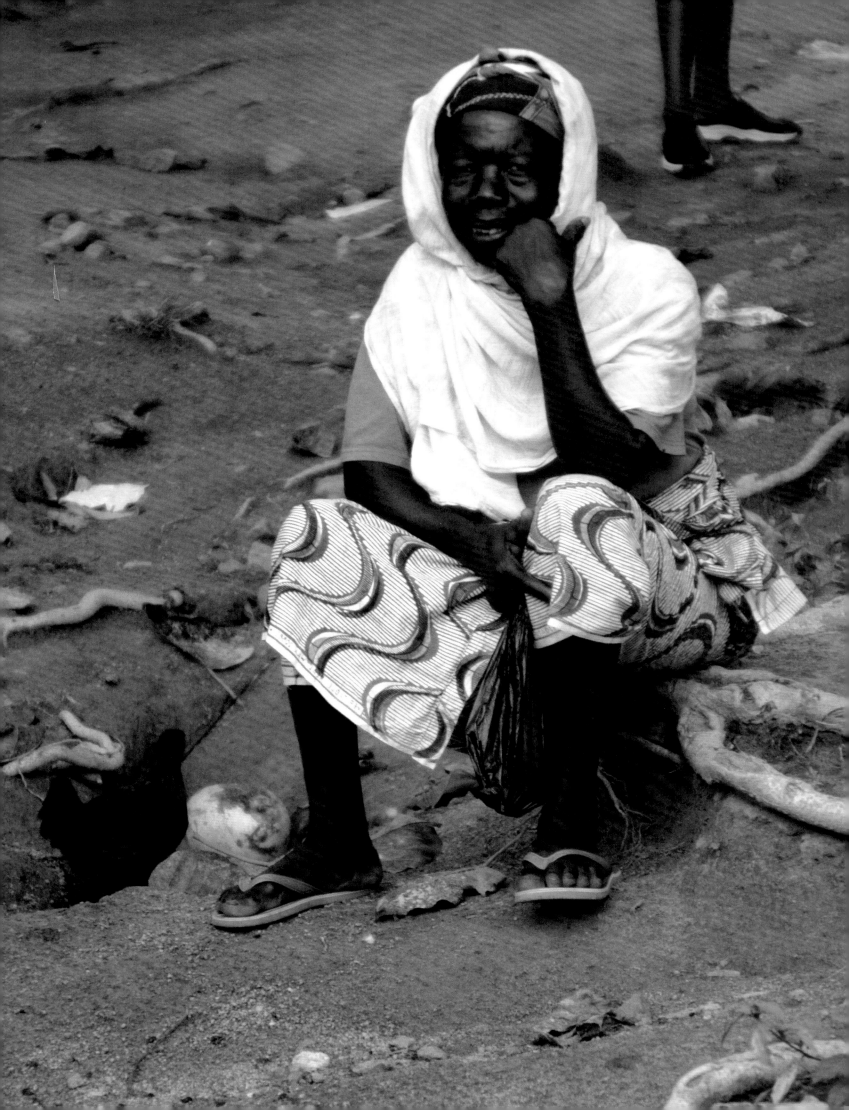

How to Get
Involved

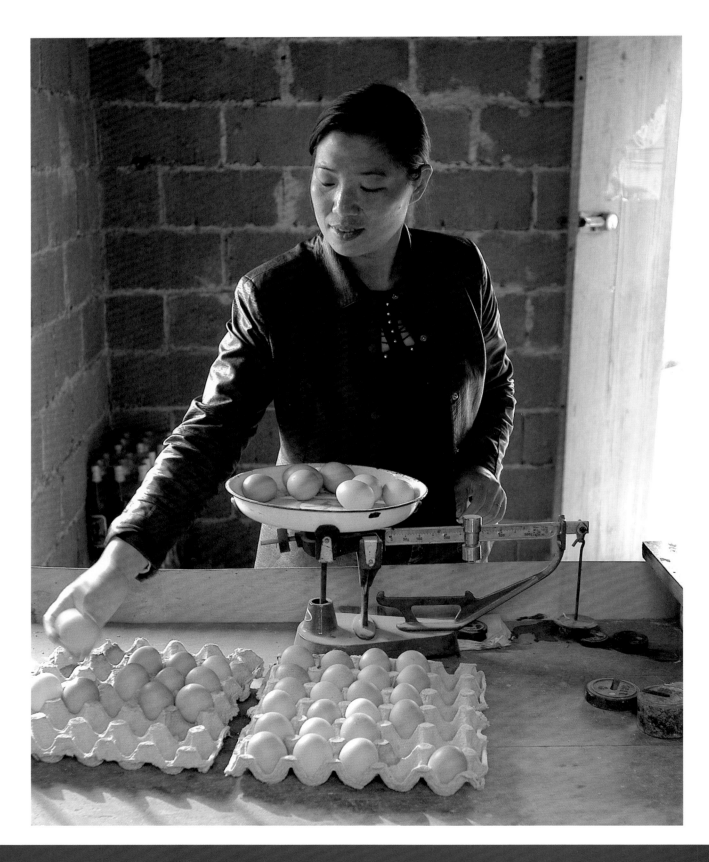

There are myriad ways to get involved in the world of microfinance. The purpose of this resource guide is to provide examples of organizations working in the field, particularly those who support MFIs whose clients are represented in the book. This list is by no means exhaustive (there are over 4100 MFIs alone); however it will serve as a starting point for your involvement, whether you decide to invest, donate, volunteer, find employment, sign up for a trip to meet an organization's clients, or gather information about one of the groups committed to eradicating poverty through microfinance.

The resource guide is broken down into the following categories: Comprehensive Resources; Market Facilitators; Government Donor Agencies and Organizations; Microfinance Institutions (MFIs); Investment Opportunities; Banks (investing in microfinance); Education Programs (with a focus on microfinance) and Advocates. Within each category, organizations are listed in alphabetical order and are followed by a website address, unless otherwise noted.

Organizations in **BOLD** are those that currently are or were involved in some way with the microentrepreneurs featured in the book.

Comprehensive Resources

These organizations and web sources provide extensive information on a wide range of topics in microfinance including information on hundreds of individual MFIs, MFI networks, public and private funds that invest in microfinance, raters and external evaluators, advisory firms, and governmental or regulatory agencies. The majority of organizations listed in the other seven categories will also be found in one of the following four resources.

CGAP (Consultative Group to Assist the Poor) – www.cgap.org
Microcredit Summit Campaign – www.microcreditsummit.org
Mircofinance Gateway – www.microfinancegateway.org
Mix Market – www.mixmarket.org

Market Facilitators

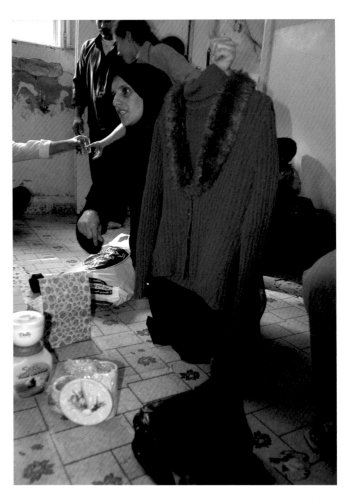

These organizations are networks, development program/ service providers and raters/external evaluators that provide financial services, knowledge management, policy advocacy, research and development, institutional start-up and transformation assistance, and technical services.

ACCION – www.accion.org
Association for Enterprise Opportunities (AEO) (USA)– www.microenterpriseworks.org
Alternative Credit Technologies, LLC – www.alternative-credit.com
CARE – www.care.org
CASHPOR – www.cashpor.org
International Cooperation for Development and Solidarity (CIDSE) – www.cidse.org
Citigroup Foundation – www.citigroupfoundation.org
Catholic Relief Services (CRS) – www.catholic relief.org
Chemonics International, Inc. – www.chemonics.com
Development Alternatives Inc. (DAI) – www.dai.com
Enterprising Solutions Global Consulting – www.esglobal.com
FINCA International – www.villagebanking.org
Freedom from Hunger – www.freedomfromhunger.org
Grameen Foundation – www.grameenfoundation.org
Grameen Trust – www.grameen-info.org
Katalysis Network – www.katalysis.org
Microcredit Summit Campaign – www.microcreditsummit.org
MicroFinance Network – www.mfnetwork.org
Microfinance Opportunities – www.microfinanceopportunities.org
Omidyar Network – www.omidyar.net
Opportunity International and Women's Opportunity Fund – www.opportunity.org
Oxfam International – www.oxfam.org
PlaNet Finance – www.planetfinance.org
ProMujer – www.promujer.org
Sanabel – www.sanabelnetwork.org
Save the Children – www.savethechildren.org
The Small Enterprise Education and Promotion (SEEP) Network – www.seepnetwork.org
ShoreBank Advisory Services (USA) – www.sasbk.org

Unitus – www.unitus.com

Women Advancing Microfinance International –
 www.wam-international.org

Women's World Banking (WWB) – www.swwb.org

World Council of Credit Unions (WOCCU) – www.woccu.org

World Vision – www.WorldVision.org

Government Donor Agencies and Organizations

The following organizations may provide financing to MFIs for research and development, knowledge management, business training, staff development, technical services, loan guarantees and loans.

African Development Bank (AfDB) – www.afdb.org

AFD (France) – www.afd.fr

AusAID (Australia) – www.ausaid.gov.au

Consultative Group to Assist the Poor (CGAP) – www.cgap.org

Canadian International Development Agency (CIDA) –
 www.acdi-cida.gc.ca

CORDAID (Netherlands) – www.cordaid.nl

Ministry of Foreign Affairs, Denmark (DANIDA)– www.um.dk

Department for International Development, United Kingdom (DFID)
 – www.dfid.gov.uk

Belgian Development Cooperation (DGIC) – www.dgic.be

European Bank for Reconstruction and Development (EBRD) -
 www.ebrd.com

Groupe de Recherche et d'Echanges Technologiques (GRET) (France)
 – www.gret.org

Inter-American Development Bank (IADB) –– www.iadb.org

International Finance Corporation (IFC) – www.ifc.org

Swedish International Development Agency (SIDA) – www.sida.se

United States Agency for International Development (USAID)
 – www.usaid.gov

World Bank – www.worldbank.org

Microfinance Institutions

AFRICA

BENIN
PADME – http://www.padmebenin.org/

EGYPT
ABA – www.aba-sme.com

KENYA
Equity Bank Limited – www.ebsafrica.com
K-Rep Bank Limited – www.k-repbank.com

MALI
Kafo Jiginew – www.afribone.nt.ml/apim/members-jiginew.html

MOROCCO
Al Amana – www.alamana.org

SOUTH AFRICA
SEF-ZAF (Small Enterprise Foundation) – www.sef.co.za
Teba Bank – www.tebabank.co.za

TANZANIA
PRIDE-TZA – www.ptzadmin@pridetz.org

UGANDA
Centenary Rural Development Bank, Ltd. – www.centenarybank.co.ug/
FOCCUS – www.(email) admin@foccasuganda.org
Uganda Microfinance Limited – http://www.umu.co.ug/

CENTRAL AMERICA

DOMINICAN REPUBLIC
Banco ADEMI – www.bancoademi.com.do/

GUATEMALA
Friendship Bridge – www.friendshipbridge.org
NamasteDirect – www.namaste-direct.org

NICARAGUA
Fundacion Para El Apoyo a La Microempresa (FAMA) –
www.fama.org.ni

CARIBBEAN
HAITI
Fonkoze – www.fonkoze.org
SogeSol – www.sogebank.com/groupe/sogesol/html

NORTH AMERICA
MEXICO
Compartamos – www.compartamos.com

UNITED STATES
AEO (The Association for Enterprise Opportunity) –
www.microenterpriseworks.org
The Abilities Fund – www.abilitiesfund.org

CALIFORNIA
Women's Initiative for Self Employment – www.womensinitiative.org

OREGON
Lane MicroBusiness – www.lanemicrobusiness.org

SOUTH AMERICA
ARGENTINA
Grameen Mendoza – www.grameenmendoza.org.ar

BOLIVIA
BancoSol – www.bancosol.com.bo
Banco Los Andes ProCredit - www.losandesprocredit.com
CRECER – www.crecer.org.bo
ProMujer – www.promujer.org
FFP PRODEM , S.A. – www.prodemffp.com

CHILE
FINAM – www.finam.cl
Bandesarrollo – www.bdd.cl

COLOMBIA
Finamerica – http://www.mfnetwork.org/members/finamerica.html
Cooperativa Emprender – www.mfnetwork.org/memberCOOP.html

PERU
Mibanco – www.mibanco.com.pe

EASTERN EUROPE
ARMENIA
Microenterprise Development Fund Kamurj – www.mdf-kamurj.am

BOSNIA & HERZEGOVINA
Prizma Mikro – www.prizma.ba

GEORGIA
Constanta Foundation – www.constanta.ge

POLAND
Fundusz Mikro,Ltd. – www.funduszmikro.com.pl

ASIA
BANGLADESH
BRAC – www.brac.net
Grameen Bank – www.gdrc.org
SSS (Society for Social Services, Bangladesh) – www.ssstangail.org

CHINA
Funding the Poor Cooperative – (email) duxiaoshan@cass.org.cn
Women's Development Association (WDA) –
(email) haojinlian@yahoo.com.ch

INDIA
SHARE MICROFIN Limited – www.sharemicrofin.com
SWAYAM KRISHI SANGAM (SKS) Microfinance – www.sksindia.org

INDONESIA
Bank Rakyat Indonesia, Unit Desa – www.bri.co.id/english

PAKISTAN
The First Microfinance Bank of Pakistan – www.mfb.com.pk

PHILLIPPINES
CARD – www.cardbankph.com
TSPI Development Corporation – www.tspi.org

VIETNAM
Tau Yeu Mai Fund (TYM) – (email) tym@fpt.vn

EURASIA
KYRGYZSTAN
FINCA Microcredit Company –
www.villagebanking.org/work-ind_kyr.htm

MONGOLIA
XacBank – www.xacbank.org

EUROPE
FRANCE
Adie – www.adie.org

MIDDLE EAST
JORDAN
Jordan Micro Credit Company – www.tamweelcom.org
Microfund for Women – www.microfund.org.jo

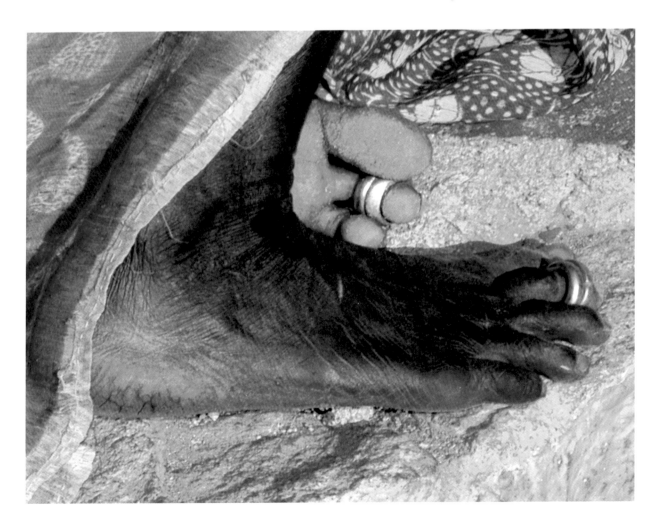

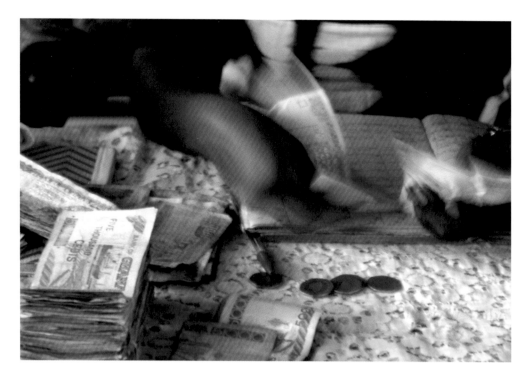

Investment Opportunities

Some of these funds may be available for individual investments.

Accion Gateway Fund – www.accion.org
Calvert Foundation – www.calvertfoundation.org
Dexia Microcredit Fund – www.blueorchard.ch
Grameen Foundation – www.grameenfoundation.org
KIVA Microfunds – www.kiva.org
Katalysis Bootstrap Fund - www.bootstrapfund.org
MicroCredit Enterprises – www.mcenterprises.org
Ms. Foundation – ms.foundation.org
NICA Fund - www.wccnica.org
PKSF (Bangladesh) – www.pksf-bd.org
responsAibility Global Microfinance Fund – www.responsAbility.com/en
Shared Interest – www.sharedinterest.org

Banks

Citigroup Inc. – www.citigroup.com
HSBC – www.hsbc.com
ShoreBank – www.shorebank.com
Wells Fargo Bank – www.wellsfargo.com

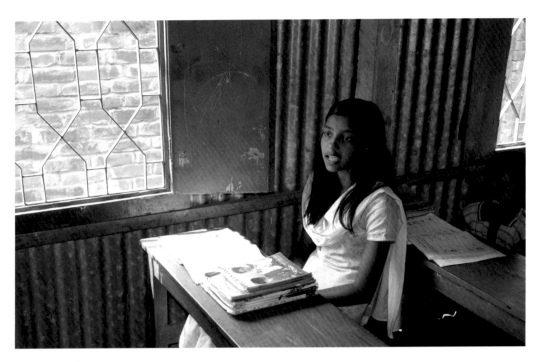

Education Programs

Brigham Young University – www.marriottschool.byu.edu

Columbia University, School of International and Public Affairs – www.sipa.columbia.edu

Harvard University, John F. Kennedy School of Government – www.ksg.harvard.edu

John s Hopkins University, The Paul H. Nitze School of Advanced International Studies (SAIS) – www.sais-jhu.edu

Northwestern University, Kellogg School of Management – www.kellogg.northwestern.edu

Ohio State University, Department of Agricultural, Environmental, and Developmental Economics – http://aede.osu.edu

Southern New Hampshire University, International Community Economic Development Program – www.snhu.edu

Stanford University, Graduate School of Business – www.gsb.stanford.edu

University of California at Berkeley, Haas School of Business – www.haas.berkeley.edu

University of Chicago – www.chicagosb.edu

University of Maryland, Center on Institutional Reform and the Informal Sector (IRIS) – www.iris.umd.edu

University of Pennsylvania, The Wharton School – www.wharton.upenn.edu

Advocates

Results International – www.results.org

Glossary of Microfinance Terms

Collateral is an asset pledged by a borrower to secure a loan. Collateral can vary from fixed assets (a car, a sewing machine) to cross-guarantees from peers.

Credit Union is a nonprofit, cooperative financial institution owned and run by its members. Members pool their funds to make loans to one another and elect a volunteer board to run their credit union. Most credit unions are organized to serve people in a particular community, group or groups of employees, or members of an organization or association.

Financial Self-Sufficiency (FSS) is total operating revenues divided by total administrative and financial expenses, adjusted for low-interest loans and inflation. A microfinance institution is financially self-sufficient when it has enough revenue to pay for all administrative costs, loan losses, potential losses and funds.

Housing Finance is a specialized loan that allows households of both microentrepreneurs and wage-earners to finance home improvements or additions. Loans tend to be longer-term, and in larger amounts, than traditional microenterprise loans that are focused on providing working capital. Home improvement loans may enhance at-home businesses.

Informal Sector/ Economy is a subset of the economy consisting of self-owned enterprises and the enterprises of informal employers, in both urban and rural areas. Businesses within the informal sector are not registered with any taxation or regulatory bodies. The main features of the informal sector are ease of entry, self-employment, small-scale production, labor-intensive work, lack of access to organized markets, and lack of access to traditional forms of credit.

Microcredit, a component of microfinance, is the provision of relatively small loans to low-income entrepreneurs. Microcredit is often offered without collateral and may be lent to either a group or an individual.

- **Group lending** allows a number of individuals to borrow collectively. The incentive to repay is based on friendship and peer pressure; if one member of the group defaults, the other members have often pledged to make up the payment amount. The member who defaults is expected to reimburse the group as soon as possible.
- **Individual lending** focuses on one client, usually one with a successful business and a proven repayment record as a group member. Individual loan amounts are generally higher than group loans.

Microentrepreneurs are individuals who own and operate small-scale businesses. Typical microentrepreneurial businesses can include retail kiosks, sewing workshops, carpentry shops, and market stalls selling both purchased and homegrown or homemade foods or other goods.

Microenterprise development has various meanings. It is the term often used in the United States to refer to microfinance. It may also mean the provision of non-financial services and training to microentrepreneurs including business and leadership training, mentoring and financial planning services.

Microenterprise is a business in the informal sector, usually employing fewer than 5 people, and often based out of the home. A microenterprise may provide the sole source of family income, or it may supplement other forms of income.

Microfinance targets low- and moderate-income businesses and households with financial services ranging from loans (microcredit), savings, insurance, transfer services (remittances), and other services such as business training.

Microfinance Institution (MFI) is a financial institution that offers financial and, sometimes, other business services to low- and moderate-income clients.

Microinsurance is a growing sector of microfinance that provides property, health, life and business insurance products to microentrepreneurs and employees in the informal sector which allows them to concentrate more on growing their businesses while mitigating other risks affecting property, health or the ability to work.

Microsavings are deposit services providing low- and moderate-income individuals with a secure place to save small amounts of money, often without minimum balance requirements. Typically, contributions are made weekly along with loan and interest payments. Savings programs allow low- and moderate-income individuals to cover unexpected medical expenses and plan for future investments such as their children's education and their own retirement.

Remittances are transfers of funds from people in one location to family and friends living in another location either from one country to another or within a country.

Unbanked describes people who have little or no access to affordable financial services (such as savings, credit, money transfers, insurance or pensions) through any type of formal financial sector organization. Implicit in this definition is that financial services are usually available only to those individuals termed "economically active" or "bankable."

Portions of the Microcredit Glossary are borrowed from:
Year of Microcredit 2005 Website: http://www.yearofmicrocredit.org and
Accion International Website: http://www.accion.org/micro_glossary.asp

Reading List

Microfinance

Banker to the Poor: Micro-Lending and the Battle Against World Poverty, Muhammad Yunus

Commercialization of Microfinance: Balancing Business and Development, ACCION International, Deborah Drake and Elisabeth Rhyne

Commercialization: The New Reality of Microfinance, Robert P. Christen and Deborah Drake

Defying the Odds: Banking for the Poor, Eugene Versluysen

The Economics of Microfinance, Beatriz Armendariz De Aghion and Jonathan Morduch

Kitchen Table Entrepreneurs: How Eleven Women Escaped Poverty and Became Their Own Bosses, Martha Shirk and Anna S. Wadia

Mainstreaming Microfinance: How Lending to the Poor Began, Grew, and Came of Age in Bolivia, edited by Maria Otero and Elisabeth Rhyne

Microfinance By the Numbers, CGAP

Microfinance: Evolution, Achievement and Challenges, Malcolm Harper

Microfinance Handbook: An Institutional and Financial Perspective, Joanna Ledgerwood

The Microfinance Revolution, Marguerite S. Robinson

Microfinance Systems: Designing Quality Financial Services for the Poor, Graham Wright

The New World of Microenterprise Finance: Building Healthy Financial Institutions for the Poor, Maria Otero and Elisabeth Rhyne

Occasional Paper No. 4: Institutional Metamorphosis: Transformation of Microfinance NGOs into Regulated Financial Institutions, Anita Campion and Victoria White, Microfinance Network.

Our Money, Our Movement: Building a Poor People's Credit Union, Alana Albee and Nandasiri Gamage

Pathways Out of Poverty: Innovations in Microfinance for the Poorest Families, Sam Daley-Harris

Practical Microfinance: A Training Manual, Malcolm Harper

The Price of a Dream, The Story of the Grameen Bank, David Bornstein

Rural Credit: Lessons for Rural Bankers and Policy Makers, K. P. Padmanabhan,

Small Customers, Big Market: Commercial Banks in Microfinance, Malcolm Harper and Sukhwinder Singh Arora

State of the Microcredit Summit Campaign Report 2005, Sam Daley-Harris

Women and Microcredit in Rural Bangladesh: An Anthropological Study of Grameen Bank Lending, Aminur Rahman

Women's Issues

Fifty Ways to Improve Women's Lives: The Essential Guide for Achieving Health, Equality, and Success for All, National Council of Women's Organizations and Martha Burk

In Her Hands, Craftswomen Changing the World, Paola Gianturco and Toby Tuttle

Taking Action: Achieving Gender Equality and Empowering Women, (UN Millennium Project, Caaren Grown, Geeta Rao Gupta, Aslihan Kes and Jeffrey D. Sachs

The Other Side of War: Stories of Survival and Hope, Zainab Salbi

Women in the Material World, Faith D'Aluisio and Peter Menzel

International Development

Development as Freedom, Amartya Sen

Guns, Germs and Steel, Jared Diamond

The End of Poverty: Economic Possibilities for Our Time, Jeffrey D. Sachs

The Fortune at the Bottom of the Pyramid: Eradicating Poverty Through Profits, C.K. Prahalad

How to Change the World, David Bornstein

The Lexus and the Olive Tree: Understanding Globalization, Thomas Friedman

The Mystery of Capital, Hernando DeSoto

The Poor and Their Money, Stuart Rutherford

The World is Flat: A Brief History of the Twenty First Century, Thomas L. Friedman

The Wealth and Poverty of Nations: Why Some Are So Rich and Some So Poor, David S. Landes